IMAGES of America
JOHNSON CITY FIREFIGHTING

On the cover: Please see page 10. (Courtesy of the R. G. Blakeslee photograph collection.)

IMAGES
of America

JOHNSON CITY FIREFIGHTING

Robert G. Blakeslee and Michael J. McCann

Copyright © 2007 by Robert G. Blakeslee and Michael J. McCann
ISBN 978-0-7385-5008-4

Published by Arcadia Publishing
Charleston SC, Chicago IL, Portsmouth NH, San Francisco CA

Printed in the United States of America

Library of Congress Catalog Card Number: 2006940926

For all general information contact Arcadia Publishing at:
Telephone 843-853-2070
Fax 843-853-0044
E-mail sales@arcadiapublishing.com
For customer service and orders:
Toll-Free 1-888-313-2665

Visit us on the Internet at www.arcadiapublishing.com

This book is dedicated to all those who came before us in the Lestershire and Johnson City Fire Departments—those whose names are known, and those whose names will never be known.

Contents

Acknowledgments 6

Introduction 7

1. Lester-Shire Fire Department 9

2. Endicott Johnson Fire Prevention Department 23

3. Johnson City Fire Department 37

Acknowledgments

We wish to thank the following for their generous donations, be it photographs, historical information, editing, proofreading, stories, memories, or encouragement, for without them, this book would not have been possible: Fran Jukoskie, George Trencansky, Judith K. Stadler, village of Johnson City historian Janet Ottman, town of Union historian Sue Meredith, village of Port Dickinson mayor Kevin Burke, Broome County historian Gerald Smith, the Broome County Library Historical and Genealogy Center, Joseph Bigart, Heather Lasier, and Isabel Stern Stewart. A special thank-you to the following members of the Johnson City Fire Department: retired assistant chief Frank Dohnalek; retired firefighter Harry Shannahan; retired Capt. Paul Kocak; retired battalion chief Frank Slahucka; retired firefighter Robert Matuszak; retired fire marshal Robert G. Blakeslee (photographs and photograph collection); firefighter Robert S. Blakeslee; and firefighter David Smith.

Introduction

The history of the Johnson City Fire Department is best shared in photographs. The following photographs are accompanied by descriptions of those early entrepreneurs and firefighters who pursued, diligently, the highest standards in fire protection. Of obvious note are the changes in the style of the uniforms, equipment, and overall photographic media, but what remains constant, in the faces of those who have served in the Johnson City Fire Department, is dedication and pride.

The history begins in 1850 with Horace N. Lester arriving in Binghamton, New York, with plans to start a retail shoe business. Horace was joined in this endeavor by his brother George W. Together they formed the Lester Brothers and Company, manufacturing boots and shoes on Court Street in Binghamton. Then, when Horace died in 1882, his son, G. Harry, partnered with his uncle, George W., in the business. In that same year, a young man began working for the Lester family as a foreman in one of the departments of the Binghamton factory. His name was George F. Johnson.

Johnson, who shared early the zeal of the Lester family, encouraged G. Harry to expand the business west, and outside, of Binghamton. The goal was to avoid paying city taxes and to expand to an area that was large enough to support the expansion, an area that was within the town of Union. In 1888, G. Harry began construction of his new shoe factory, which he named the Pioneer Factory. The area in which the Pioneer Factory was built, he named Lester-Shire. Hundreds of employees were hired to fill positions in the Pioneer Factory, and shoe production commenced in 1890. It was about this same time when the name of the firm was changed to the Lester Brothers Boot and Shoe Company. Two years later, on September 15, 1892, in honor of G. Harry Lester, the Village of Lester-Shire was incorporated. The following year, on October 17, 1893, the name of the village was changed to Lestershire.

In the late 1890s, the Lester brothers ran into financial difficulties and the company was turned over to the major stockholder, Henry B. Endicott of Massachusetts. Johnson soon became a partner with Endicott, and the Lester Brothers Boot and Shoe Company was renamed the Endicott-Johnson Shoe Company, later to become the Endicott Johnson Corporation—for decades the largest shoe manufacturer in the country.

As business boomed, Endicott Johnson built many more large factories in Lestershire and they would eventually employ over 20,000 workers in the first half of the 20th century. With the building of the shoe factories and influx of workers, fire protection became extremely important to the Lesters and later to the Johnsons. Fire companies were organized, fire stations were built, and fire equipment was purchased to protect the shoe factories, the workers, and the residents

of Lestershire against fire. Within the first several years of fire companies being organized, they decided to merge and became the Lester-Shire Fire Department.

The Lesters, and later the Johnsons, spared no expense in providing their business and village with the proper fire protection. Many innovations, unheard of in many other parts of the country, such as "a perfect Gamewell fire alarm street box system" and sprinkler systems in the factories, were introduced into the community even before the beginning of the 20th century. So important was fire protection to Johnson, that in the early 1900s, he created his own fire prevention department to provide 24-hour, seven-day-a-week protection to his shoe and boot factories.

In honor of George F. Johnson, on March 21, 1916, the Village of Lestershire officially changed its name to the Village of Johnson City, and with that, the Lestershire Fire Department became the Johnson City Fire Department. C. Fred Johnson, an older brother to George F., was highly involved in and had a love of firefighting. Many of the innovations that took place in the fire department in early Lestershire came about because of C. Fred. He foresaw the need and clear advantages of a paid career fire department and was instrumental in changing from a volunteer department.

The village of Johnson City, the residents, and those people that visit and work, shop, and do business in Johnson City owe a debt that can never be repaid to the Lester and Johnson families for many things, foremost being their fire department.

One

Lester-Shire Fire Department

In 1889, the first organized firefighting force in Lester-Shire was created and named the J. R. Diment Chemical Fire Engine Company No. 1. It was commonly referred to as the J. R. Diment Hose Company. As the area grew, additional fire protection was needed. As a result, the Independent Hose Company No. 1 was organized, coming from the ranks of the J. R. Diment Hose Company. Soon after, the two fire companies decided they would function better as one unit, so they merged, yet keeping separate identities, and became the Lester-Shire Fire Department.

With more factories having been built and more people having moved into the village to work in those factories, there arose the need for additional fire protection. Hence, additional fire companies were formed within the Lester-Shire Fire Department. In December 1894, the G. Harry Lester Hook and Ladder Company No. 1 was organized. A few years later, in June 1897, the C. Fred Johnson Hose Company No. 2 was organized. On July 3, 1897, the J. R. Diment Hose Company changed its name to the Henry B. Endicott Steam Fire Engine Company No. 1 in honor of Henry B. Endicott, one of the early owners of what was to become the Endicott Johnson Shoe Company.

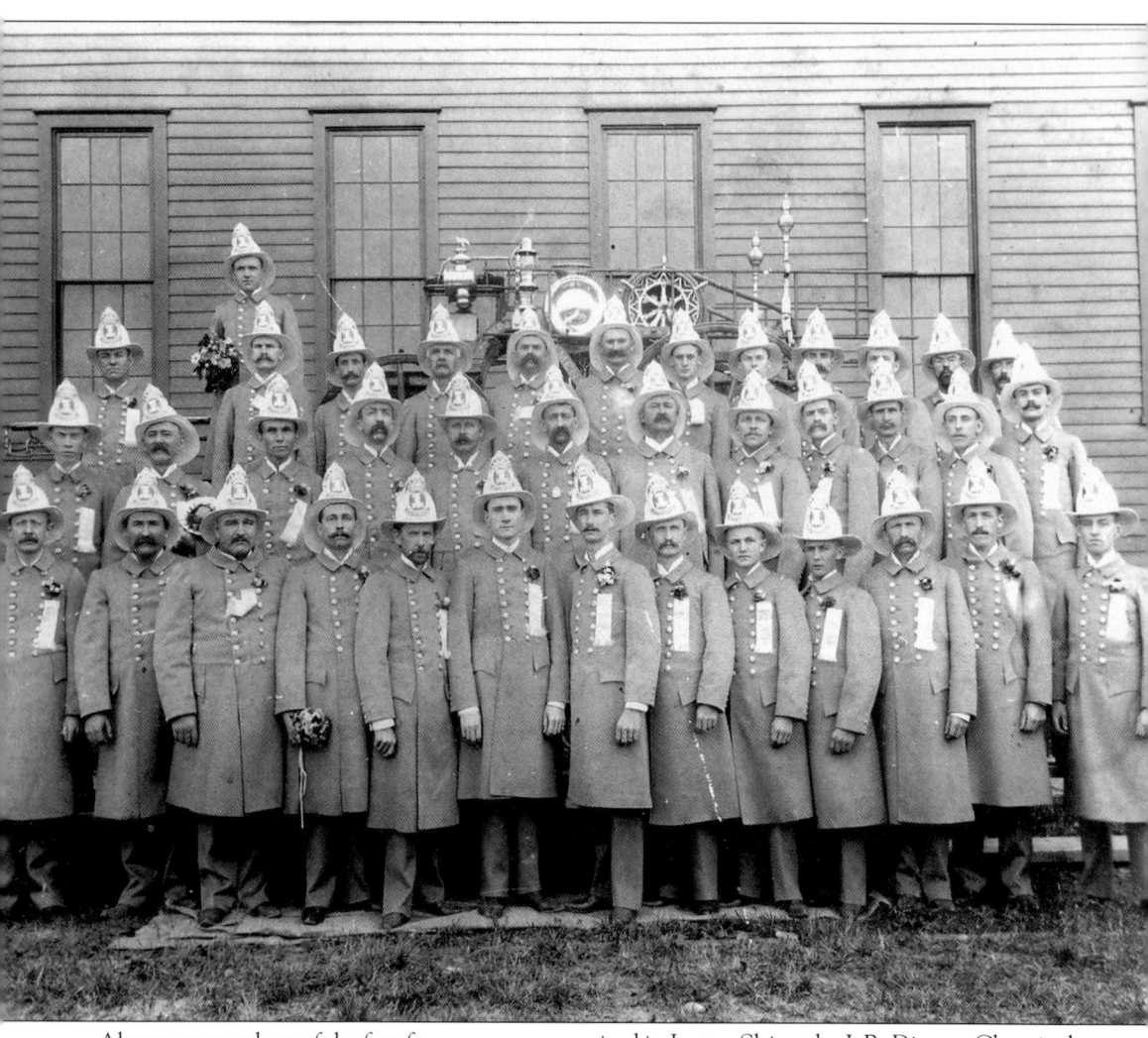

Above are members of the first fire company organized in Lester-Shire, the J. R. Diment Chemical Fire Engine Company No. 1. The company was formed in the fall of 1889 with 22 members under the command of foreman A. J. Champagne, with C. Fred Johnson as chairman of the board. The company was named in honor of Joseph R. Diment, a superintendent of the Lester Brothers Boot and Shoe Company. This company was originally housed in a brick building on Main Street, the exact location unknown, and then moved to a newly built station house on Corliss Avenue between Broad Street and Arch Street. That building stood for many years but was removed in the 1990s. On July 3, 1897, the J. R. Diment Chemical Fire Engine Company No. 1 was renamed the H. B. Endicott Steam Fire Engine Company No. 1 in honor of Henry B. Endicott, president of the Lester Manufacturing Company. Andrew Pease was named as foreman of the newly renamed fire company. The only individual identified in the c. 1895 photograph above is George F. Johnson, who is standing in the first row, far left.

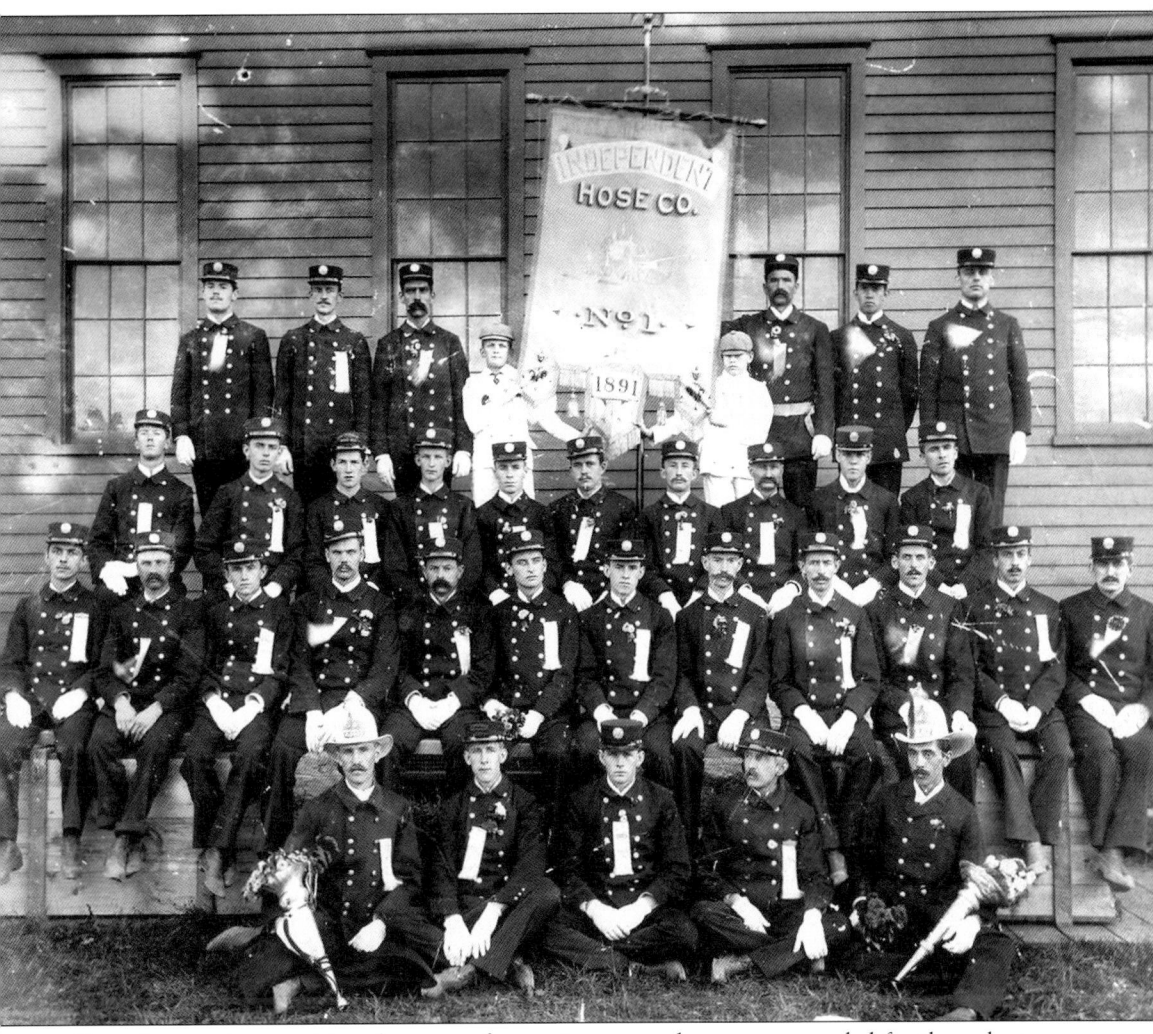

Growth caused recognition that more fire equipment and men were needed for the volunteer fire force. In early 1891, a spin-off of the J. R. Diment Chemical Fire Engine Company occurred, creating the Independent Hose Company No. 1, pictured here. This fire company was organized with 58 men under the command of foreman Arthur Smith. Both fire companies worked together without the rivalry (brawling and fighting between fire companies would occur to see who would get water on the fire first) that was common during those years in towns and cities across the country. On November 24, 1891, the J. R. Diment Chemical Fire Engine Company No. 1 and the Independent Hose Company No. 1 merged, yet kept their separate identities (just as fire companies do today within a fire department), and officially organized as the Lester-Shire Fire Department. The first official chief engineer of the Lester-Shire Fire Department was A. J. Champagne. On January 28, 1892, the Lester-Shire Fire Department incorporated. It should be noted that the fire department preceded, by some 10 months, the official formation of the Village of Lester-Shire, which was incorporated on September 15, 1892. On October 17, 1893, the village changed its name to Lestershire.

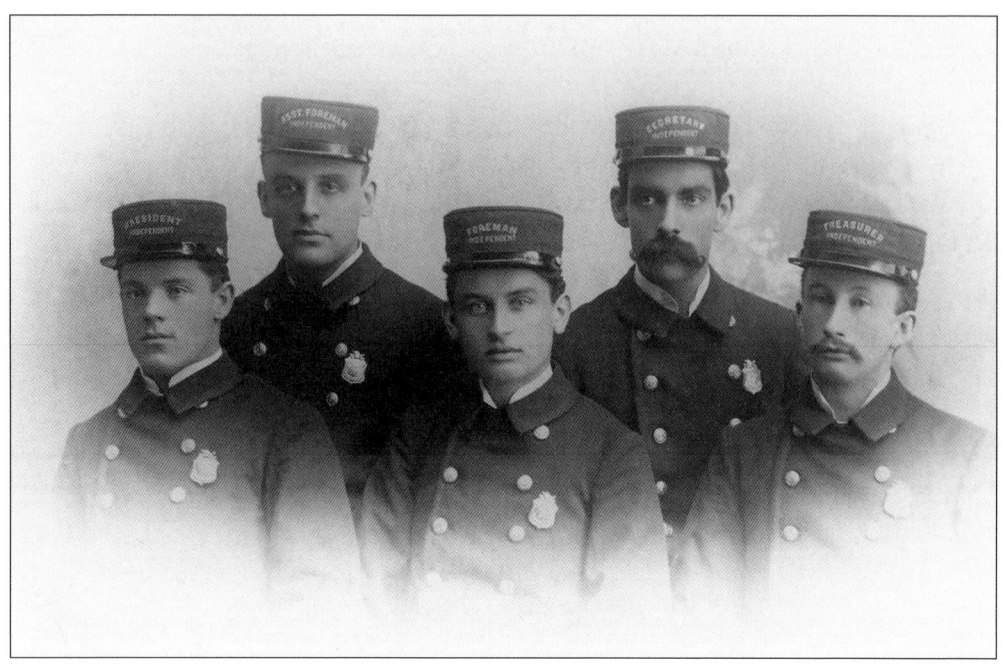

The proud officers of the Independent Hose Company No. 1 are shown here in 1895. From left to right are Pres. Frank Schoonmaker; foreman William H. Hill, who later became mayor and then postmaster of Lestershire, a New York State senator, and a U.S. Congressman; assistant foreman William M. Cresson; secretary A. A. Smith; and treasurer Arthur Jeffers. Below is Lestershire Fire Department badge number 235, more than likely issued to the 235th man to join the then all-volunteer fire department.

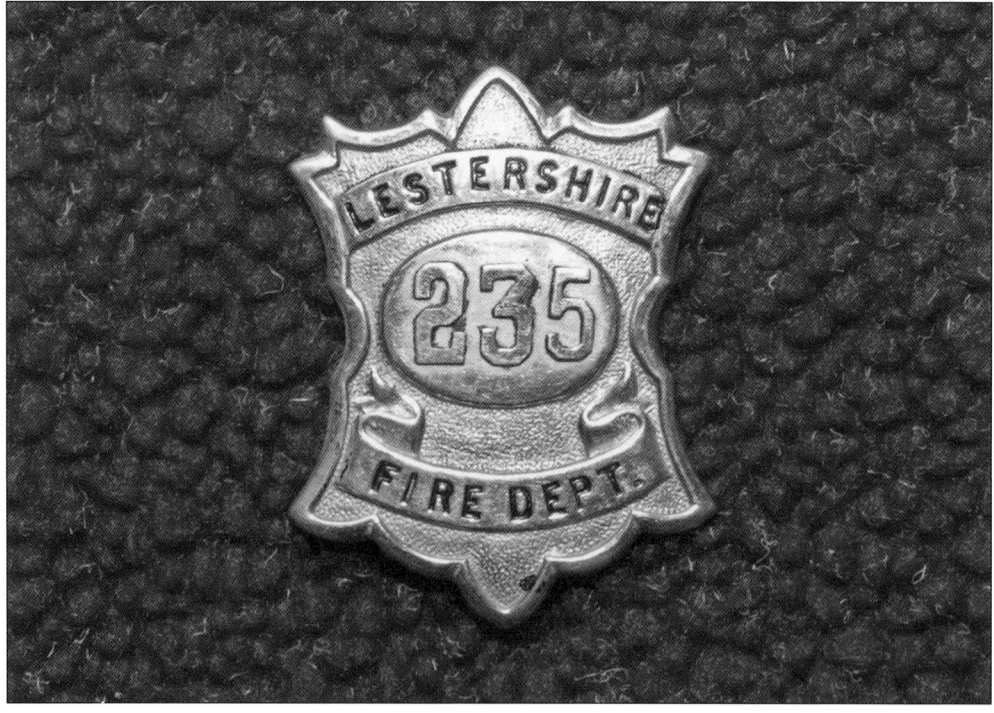

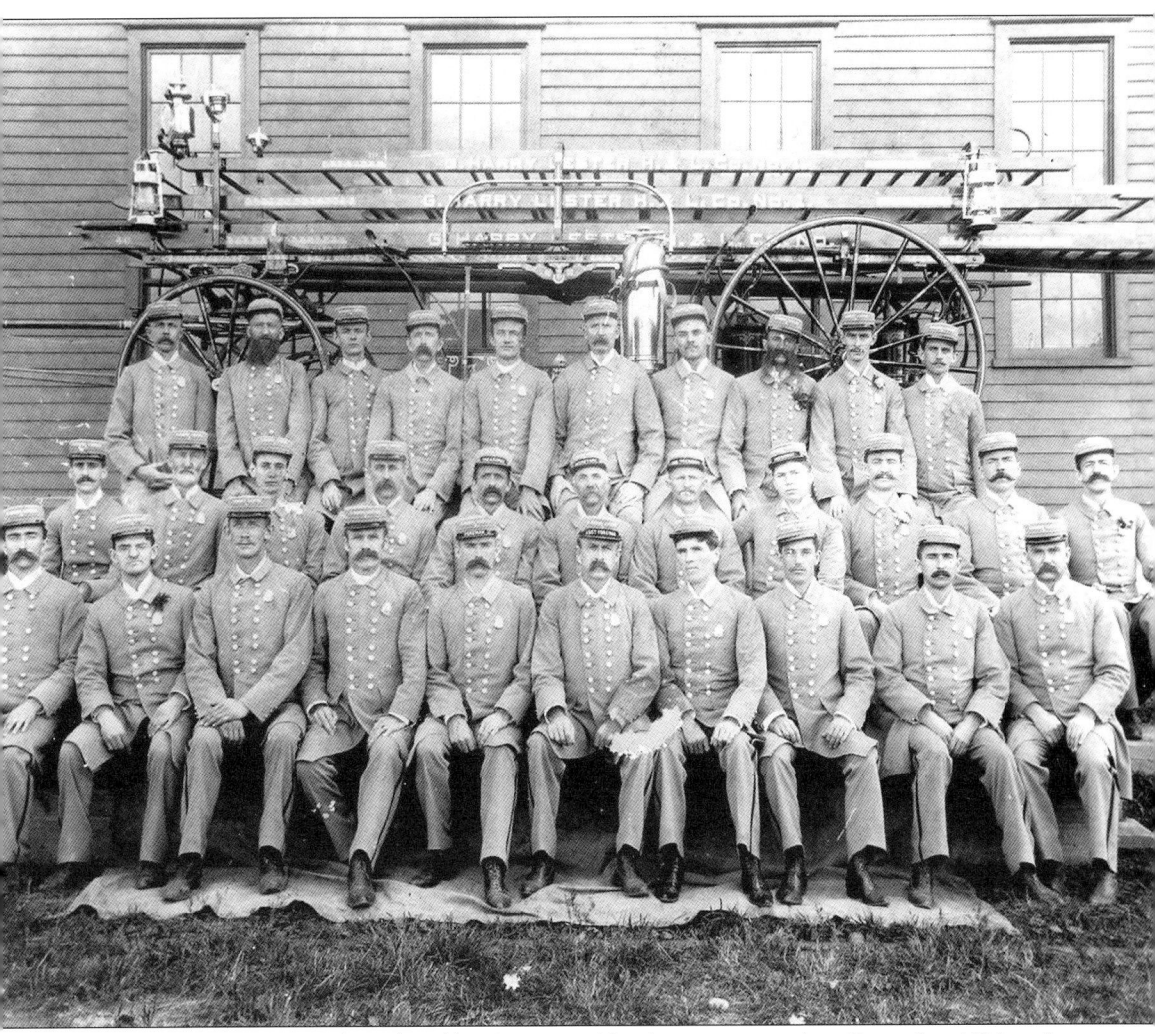

The G. Harry Lester Hook and Ladder Company No. 1 was organized in December 1894 with 44 members under the command of foreman Charles Bliven. Members in this c. 1895 photograph include, from left to right, (first row) J. Elliott, George Sturey, R. Gray, Professor Beals, James Derby, E. Baldwin, E. Foley, E. Snow, E. Kane, and C. D. Becker; (second row) C. Gray, M. Blackman, W. B. Kimball, E. Cafferty, S. L. Bump, M. White, W. H. Wilson, John Kennedy, M. Farrell, J. Foley, and R. Smith; (third row) C. Fred Johnson, John Schulte, E. H. Tracey, George Holyoke, J. S. Patterson, R. H. Spendley, H. H. Turner, E. H. Codding, James Polk, and Byron Thorne.

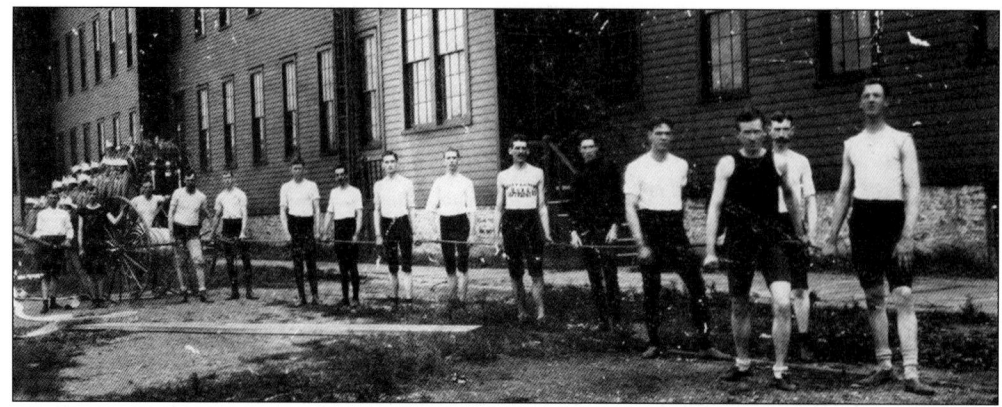

The Independent Hose Company running team (around 1895) held a record, traveling 200 yards in 22.5 seconds. From left to right are Eugene Bronson, John Burrows, William M. Cresson, Doc Tanner, William Pelham, Fred Casey, Frank Zimmer, William Hill, James Hill, Fred Ramford, Leroy Houghtaling, William Wimple, J. F. Chambers, Mike Dwyer, and Fred Woodburn. Interestingly, to the far left of the photograph can be seen the J. R. Diment Chemical Fire Engine Company No. 1, posing for their group photograph which is seen on page 10. Below is the membership certificate belonging to Melvin Chambers, elected to membership of the Independent Hose Company No. 1 on June 14, 1897.

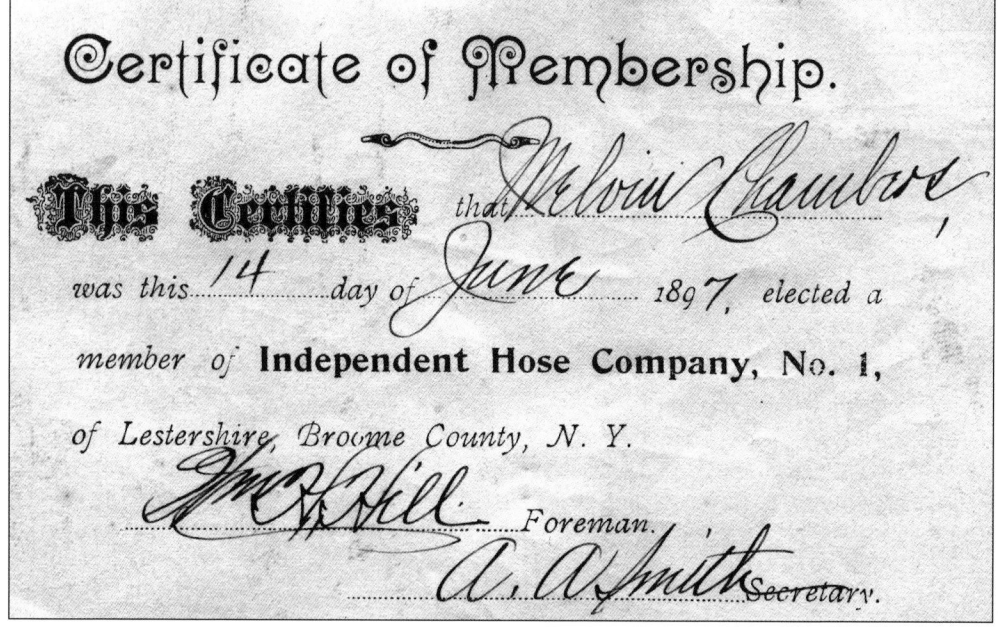

Parades were an important part of volunteer fire department life. They were also fabulous social gatherings where hundreds of firemen would get together for dinners, parties, a bit of drinking, and general carousing for fun. Most of the time the firemen behaved themselves fairly decently. The Lester-Shire Fire Department not only hosted an annual parade and convention, but the members made sure they were well represented at many other parades throughout the area and state as well during the year. The c. 1898 photograph above was taken near the current intersection of Willow Street and Main Street. The photograph below is an example of the parade ribbons that were generously given out to all participants of each annual parade in a given municipality or town. At one time, there were many parade ribbons on display in the now closed Central Fire Station. The whereabouts of most of those ribbons, and other artifacts, is now unknown.

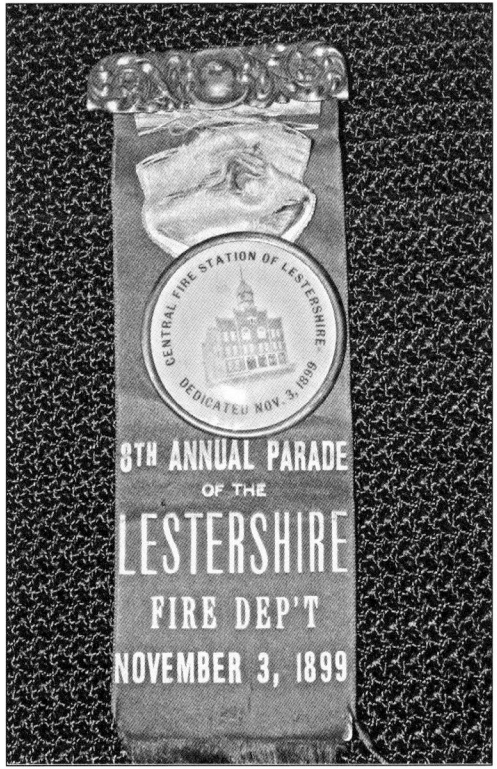

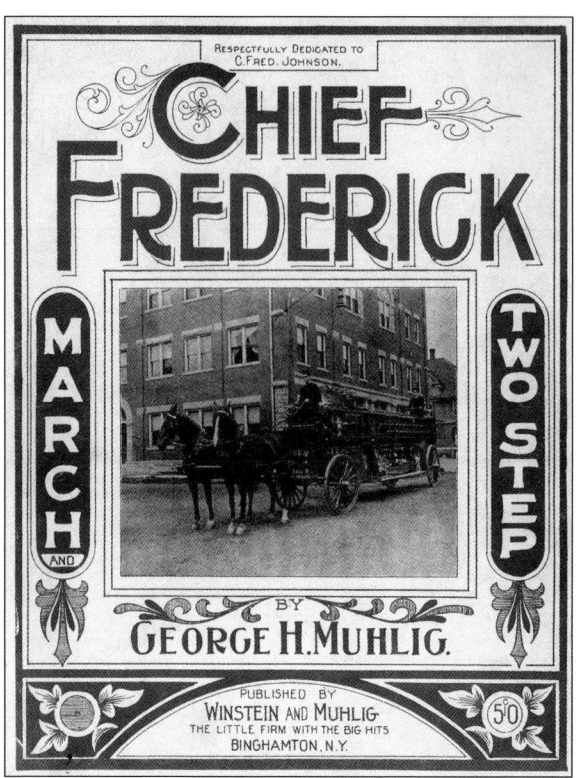

C. Fred Johnson was the major force behind the organization of the Lester-Shire Fire Department and later the Endicott Johnson Fire Prevention Department. He had a love of firefighting, and his zeal was overshadowed by no one. His passion was the fire department, and he saw to it that the best equipment was obtained for the departments. The men loved C. Fred because he loved them and looked to their welfare. He was a highly respected man in the community, liked by all. As a show of admiration, George Muhlig composed the "Chief Frederick March and Two Step" in 1906.

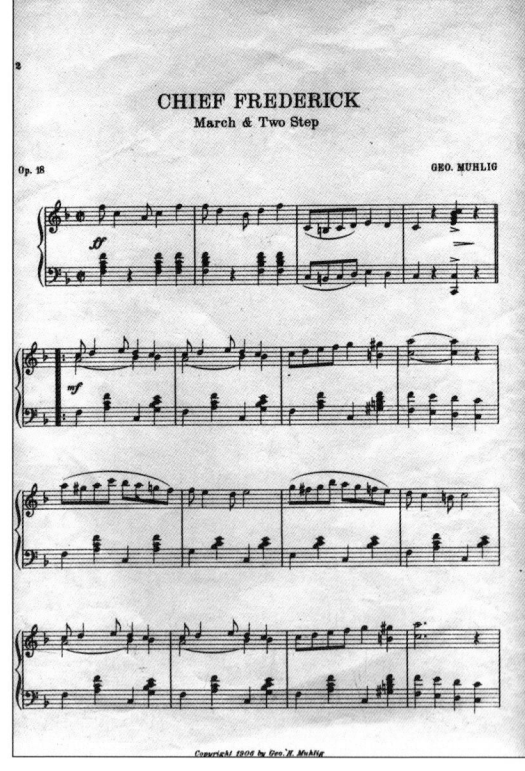

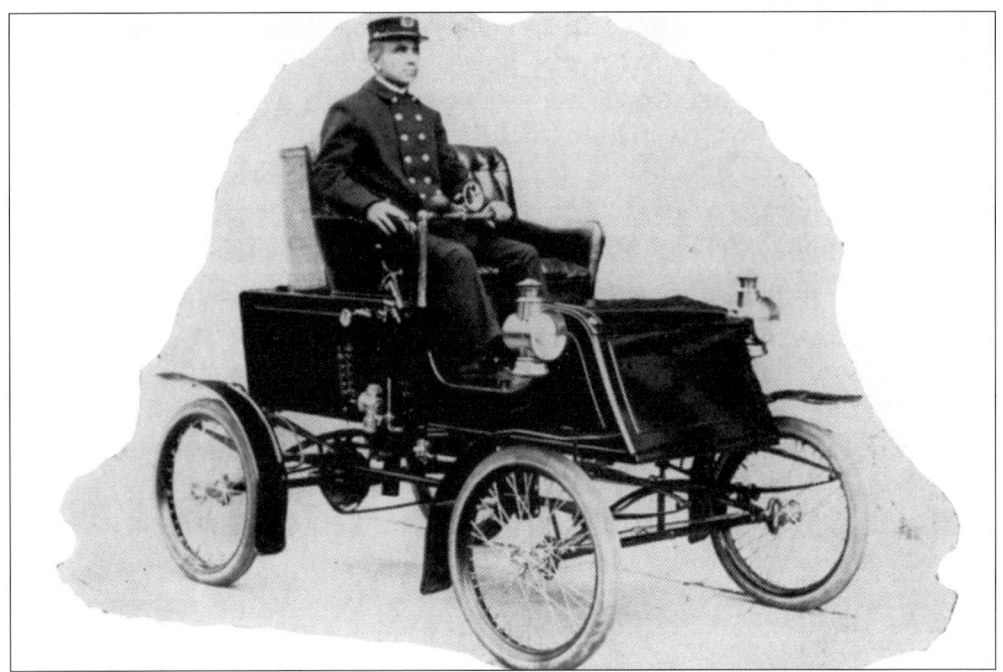

The first automobile in Lestershire was owned by then chief engineer W. G. Faatz of the Lestershire Fire Department. In this 1903 photograph, he is shown at the wheel of his new car, proudly wearing his fire department uniform. The time of the fire horses in Lestershire began coming to a close in 1914, when the first motor-driven apparatus was purchased and placed into service. The new fire engine was a Mack, which had to be started with the front-mounted crank. It was not a comfortable piece of equipment to ride on due to the solid rubber tires it was equipped with.

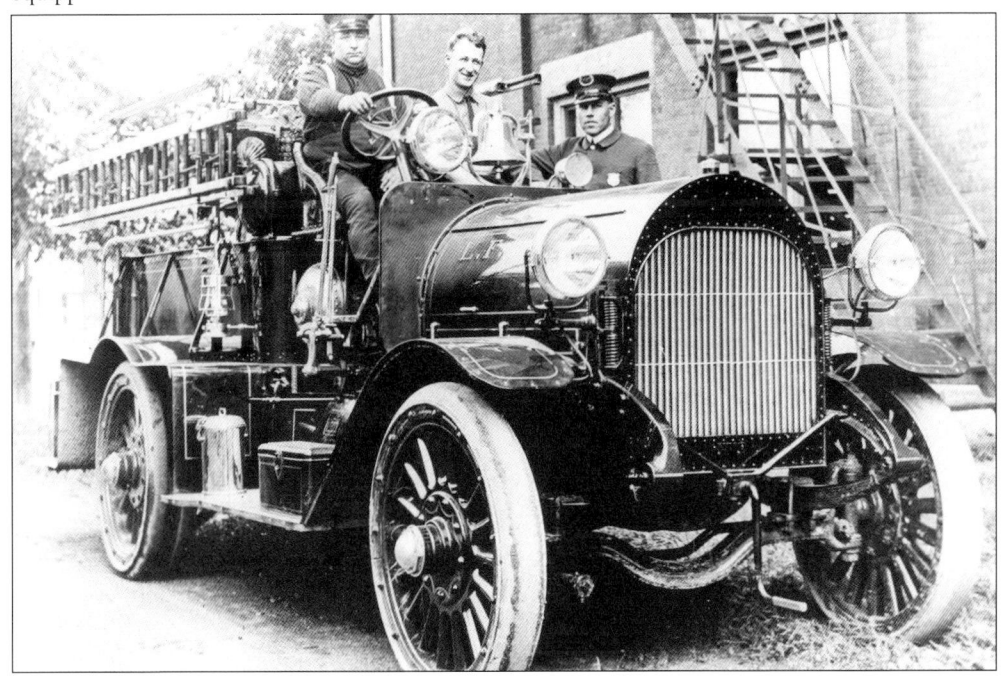

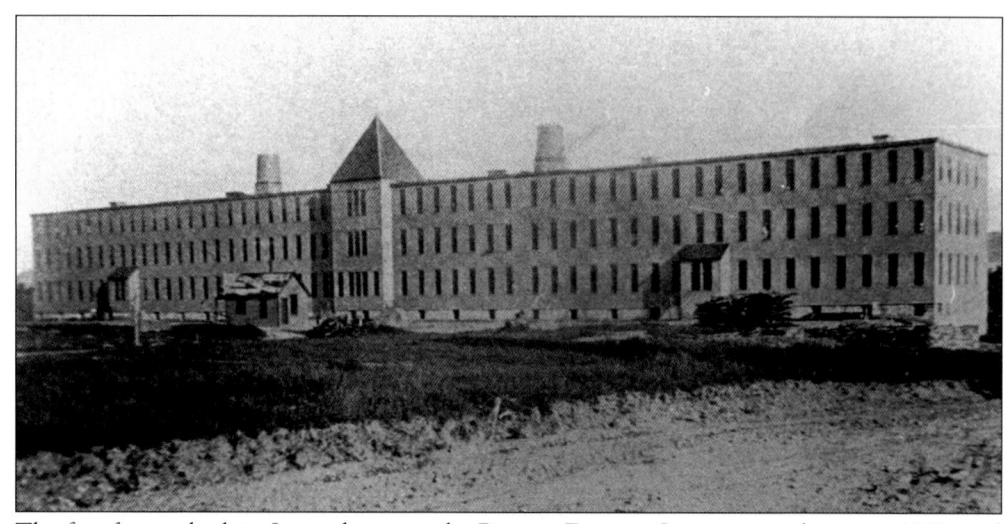

The first factory built in Lestershire was the Pioneer Factory. Construction began in 1888, and the factory was completed and placed into service in 1890. Endicott Johnson would continue to build shoe factories and tanneries, all requiring fire prevention, firefighting equipment, and men for the job to protect the factories and workers within. Many of the employees became members of the volunteer fire department, out of loyalty to the Johnson brothers, and for social reasons. After members provided five years of service to the department, the exempt fireman's certificate was issued to them. Depending upon the community, the exemption might help to reduce the member's tax burden, or exempt the member from jury duty.

Pictured here are two members of the Lester-Shire Fire Department in 1900. Above is M. S. Hotchkiss of the Harry Lester Hook and Ladder Company No. 1. Below is Thomas Brogan of the C. Fred Johnson Hose Company No. 2. In the present-day Harry L Drive fire station there is a large composite montage that was produced in 1900 of all the then current members of the Lester-Shire Fire Department. In this large composite are 163 members of the department at the time, along with various photographs of the interior of the then only one-year-old Central Fire Station. The new station lacked nothing, and beautiful rooms can be seen in these photographs. The large composite is behind glass, hanging in a truck bay, and is open to the public for viewing.

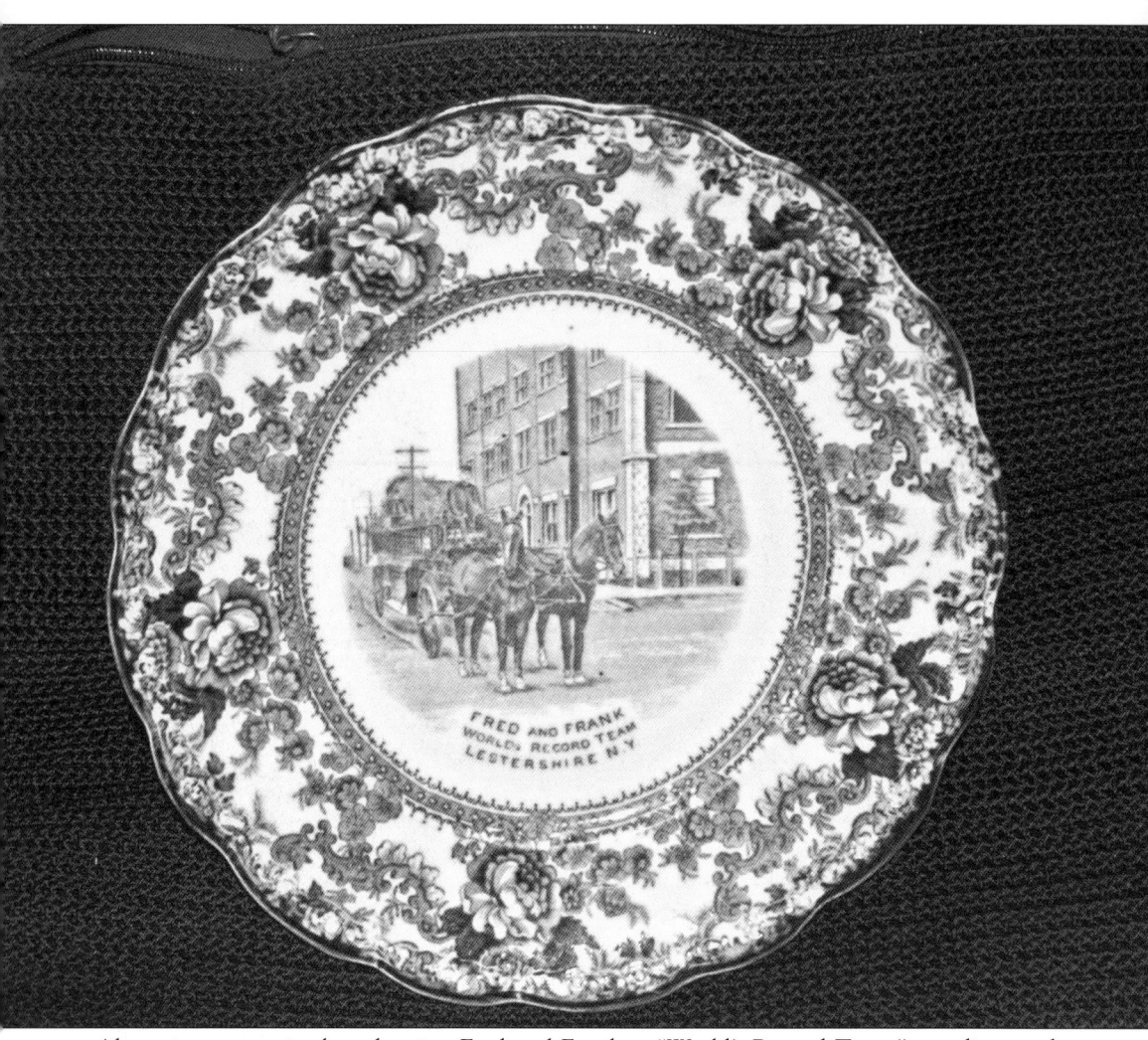

Above is a souvenir plate showing Fred and Frank, a "World's Record Team," standing at the corner of Willow Street and Corliss Avenue, where the new Central Fire Station was built in 1899. It has yet to be found just what world record the fire horse team held, but conjecture would have it they held some type of speed record for pulling a certain-sized fire engine or truck a certain distance.

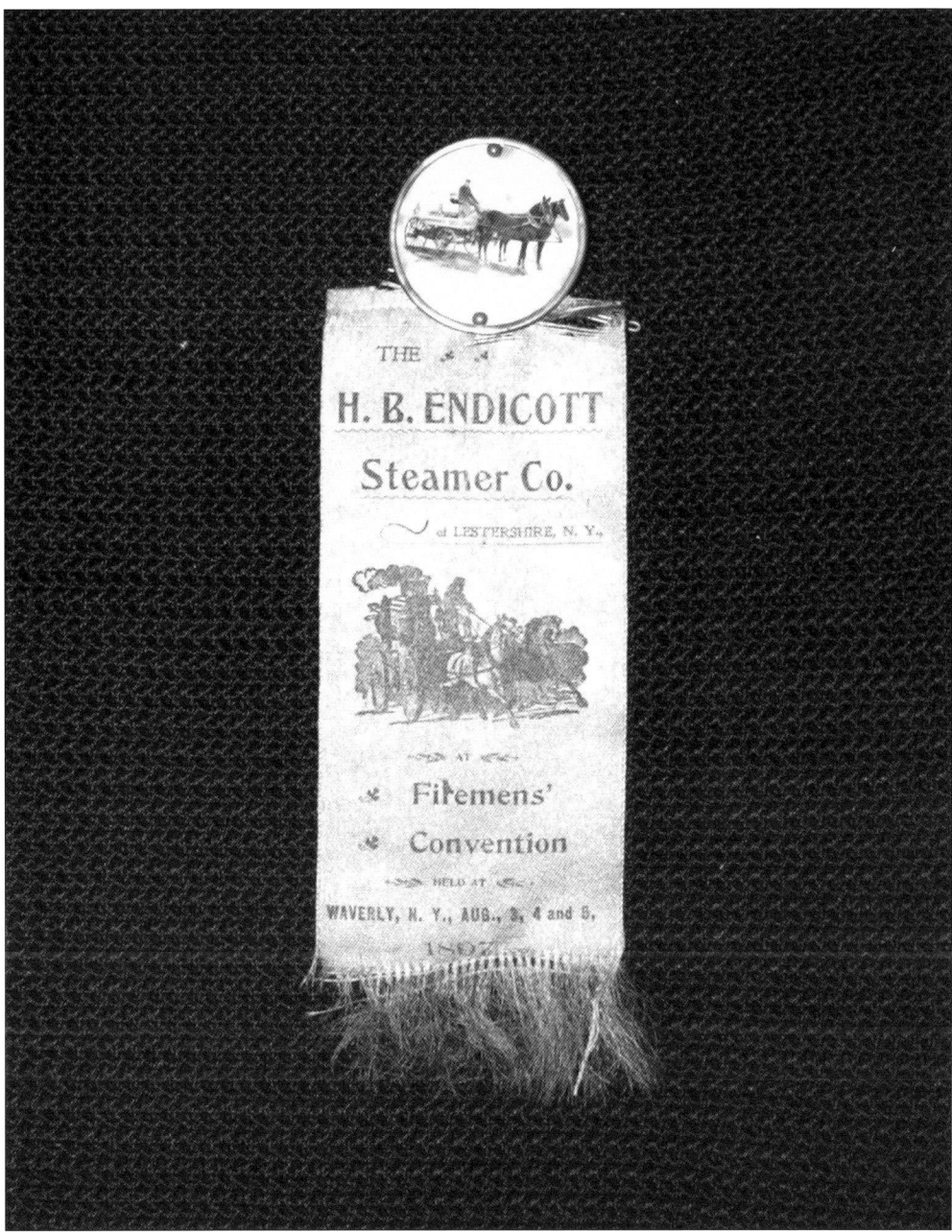

In this photograph, they are shown again on the H. B. Endicott Steamer Company parade ribbon from a convention held in Waverly, New York, in 1897. Parade ribbons and souvenir items were commonplace and a show of pride for virtually all fire departments in the country in the 1800s and into the first half of the 20th century.

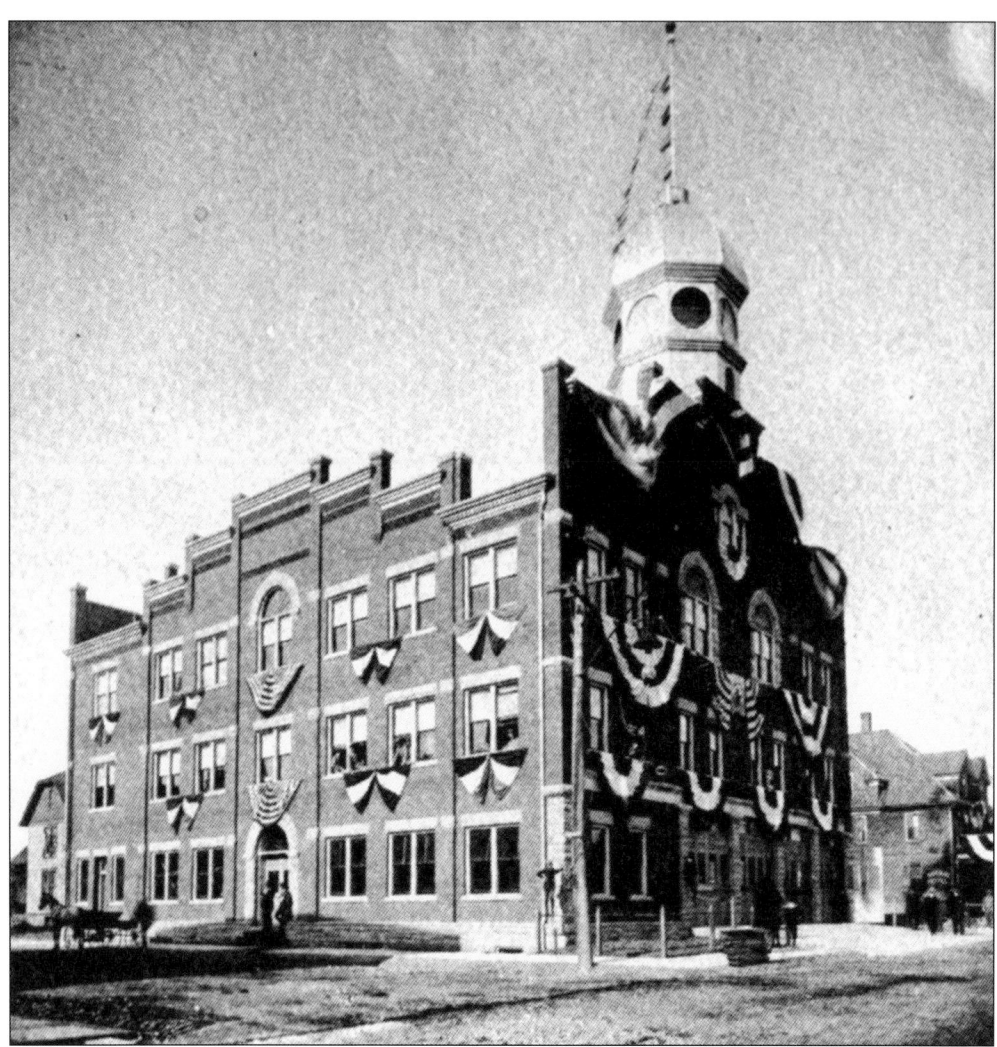

The Lester brothers, Horace N. and George W., paid for the new Lestershire Fire Department Central Station, which also housed the municipal offices. This fire station was, for its day, built quite lavishly, as the Lester brothers thought that the firemen needed a comfortable place in which to do their business and training, and to house the fire apparatus. The ground floor housed the apparatus while the second floor contained office space for the chief, reading rooms, a kitchen, a large bath and shower room, a training room, a locker room, and a large dormitory. The third floor contained more office space with a large conference or meeting room used by the fire department, and the village for public meetings. There was also ample storage space on this floor. The building was completed at a cost of $27,500, and it was dedicated on November 3, 1899, with great pomp and circumstance.

Two

Endicott Johnson Fire Prevention Department

Charles F. and brother C. Fred Johnson placed great importance on fire prevention in order to protect their vast investments. They were firm believers in Benjamin Franklin's quote "An ounce of prevention, is worth a pound of cure." Most people are familiar with these words coined by Benjamin Franklin, but few know that when he wrote and spoke those words, he was talking directly about fire prevention. Like Franklin, the Johnson brothers knew that the only way to prevent fires within their factories was with a fully functional division created for that purpose, filled to create men properly trained and on watch at all times. Even with this new division, they knew the possibility of fires existed, so they provided their division with the best firefighting equipment that money could buy at the time.

In 1915, the Endicott Johnson Fire Prevention Department was formed and placed into service. The department had two fully manned stations, station No. 1 on Avenue B in Johnson City, and station No. 2 located in Endicott. Factories were outfitted with modern fire alarms and sprinkler systems. When activated, the alarm was sent in to station No. 1, directing the firemen to the location of the fire. As far as Charles F. Johnson was concerned, when it came to fire safety in his factories and for the workers within them, nothing was going to be left to chance. The firemen were reminded, quite frequently by Charles F. and C. Fred, that they had the toughest job at the factories, in that their work could not be gauged and no record could be kept detailing the fires they had prevented. They knew their division had prevented many fires, but there was just no way to measure that fact. In C. Fred's words, "a thankless, but a no more important job, than fire prevention."

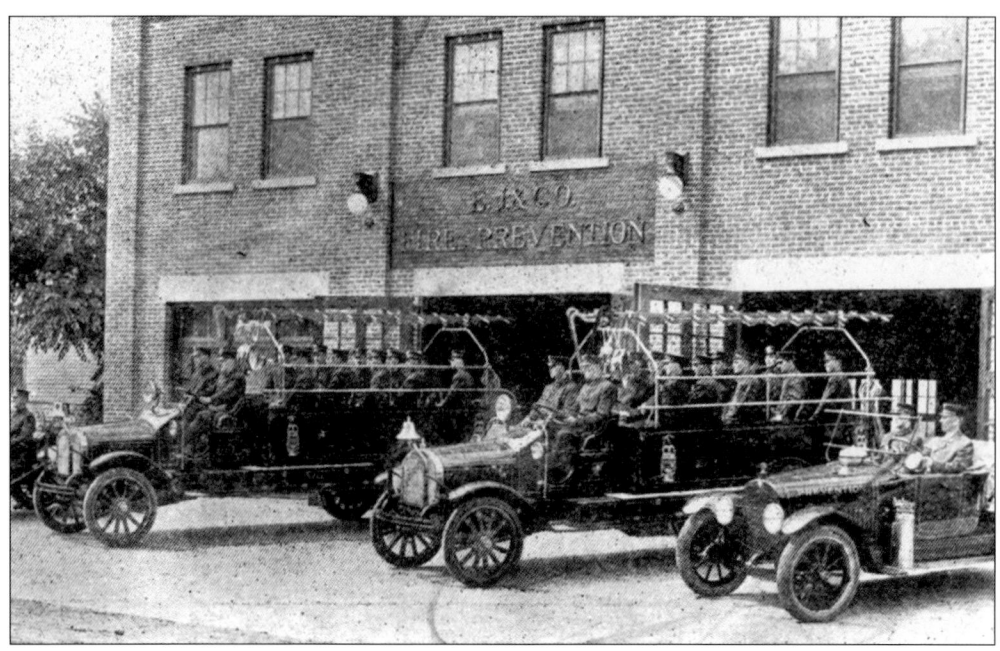

In 1915, Charles F. Johnson determined that he needed a full-time fire prevention department to prevent and protect his factories from fire. He placed this assignment with his brother, C. Fred, who oversaw the formation and implementation of the department. C. Fred spared nothing in providing the department and the men who would work in it, with the most modern and up-to-date equipment available. C. Fred also saw to it that the men of the fire prevention department were well trained in their duties. The men were detailed to training exercises every day, and the job of fire prevention was taken very seriously. All knew there was a lot at stake if they failed in their jobs. The photograph above was taken in 1916, and the photograph below was taken in 1922.

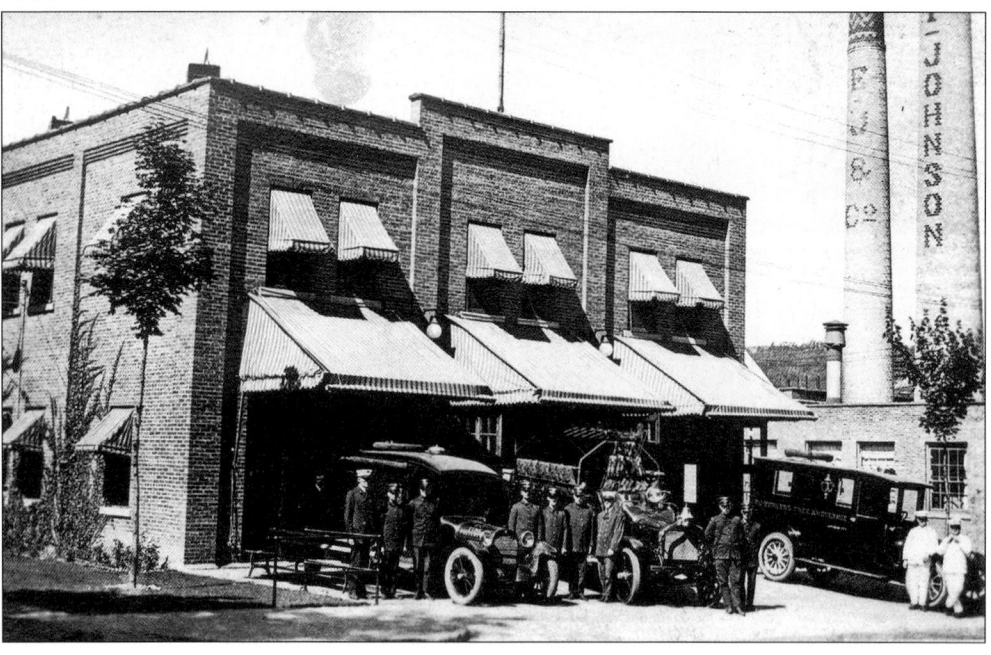

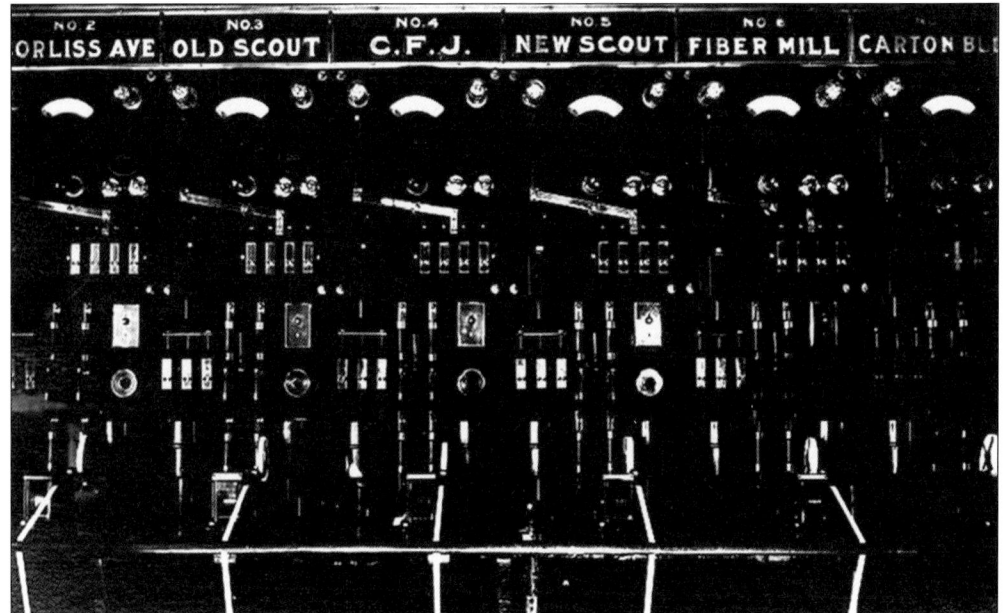

Endicott Johnson would eventually have 28 shoe factories, six tanneries, and three rubber mills producing some 45 million pairs of shoes and boots every year. According to a 1922 souvenir booklet, Endicott Johnson was, at the time, the world's largest tanner and shoe maker. This title would hold into the 1960s. With so many very large factories to provide protection to, an elaborate fire alarm system was installed to alert the on-duty fire prevention crews of any problem in any building, at any time. Shown above is a c. 1916 photograph of just a small part of the alarm console in the Endicott Johnson Fire Prevention Station No. 1. Shown below is a part of the telephone alarm system that was integrated into the whole fire alarm system at a later date.

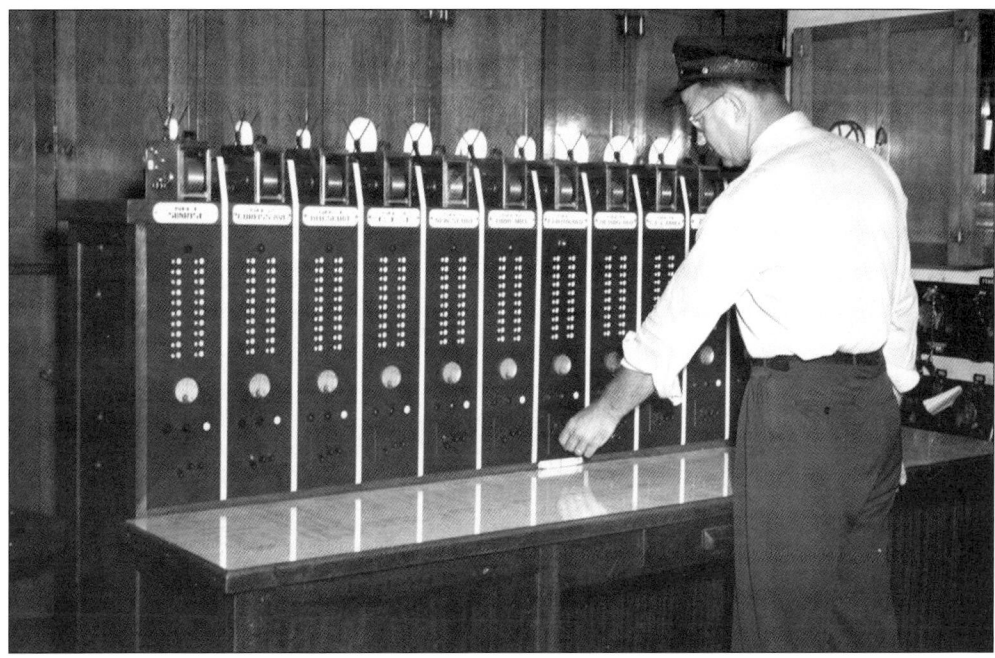

This was the dormitory on the second floor of the Endicott Johnson Fire Prevention Station No. 1 in Johnson City in 1916. It is evident that discipline and orderliness had been instilled in the men of the department. When an alarm of fire came in during the night, the bells would sound and the dormitory lights would automatically turn on. The men would jump out of bed, slide down the pole and man the apparatus they were assigned to, and respond to the scene of the alarm. Below is a *c.* 1922 photograph of an inspection being held at the Johnson City station.

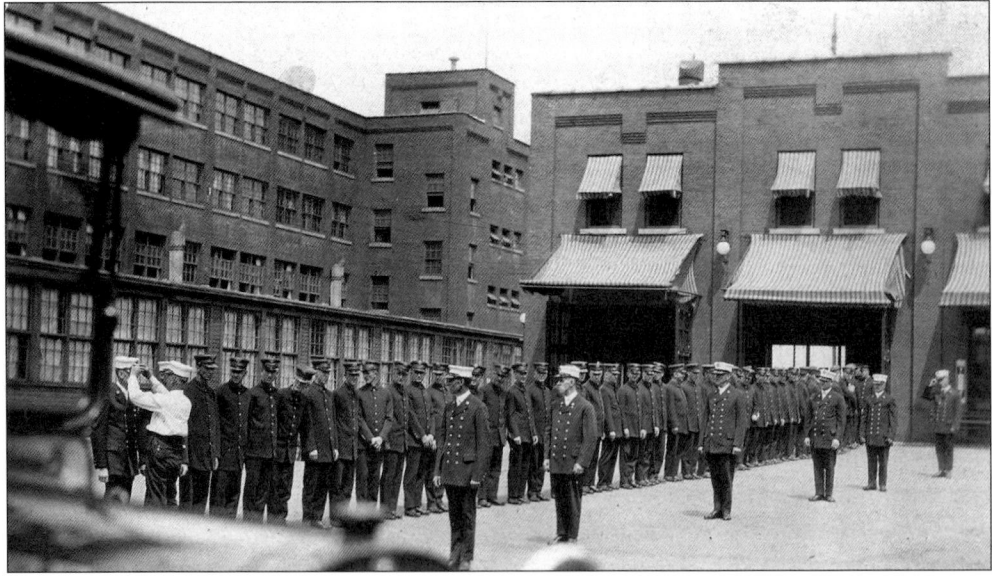

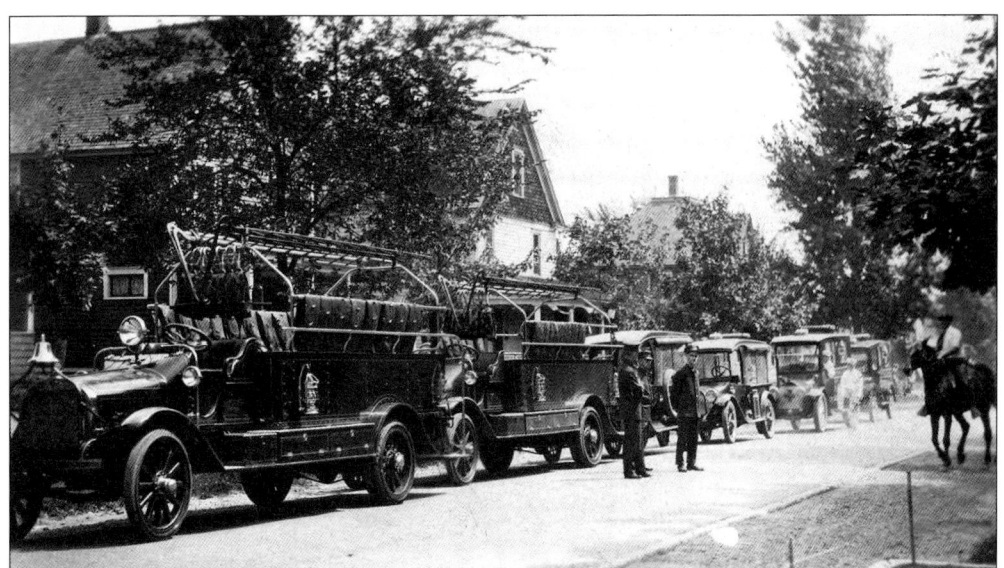

Above, the Endicott Johnson Fire Prevention Department apparatus is lined up on a village street around 1922. The c. 1922 photograph below shows both Endicott Johnson Fire Prevention and Johnson City Fire Department apparatus and men lined up on Avenue B in Johnson City. Both departments worked closely together when fires occurred in the village. Chief James Eldridge is seen standing on the left in front of the Endicott Johnson Fire Prevention car. All trucks, cars, and ambulances were maintained in very clean conditions at all times by the men of both departments, a tradition that continues today in most departments.

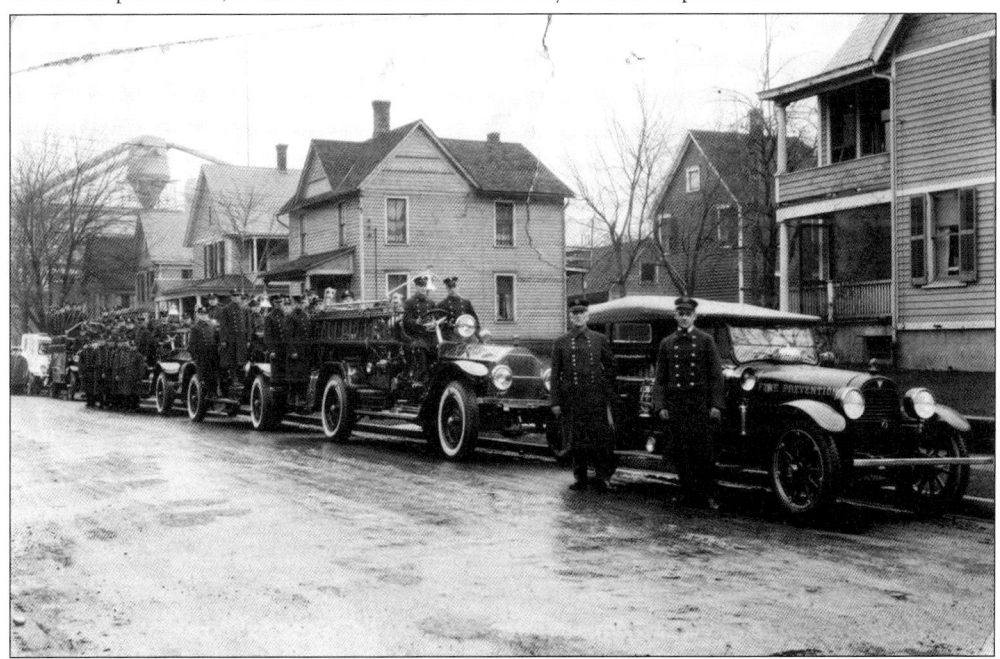

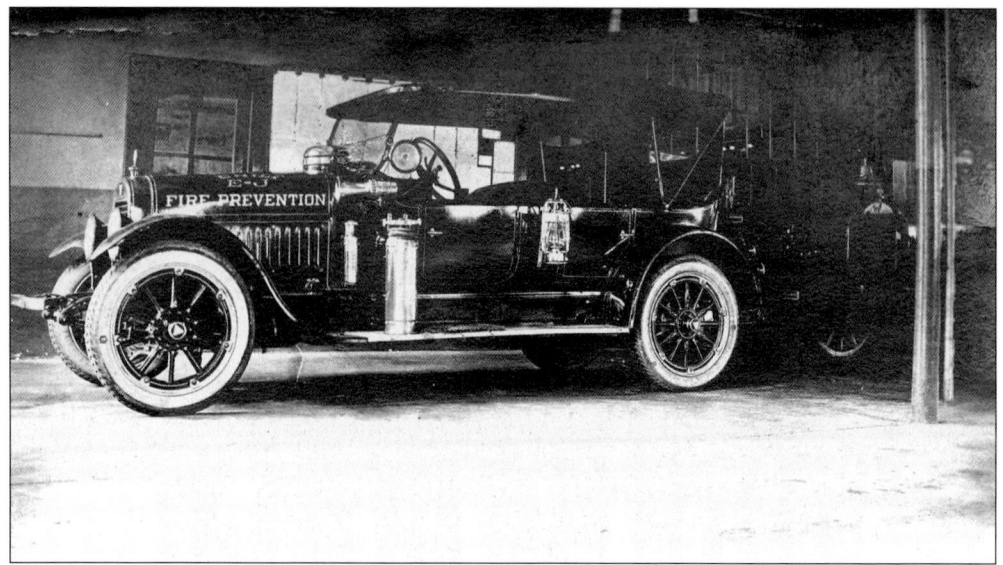

Above is an Endicott Johnson Fire Prevention car sitting inside the Johnson City station on Avenue B. Below, in this c. 1922 photograph, fireman John Stern is shown standing behind the Johnson City station. This station still stands and today is in use as a framing shop and art gallery. The second floor contains various private businesses. Although the interior of the building has been substantially altered within just the past few years, the exterior looks much as it did in the 1920s. The building was well maintained by the firemen that were stationed there, which contributed to its very good condition today.

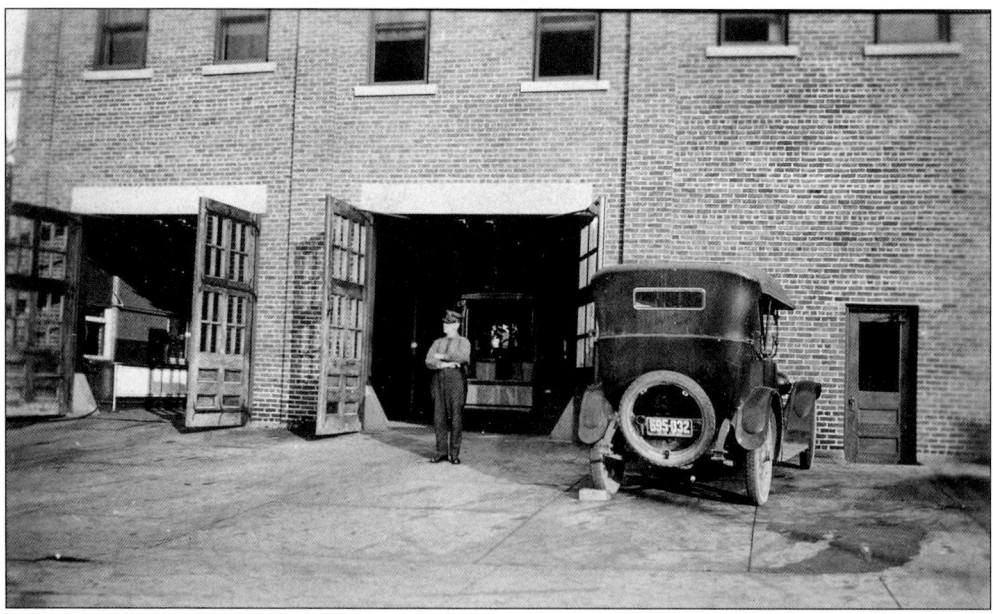

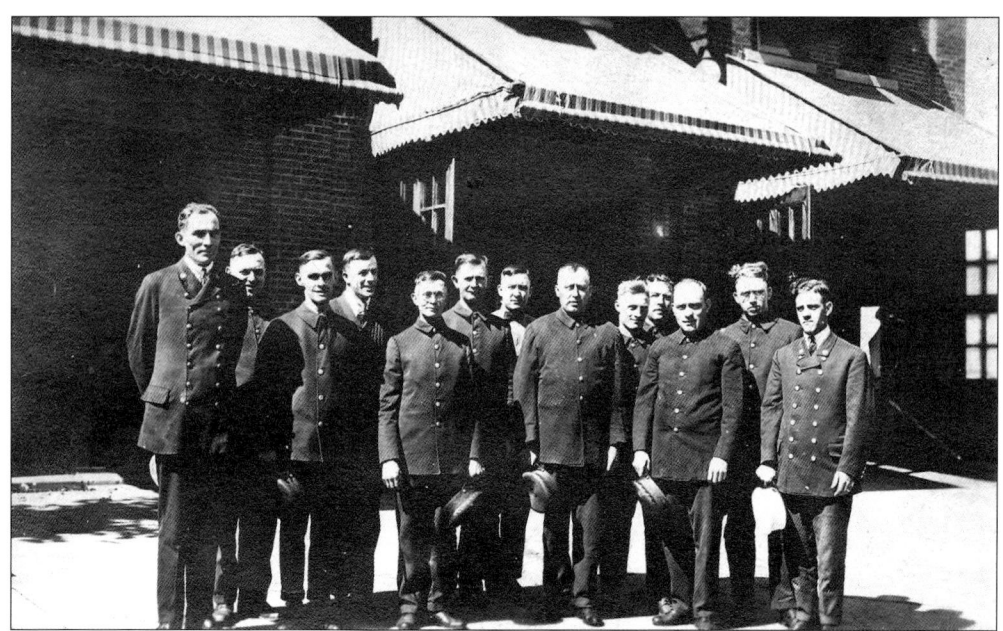

A group of Endicott Johnson Fire Prevention firemen pose for a c. 1922 photograph in front of the Johnson City station. Below is a photograph during the testing of fire hose by Endicott Johnson Fire Prevention personnel. Standing is Capt. Art Purtell, sitting left is an unidentified man, and at right is fireman John Chill. Fire apparatus and equipment was checked and tested frequently to make sure all was in good working condition. There is nothing worse than needing the equipment for a fire, only to have it fail during use. The constant checking and testing of equipment can become monotonous and tedious, but all good firemen know it is a necessity that cannot be foregone.

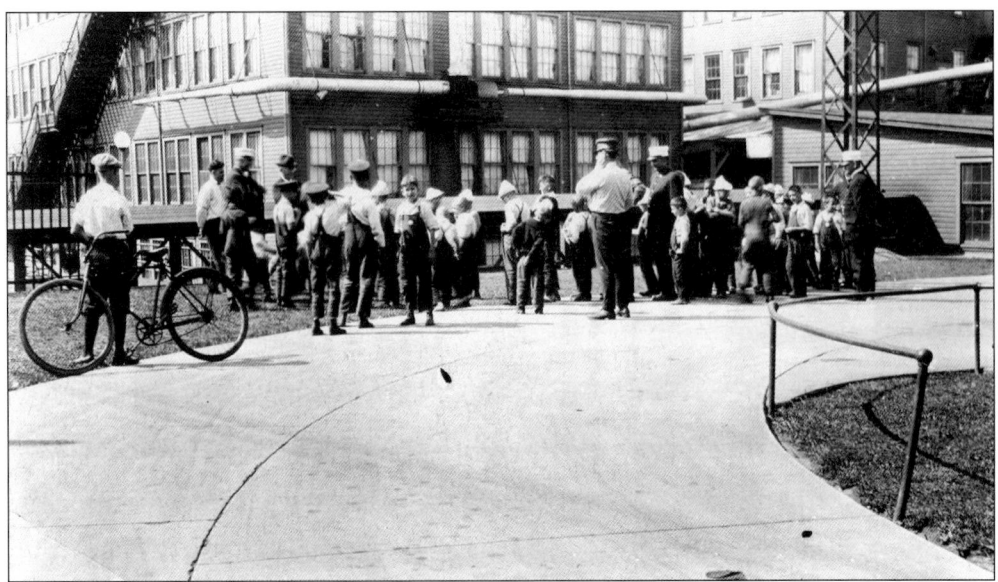

During the 1920s and 1930s, the Endicott Johnson Fire Prevention Department hosted Clean Air Kids from New York City to come up and spend some time in Johnson City to get away from city life and enjoy the "clean outdoors air" of the area. Shown above is a group of the kids being given a tour of the Endicott Johnson buildings and factories in Johnson City. Below, two Endicott Johnson Fire Prevention firemen are shown standing on the side of the Johnson City station with an unknown visitor in 1922. On the left is fireman Dan Stark, and on the right is fireman John Stern.

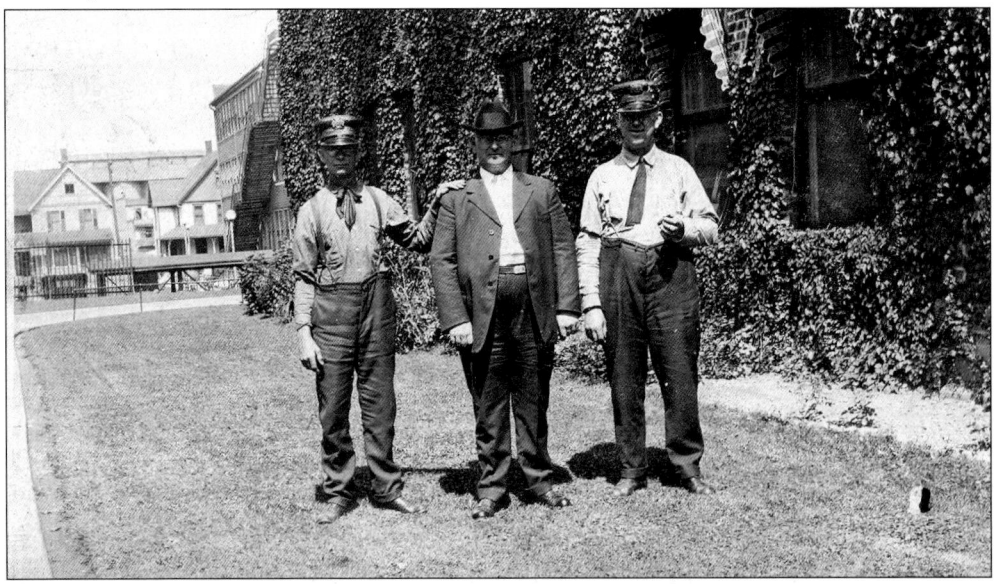

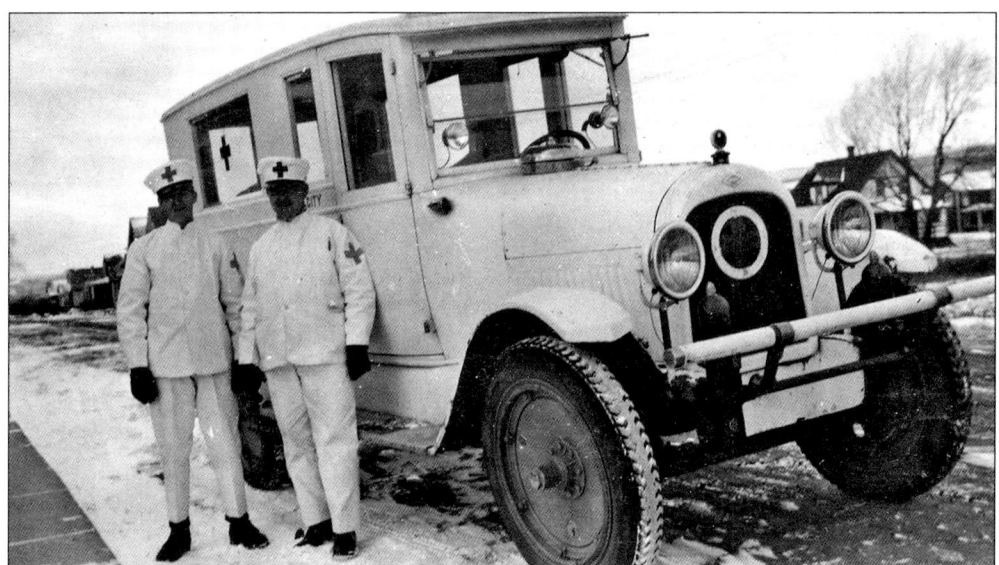

Endicott Johnson Fire Prevention Department not only provided fire protection to the factories and the workers, it also provided free ambulance service to the workers of Endicott Johnson Shoes. Ambulances would be dispatched to the factory where the worker had been injured, and the worker was then taken to either Wilson Memorial Hospital in Johnson City or to Ideal Hospital in Endicott. In addition, Endicott Johnson provided free medical care to the employees through a medical building in Johnson City. Not only was the medical care by physicians free, but any required medicines were provided to the worker at no cost. Both photographs are from around 1922.

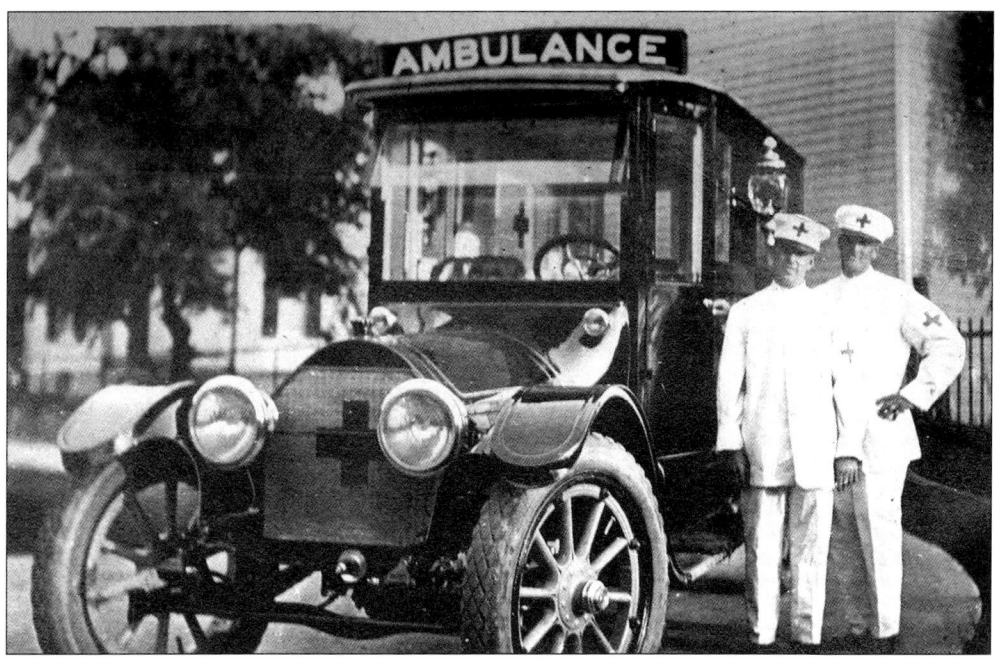

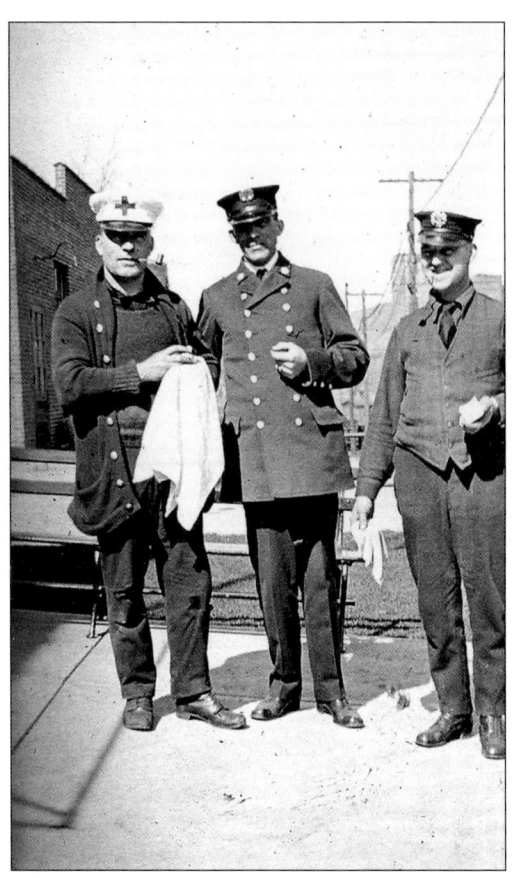

Both of these photographs were taken outside of the Endicott Johnson Fire Prevention Station in Johnson City. Comradery was the order of the day, just as it is with fire departments of today. There was time for work, and there was time for relaxing between emergency calls, and these firemen were taking advantage of their down time. Smiles can be seen on all faces in these two photographs, which were taken in 1922, but none of the men in the photographs are identified. The men in civilian clothing could have been off-duty firemen or simply visitors to the station.

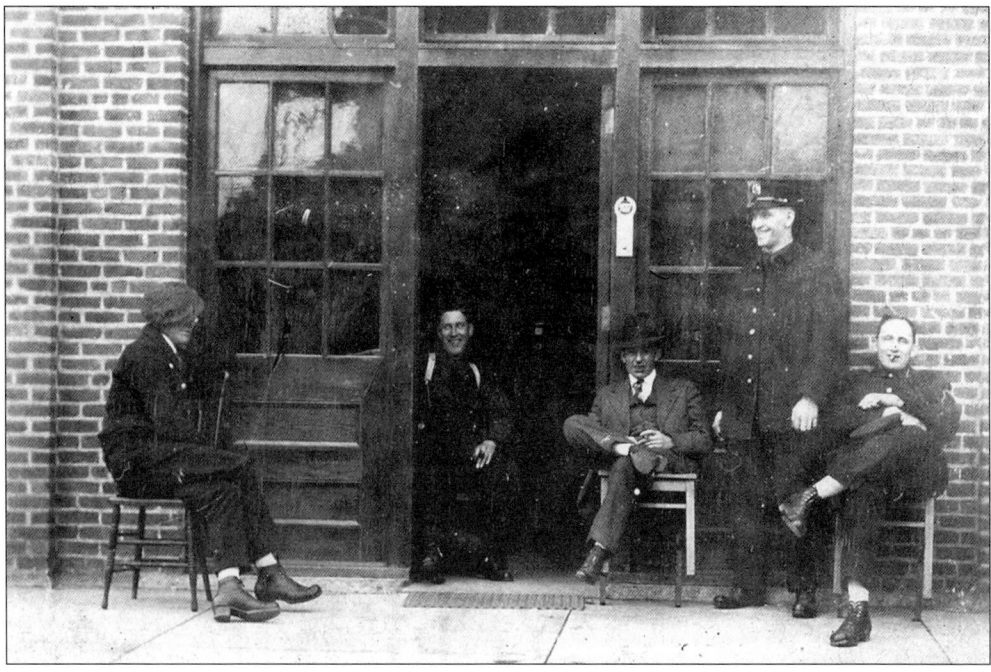

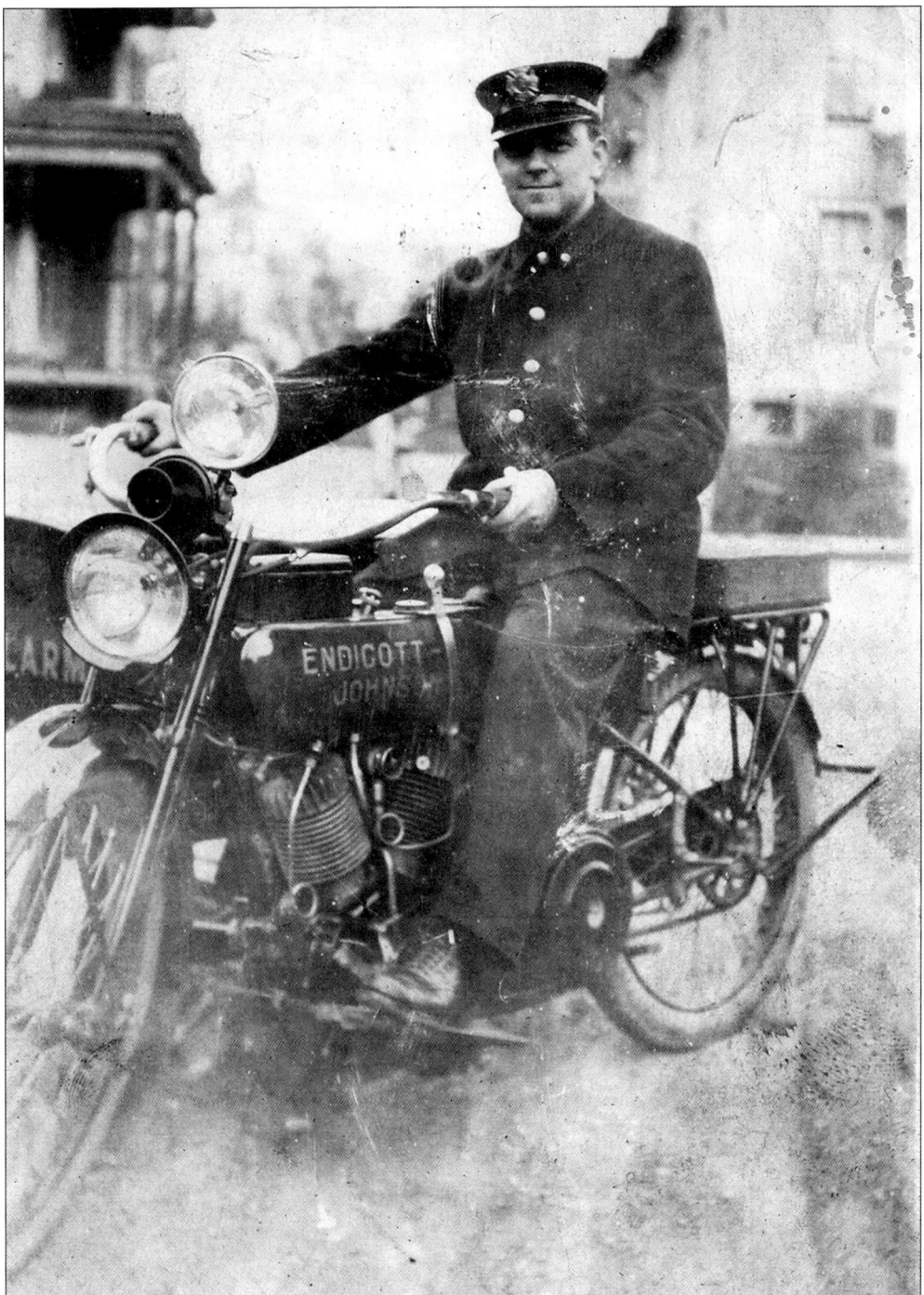

Fireman John Stern is pictured here aboard the Endicott Johnson Fire Prevention motorcycle in 1922. The motorcycle was used mainly for running errands or messages between the many Endicott Johnson factories in Johnson City. This allowed the taking of only one man off the fire apparatus to take care of nonemergency work that was at times necessary, without having to tie up one of the fire or utility cars the department owned.

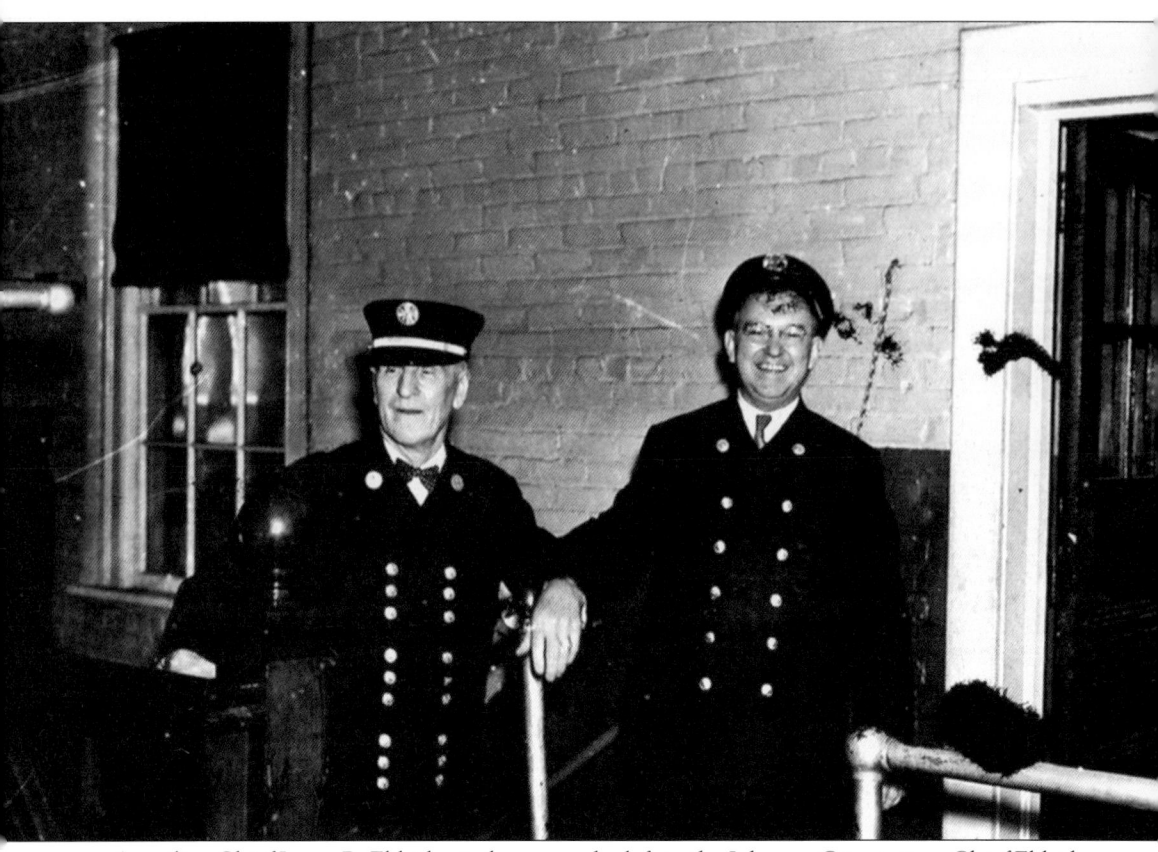

A smiling Chief James R. Eldridge is shown on the left in the Johnson City station. Chief Eldridge was famous for almost always wearing his favorite bow tie.

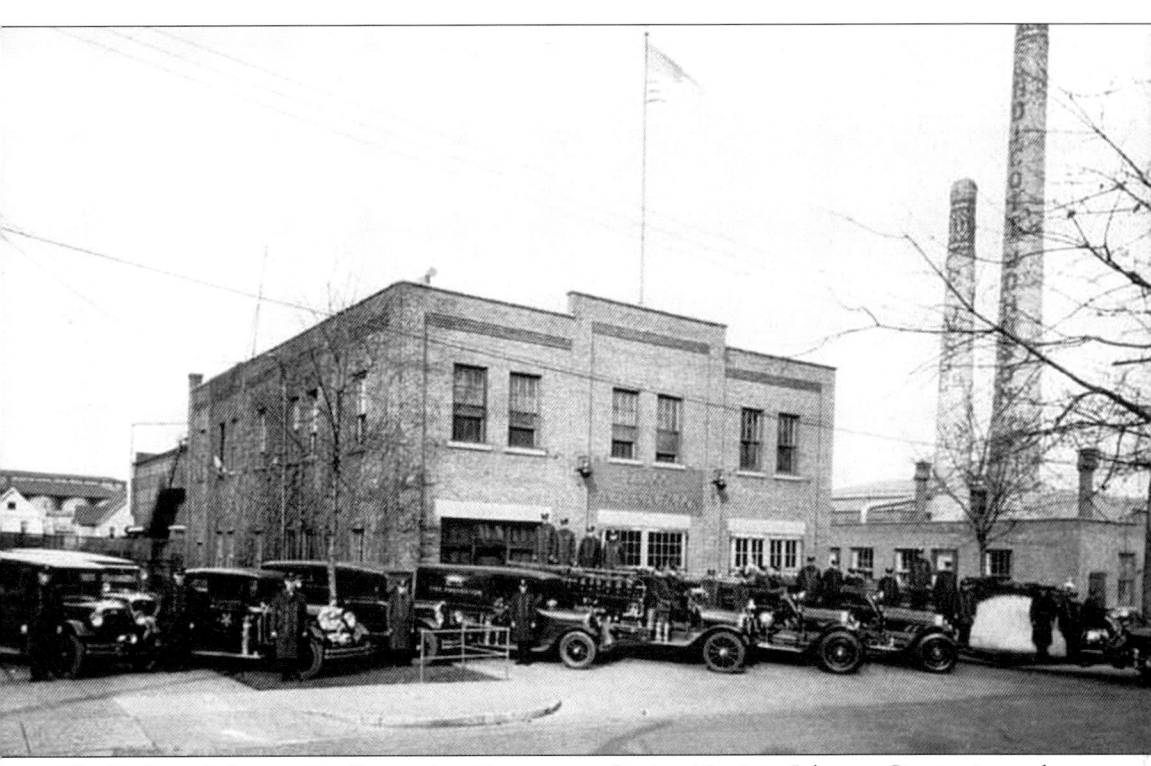

The Endicott Johnson Fire Prevention Department Station No. 1 in Johnson City is pictured here on Avenue B in the 1920s. The department complement was a chief, two assistant chiefs, and 67 men who patrolled all of the Endicott Johnson factories and facilities 24 hours a day, 365 days a year. The apparatus of the department consisted of five ambulances, two engines, two utility cars, one motorcycle, two armored cars (which were used to transport company cash), one chief's car, and one assistant chief's car. At the end of the work day, workers in the factories swept up and carried out every scrap of waste in the fire prevention effort. The fire prevention firemen would then walk through every inch of the factories to make sure no waste had been left behind that could cause or contribute to a fire. In one Endicott Johnson newsletter it was stated, "Careful supervision of all buildings has reduced losses to practically nothing."

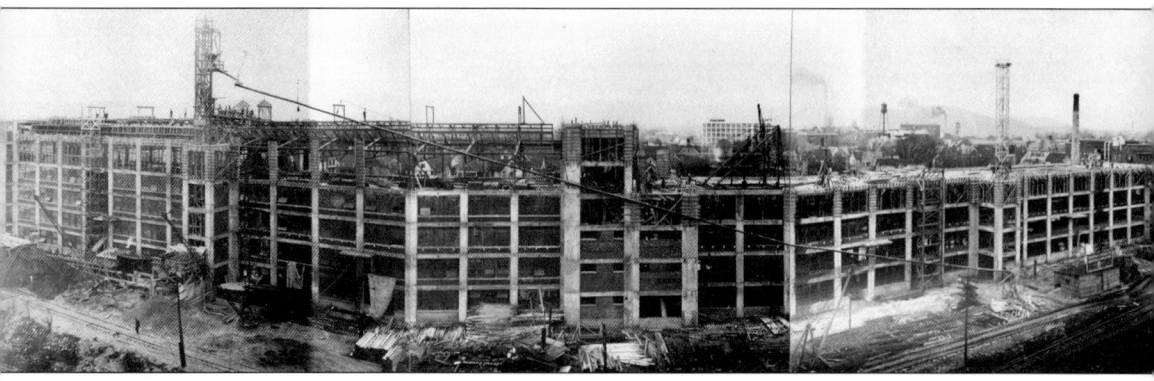

This is the Endicott Johnson Victory Factory under construction in 1919. Although the building looks as though it is curved, it is not. The way the original photograph was taken creates the curved look. This was three separate photographs "stitched" together to show the entire structure. It is an immense building standing five stories high and several blocks in length. The building still stands and is privately owned and used for storage. This was not the largest of the factories, but one of the largest. With the many huge factories that had been built, the Johnson family wanted to ensure they were kept safe from the ravages of fire. They built a fire prevention department that was second to none in the country, and it became a model department that other privately owned companies used to create their own fire prevention departments. Without the fire prevention men, one can wonder just how many of those factories would have succumbed to fire, as fires occurred frequently in the machinery of these huge factories. Charles F. Johnson was wise when he followed Benjamin Franklin's teaching of "An ounce of prevention, is worth a pound of cure."

Three

Johnson City Fire Department

On March 21, 1916, Lestershire officially changed its name to Johnson City. As a result, the Lestershire Fire Department became the Johnson City Fire Department. During the formation of the Endicott Johnson Fire Prevention Department the previous year, James R. Eldridge, an assistant chief in the City of Binghamton Fire Department, was hired as chief of both the Endicott Johnson Fire Prevention Department and the Johnson City Fire Department.

 It was Chief Eldridge who began the change from an all-volunteer fire department to a paid, career fire department in Johnson City. The change was actually due to the prodding of the Endicott Johnson Fire Prevention Department and C. Fred Johnson. As the Endicott Johnson Fire Prevention Department was a well-organized and fully manned department providing 24–7 coverage, they found themselves spending more and more time responding to fire alarms in the village of Johnson City due to the slower response times of the volunteers. Endicott Johnson management felt they were now providing the village of Johnson City with its primary fire protection, as well as having their own men and apparatus being taken out of service for any calls at their own factories when they were called out to fire alarms in the village. Simply put, talks were initiated, and the need for a highly trained, full-time fire department belonging to, and paid for by, the village was at hand. Within a few short years, the Village of Johnson City Fire Department went from the all-volunteer firefighting force to an all-paid, career firefighting force, which is providing fast and unparalleled fire prevention and emergency services to its residents, workers, and visitors today.

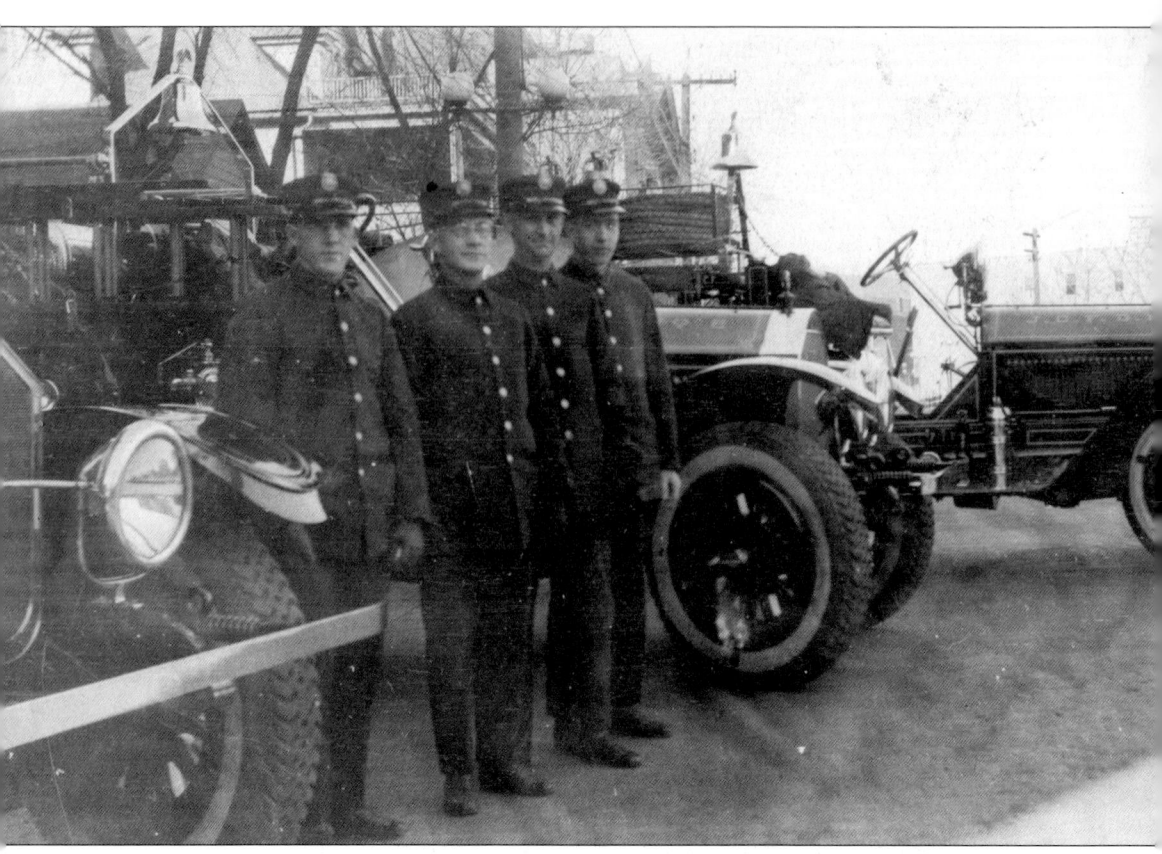

The early years of Johnson City saw a transition from an all-volunteer to a paid, career fire department. Several of the Lestershire Fire Department firemen were hired by Chief James R. Eldridge with the initial change. Some of these newly hired men are seen here with some of the apparatus.

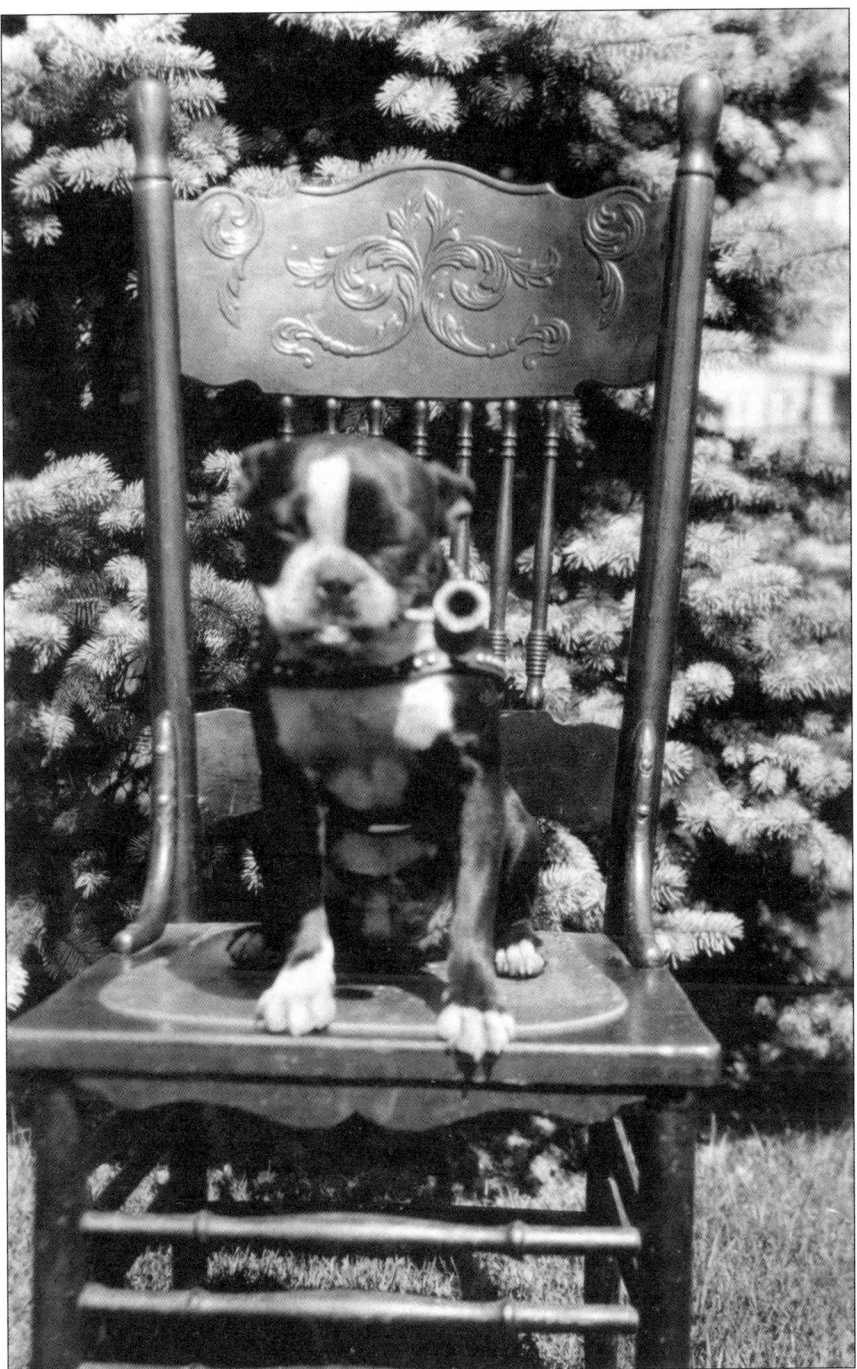

Many fire departments had dogs as mascots. The Lestershire Fire Department had at least one dog named Spider seen in a 1900 photograph. They also had an unusual mascot named Black Diamond, which was a mule. In the photograph above was an early Johnson City Fire Department mascot, a Boston terrier named Speed, but called Speedy. Speedy kept the firemen company and loved sitting in his chair while holding his pipe. It is said that Speedy seldom missed fire calls.

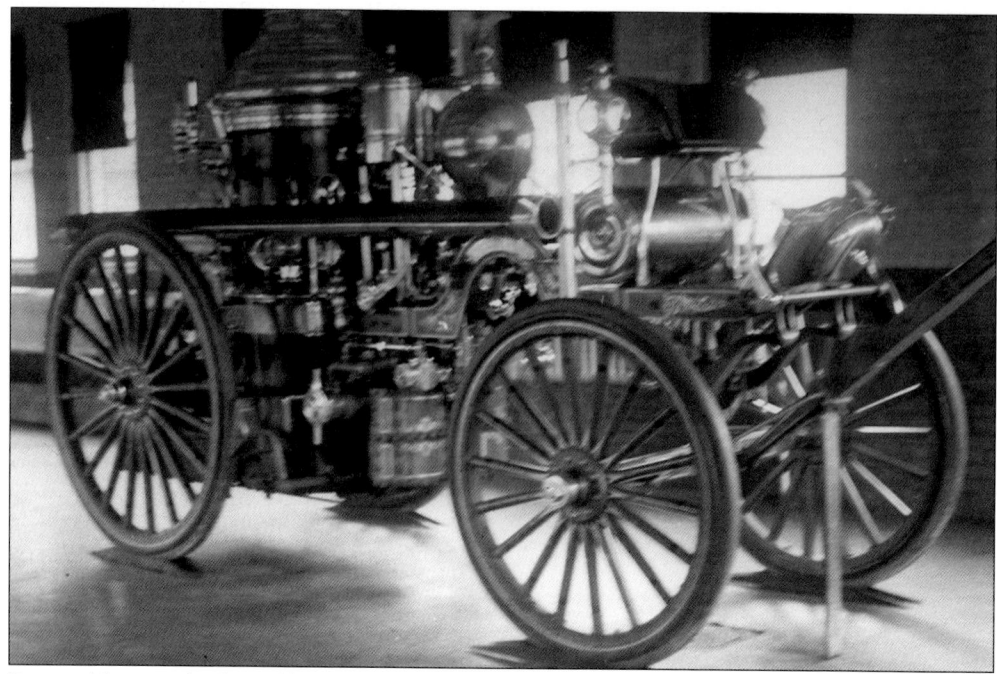

Pictured here is the last old steamer used by Lestershire and Johnson City. It was taken out of service when motorized fire apparatus started being used in the village. The steam engine was transported to the fires by the fire horses. It was stored at the Floral Avenue fire station for many years as a display piece. As can be seen in the photograph, it had large wooden-spoke wheels and large amounts of brass appliances. When World War II broke out, no one gave it a second thought when it was decided to donate this piece of history to the scrap metal drive that was so common in communities across the nation.

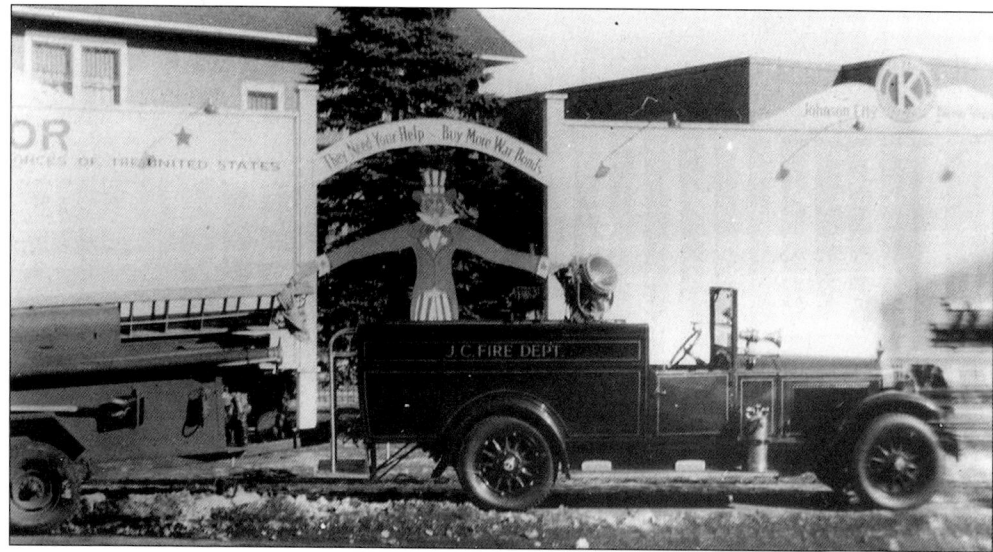

This is a very early example of a rescue squad from the Johnson City Fire Department. It was used to carry lights and other equipment, such as fire extinguishers and hand tools, to fires. The sign in the background illustrates that this photograph was taken during World War II. It states to buy war bonds to help with the war effort.

While World War II was in full swing, Americans were asked to donate metal for the war effort. At the Central Fire Station on Willow Street, Johnson City fireman Larry Jukoskie (left) and an unidentified fireman help collect metal pots and pans for the scrap metal drive; the metal was melted down and turned into ammunition and guns.

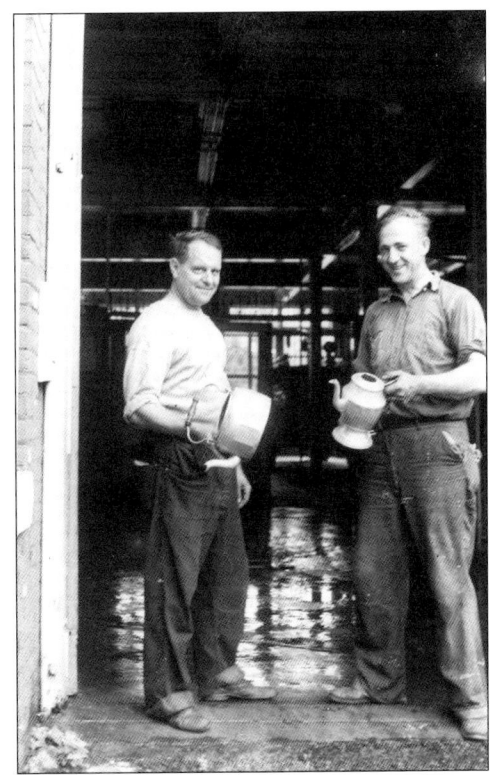

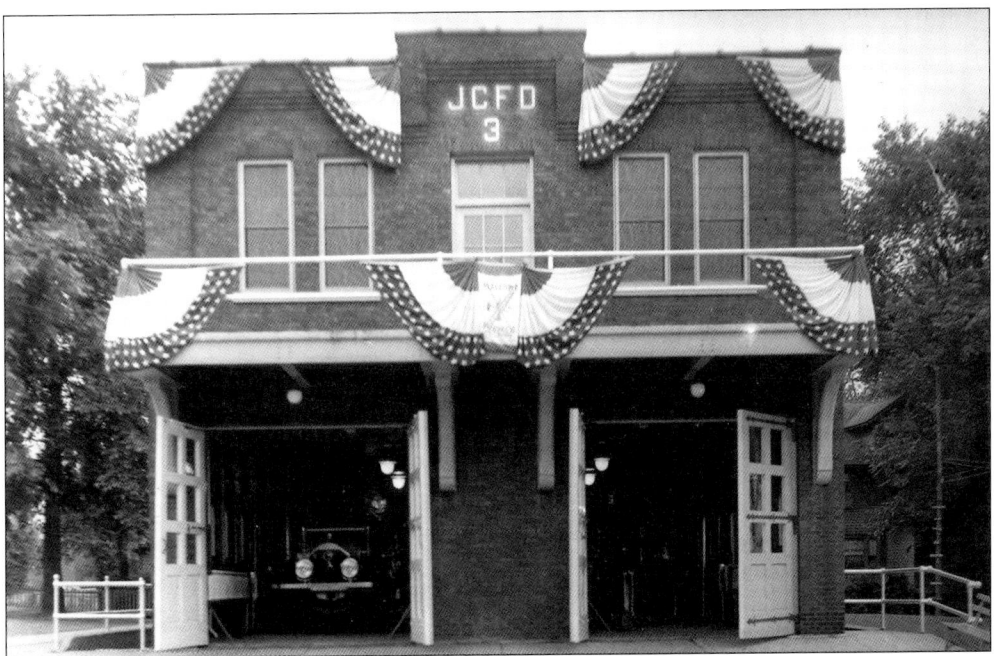

The Floral Avenue station used to house engine No. 3. When the old Central Fire Station on Willow Street was closed down in the later 1970s, the station became home to fire department administration and was then referred to as station No. 1. This photograph, taken prior to World War II, shows the old apparatus in the truck room bays.

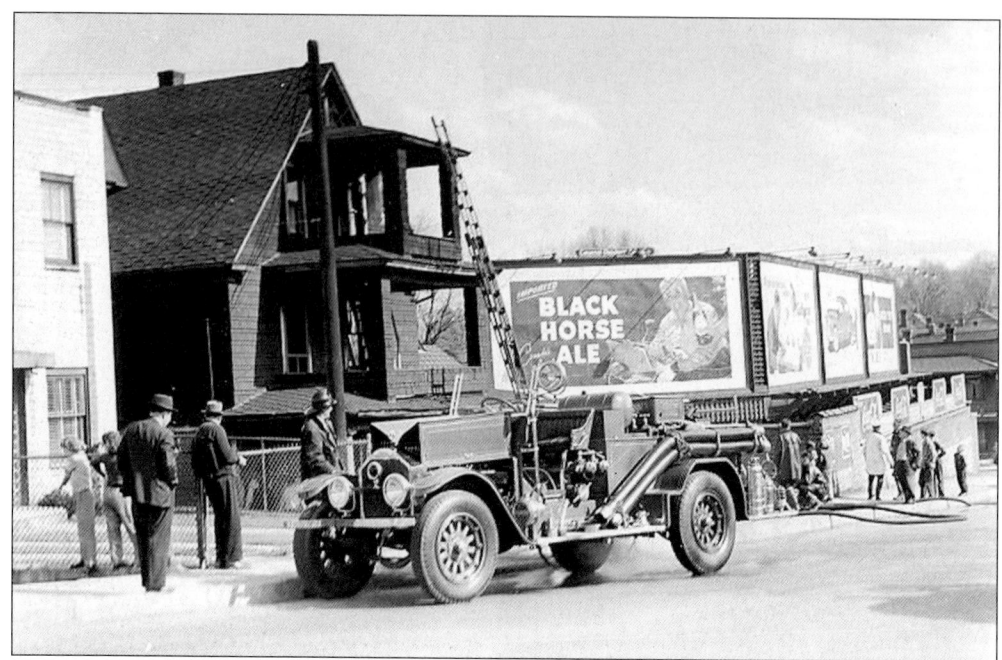

In 1941, this apartment building caught fire on the top floor. The building was located on Willow Street behind the bowling alley at the corner of Grand Avenue. Firefighters used a ground extension ladder to hoist a hose up and extinguish the fire. The fire was not too destructive, and the building still stands today.

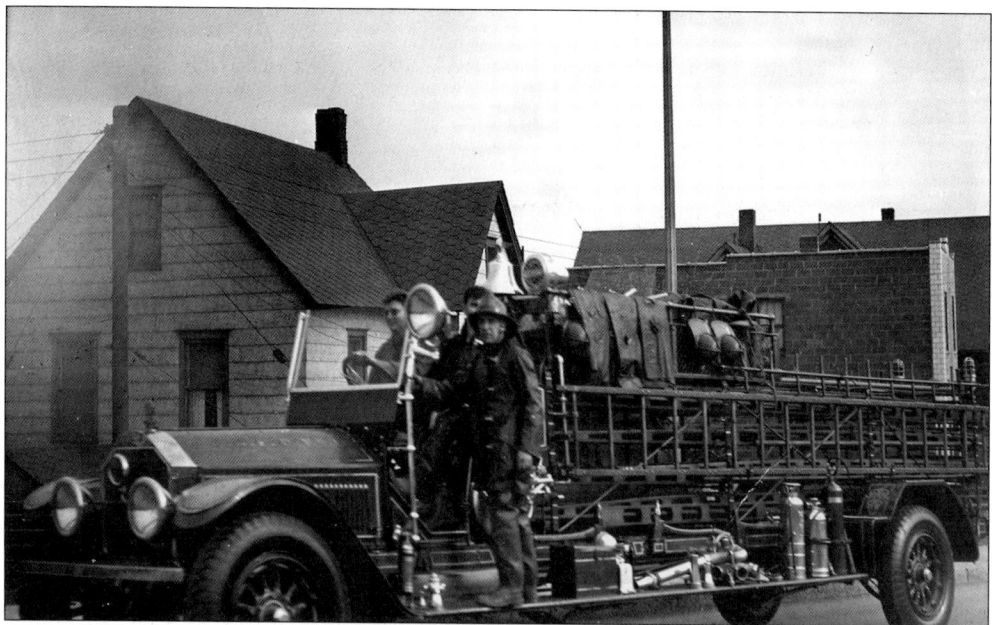

This is a fire engine from the mid-1940s. Inclement weather was always a problem back then because no one on the engine was protected from it. Also seen here is a device (along the rear and top) called a pompier ladder. Most ladders have two rails with the rungs in the middle. A pompier ladder has a center rail with the rungs sticking out to the sides and was very tricky to use.

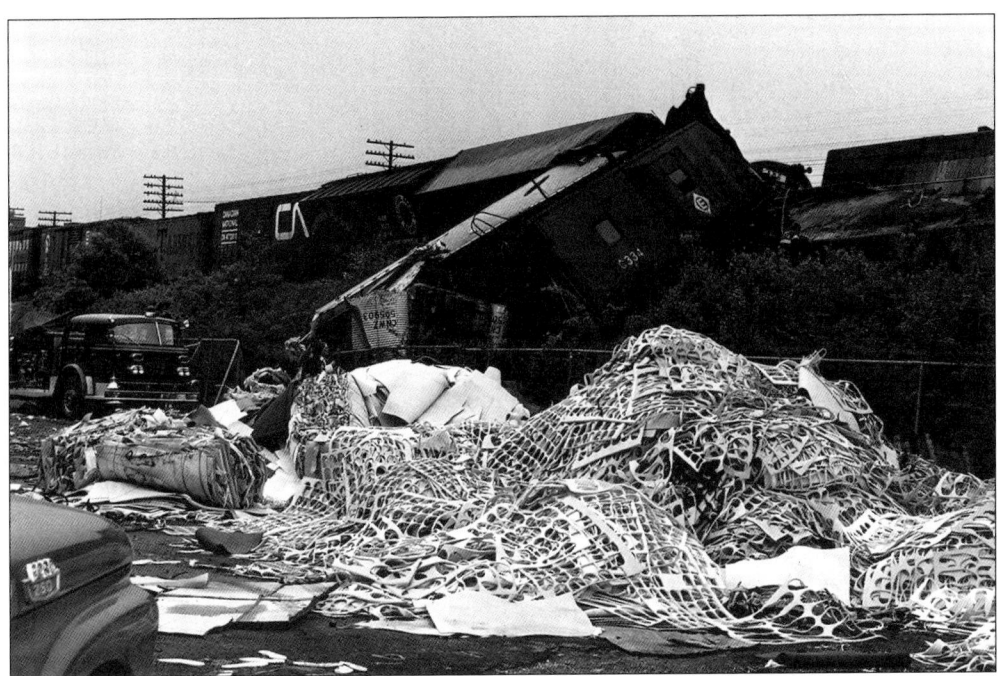

Shipping by rail was still very common when this train derailed in Johnson City. This section of track ran right behind several factories of the Endicott Johnson Shoe Company. The cleanup of the wreck and debris took several days. Today it would be cleaned up in just a matter of hours with the aid of heavy equipment. However, most of this was cleared by hand and cutting tools. The picture below shows personnel from the railroad, fire department, and police department. The people on the left who are walking on the low side of the wreck picked a bad spot to inspect the damage. If this train were to tip over, they would be crushed.

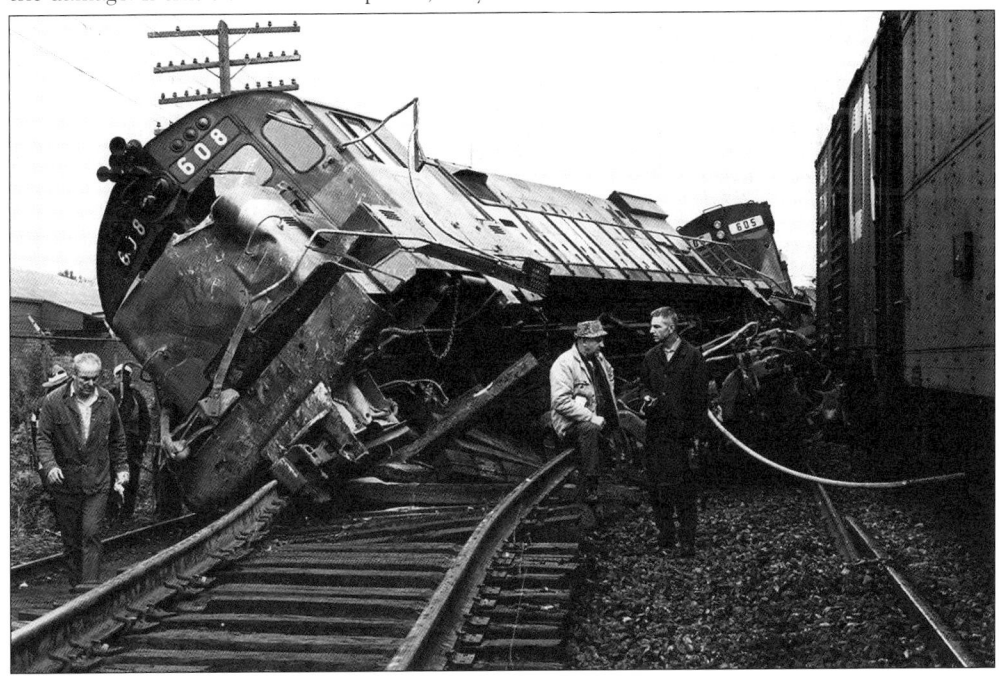

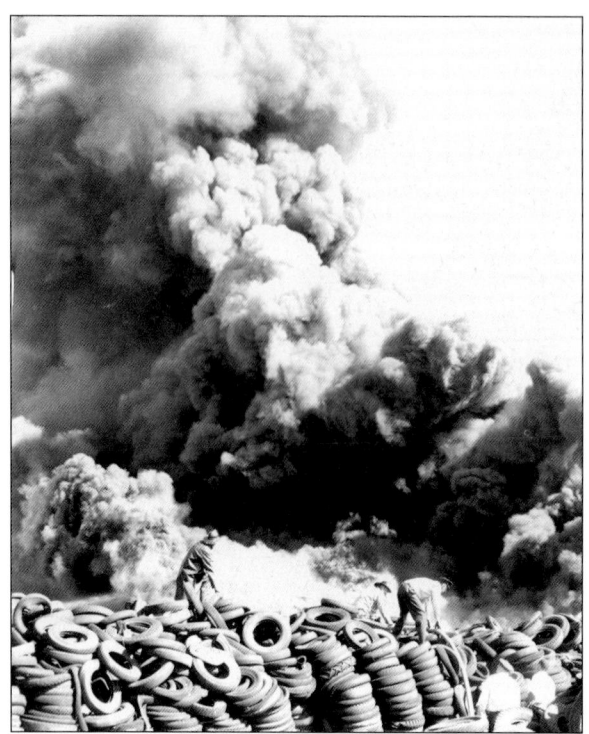

This was one of the many dump fires that plagued Johnson City in the 1940s, 1950s, and 1960s until development started taking place, most notably, on the north side of town. Many hours were spent fighting these dump and tire fires, and even after new commercial buildings were built, the underlying dumped materials would at times catch fire, causing even more difficulties in trying to extinguish these fires.

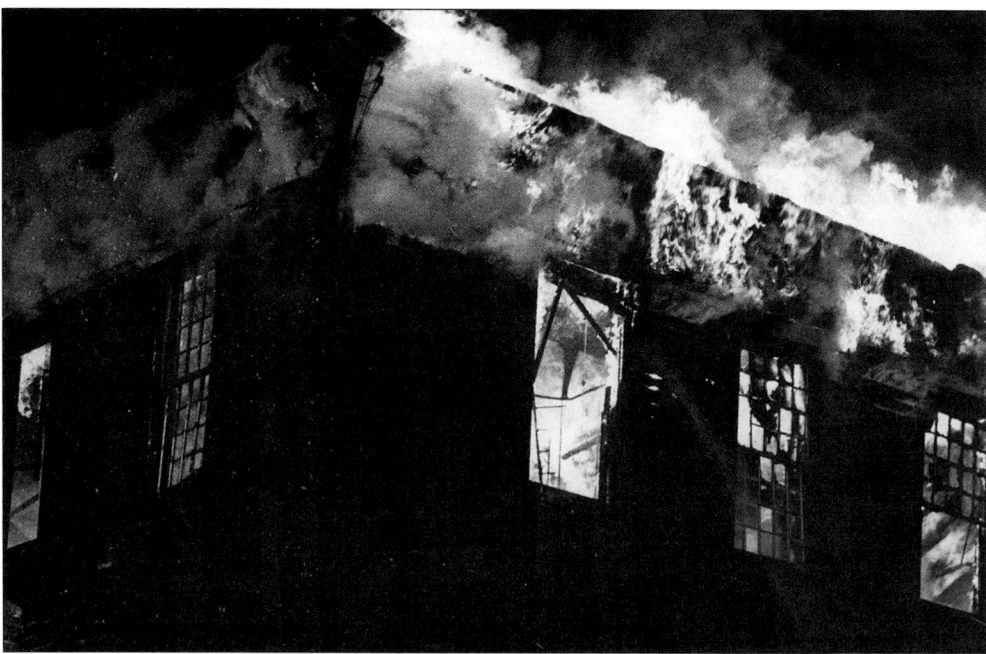

The Roberson Lumber factory was fully engulfed in 1968. This particular building was a total loss. When fire spreads across an entire floor like this, the building will usually have to be razed if it has not already fallen on its own. The fire raged out of control for a long time before anyone noticed it and turned the alarm in to the fire department.

This undated photograph shows the old American LaFrance Engine No. 1 on Willow Street across from the Central Fire Station. From left to right are firefighters John Okenica, Joseph Waskovics, Leslie Genthner, Harry Rezmersky, unidentified, William Lux, unidentified, and Capt. George Major.

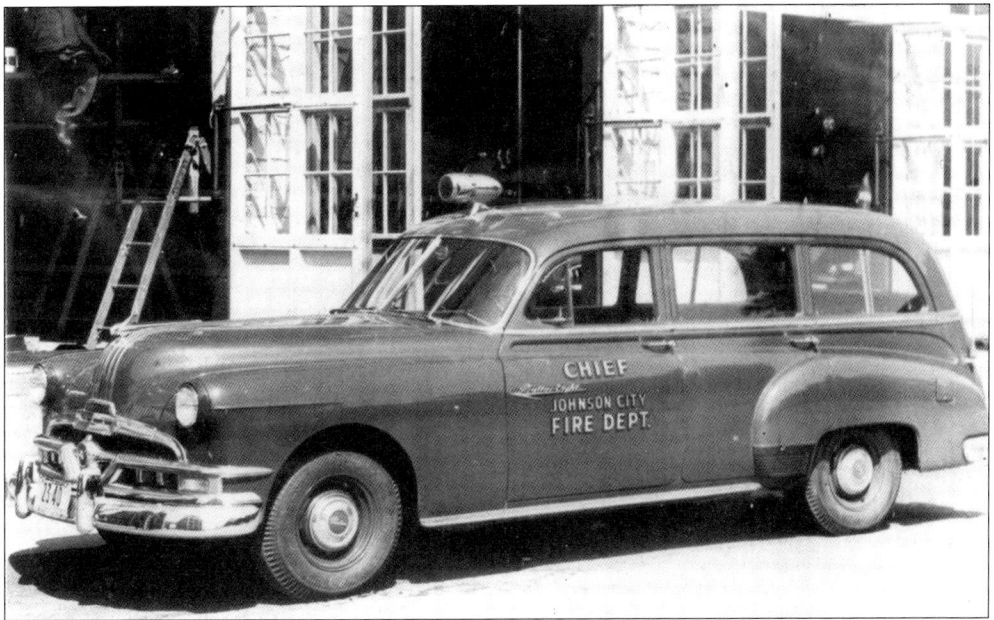

Shown here in this c. 1949 photograph is an old Pontiac Eight fire chief's car sitting in front of the Central Fire Station. The old station wagon was also used to carry smaller pieces of equipment that the chief would always have on hand. Inside the station, firemen can be seen performing their annual spring cleaning, where the entire station, from top to bottom, was thoroughly washed and cleaned and painted if needed.

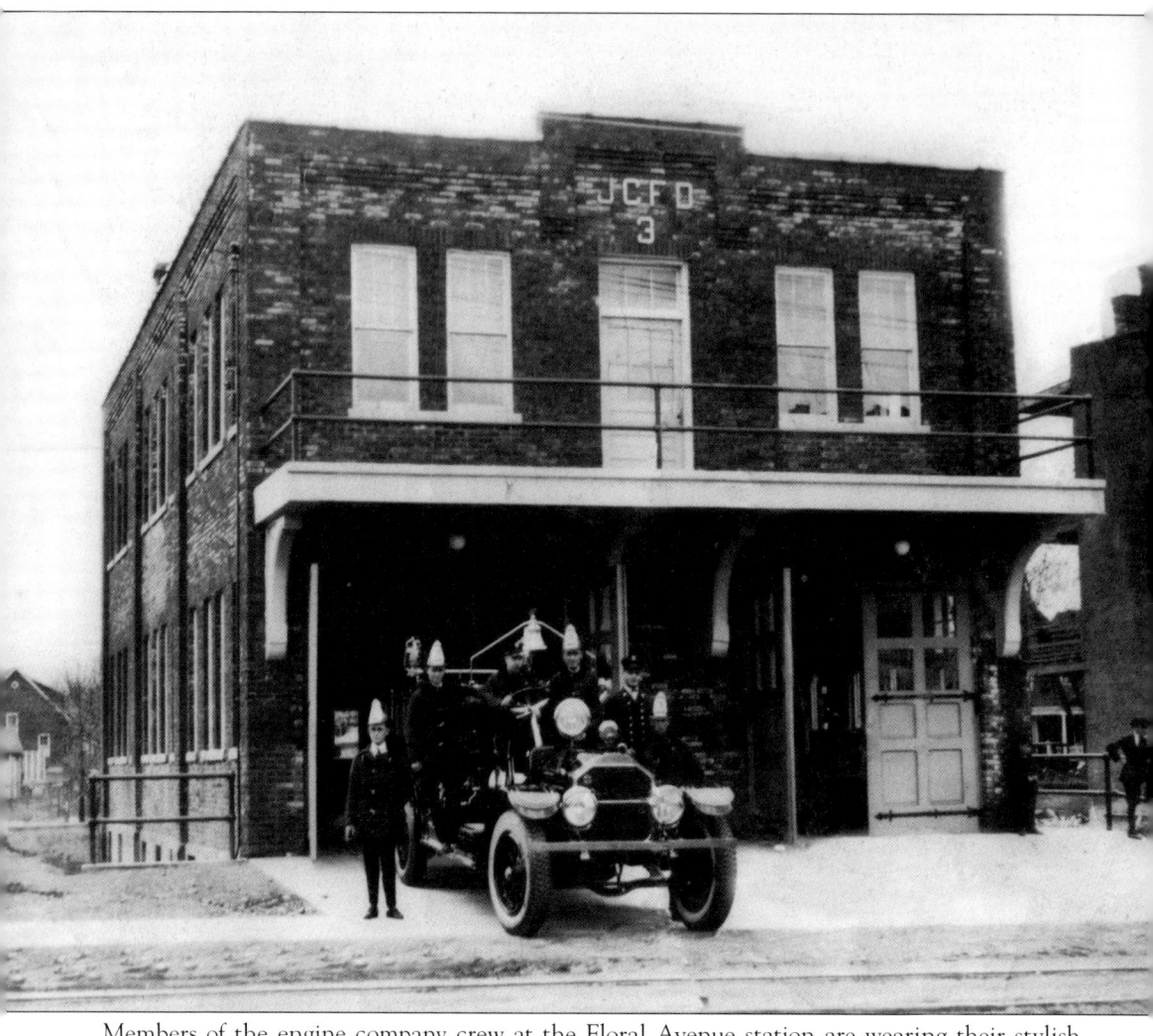

Members of the engine company crew at the Floral Avenue station are wearing their stylish high-brimmed fire helmets for the camera. The Floral Avenue fire station was constructed and opened in 1922. It is one of the few fire stations in the state, and probably the nation, that has separate rooms for the men rather than the normal open-bay dormitories.

The photograph above shows a chief officer walking in front of the Park View Public Market, which caught fire during the late night hours. The building also contained apartments, and a great amount of smoke can be seen coming from both floors of the building. By the time the alarm was sounded, fire had raced through the first and second floors, which created the need to fight the fire from the outside. Shown in the photograph below are four firemen placing water streams through the windows and into the first floor. The building, at the time of the photograph, was being considered a total loss. The fire is undated, and the four firemen in the photograph are unidentified.

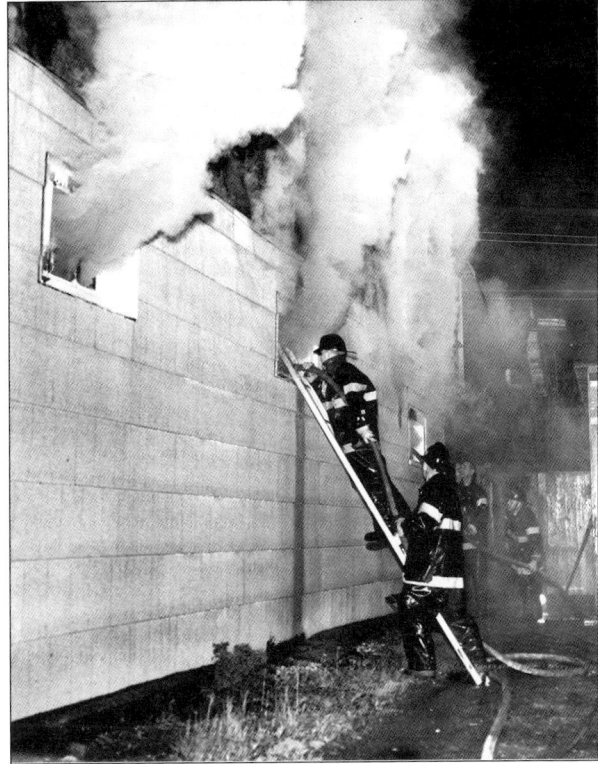

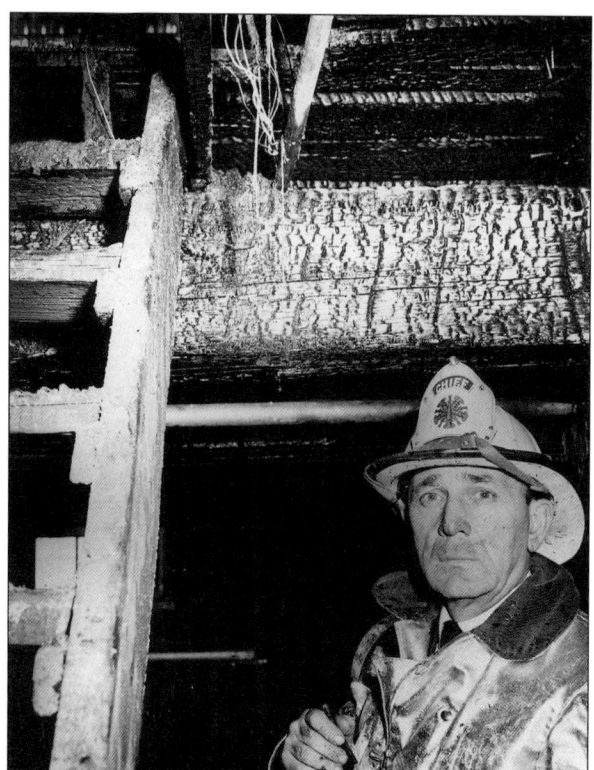

They say a picture says a thousand words. Johnson City Fire Department chief William Grace shows the character of a man who has seen over a thousand fires. Chief Grace worked for the Johnson City Fire Department for over 44 years. He had literally seen and done it all during his long tenure.

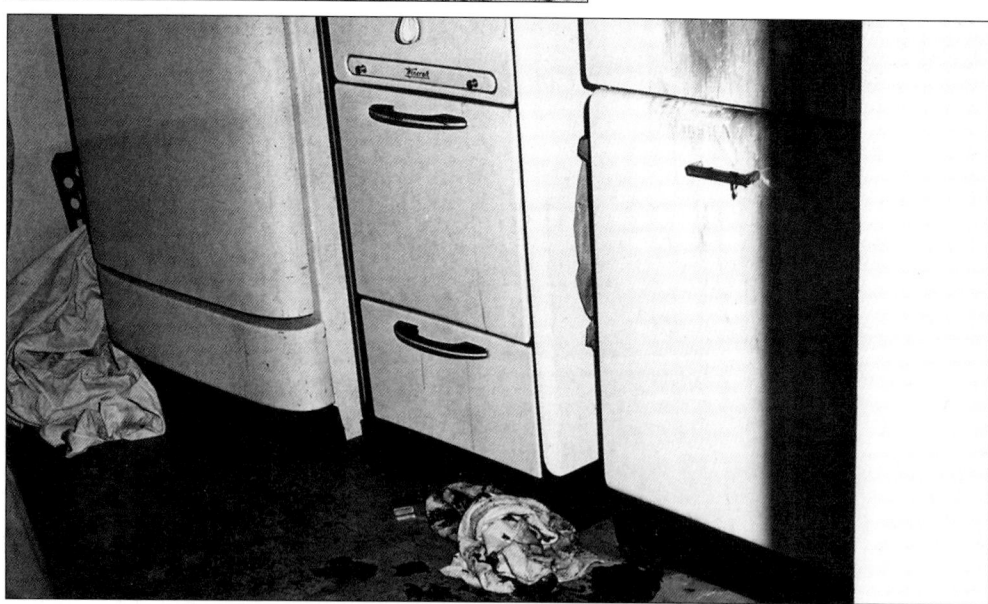

The photograph above is the scene of a fatal fire on Willow Street in 1970. Investigation of the fire scene did not determine just what the apartment occupant was trying to do when the fire began. The individual could have simply been trying to refill a cigarette lighter, which is shown on the floor next to a towel, or he could have been attempting to start a fire in the apartment, but things went wrong. Other than the victim, there was little to no fire damage to the apartment and contents.

Although fighting fires is a tough and rigorous job, the real strength is needed by the people affected by the fire. Above, employees of this store are sifting through the remaining inventory to find out the total amount of fire damage. Below, family members try to salvage as much as they can from their house fire. Most people have no idea of the exact contents of their homes, so finding out a total amount for insurance purposes is a very difficult task. If one has never been affected by a fire, it is hard to understand the feeling of losing everything one owns in just a matter of minutes.

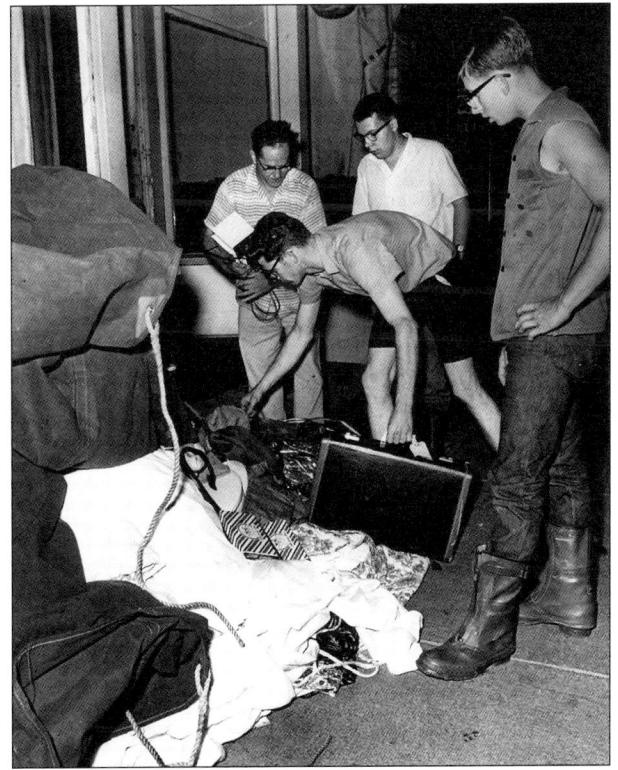

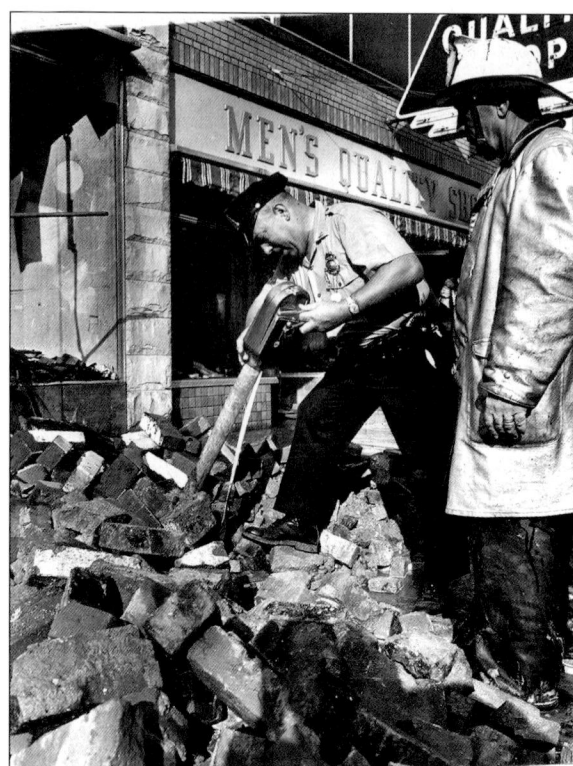

Johnson City fire chief William Grace (right) watches as patrolman Eddie Lee retrieves a parking meter from the debris of the Hamlin's Drug Store fire on Main Street. This building crumbled to the ground, destroying any property in its way. Fortunately, the parking meter was able to be used again once the rubble was removed and the street was back to normal.

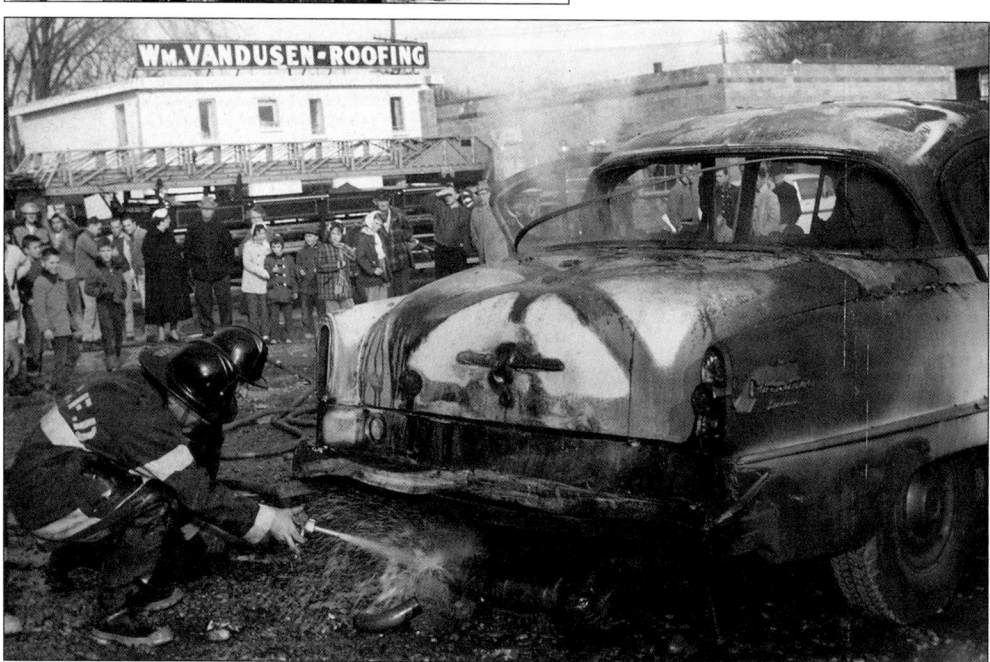

Car fires are always a hazard because of the plastics, gasoline, and other flammable liquids in the engine. Firefighters hose down some hot spots and car parts to make sure the fire is out. Another danger in a car fire is the possibility of tires and shocks blowing out, injuring firefighters and onlookers.

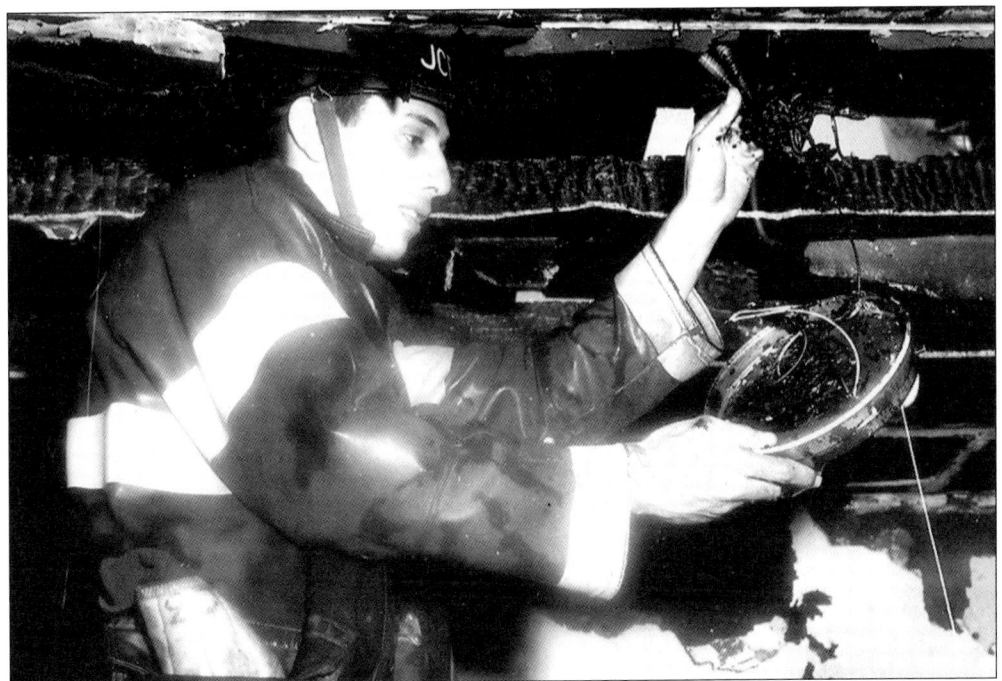

Firefighter Frank Carro was hired by the Johnson City Fire Department during the mid-1960s. Shown here as a young firefighter in 1965, he investigates a fire by checking the wiring of a ceiling light. He probably noticed the heavy charring as a possible point of origin. Carro's attention to detail is what led to his promotions, eventually up to fire marshal.

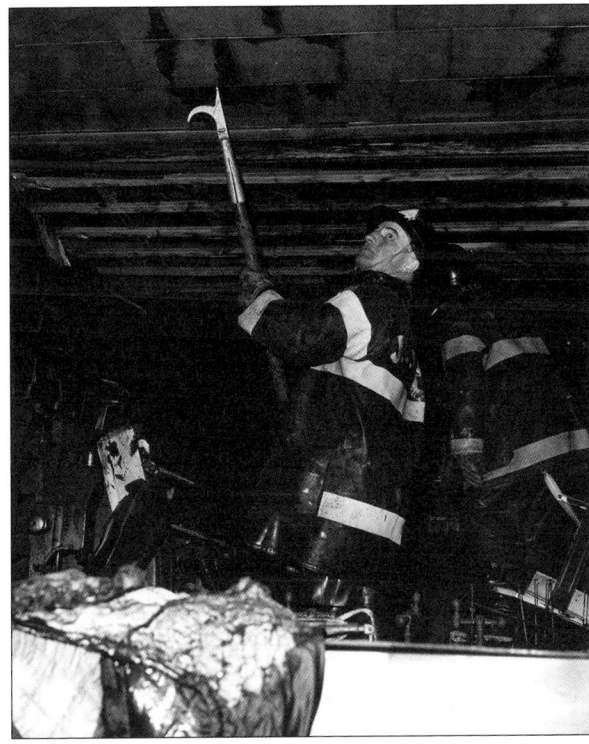

Lt. Frank Slahucka helps in the overhaul process at this Main Street fire in 1965. In this photograph, Slahucka uses a hook or pike pole to pull down the ceiling tiles to check for fire extension. Preventing the spread of fire is essential, but this also aids in the investigation to see where and why the fire began.

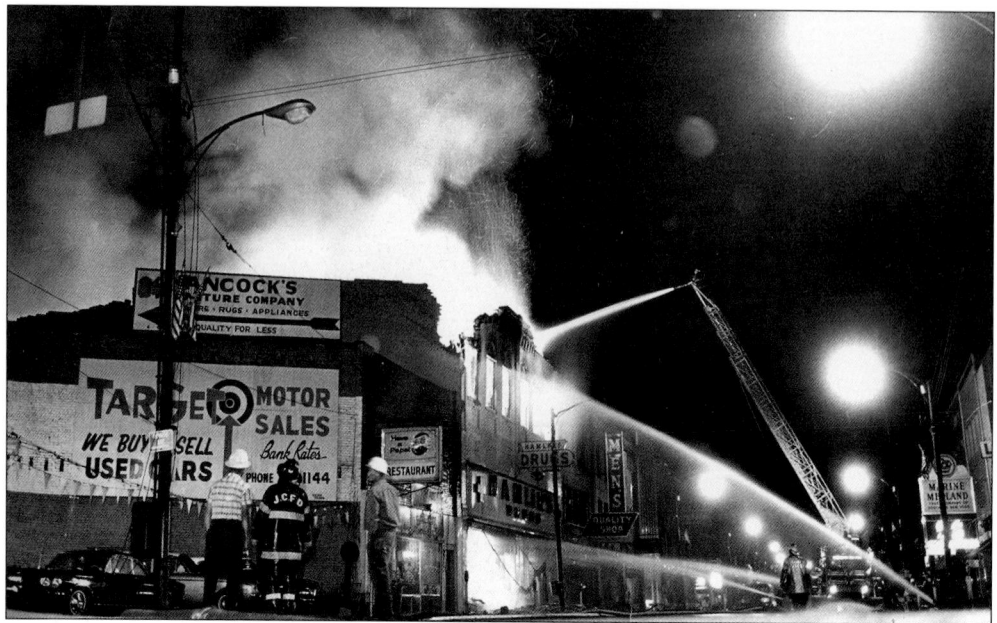

Fire lights up the night sky as the Hamlin's Drug Store on Main Street burns. The fire occurred the evening of July 7, 1966, and was not brought under control until the following day. The fire department had to clear from the front of the building because the top started to crumble to the ground. The bricks were weakened from the fire and the high pressure of the water being sprayed onto the building.

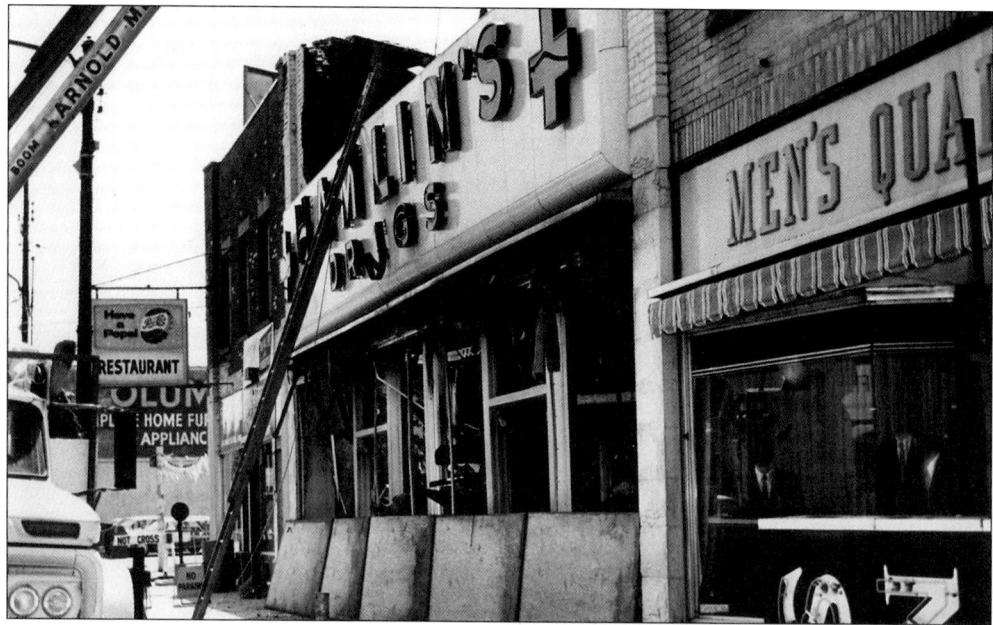

After the Hamlin's Drug Store fire was extinguished, a crane was brought in to pull down its large sign that hung over Main Street. Although Hamlin's Drug Store is long gone, the building was saved and is in use today as a music store. There have been numerous commercial buildings along Main Street in Johnson City that have suffered from the ravages of fire through the years. Virtually all have been saved by the quick response and efforts of the fire department.

Sampson's Grocery Market, which was located on Sergeant Street, went up in flames in the early 1960s. These Johnson City firefighters try to dowse the fire as well as protect the neighboring buildings. These photographs were taken just after the first arriving engine company was on the scene and getting water on the fire. Looking through old records, nothing could be found that would indicate what the cause of this particular fire was. Reports state that the building was well involved in fire upon the fire department's arrival.

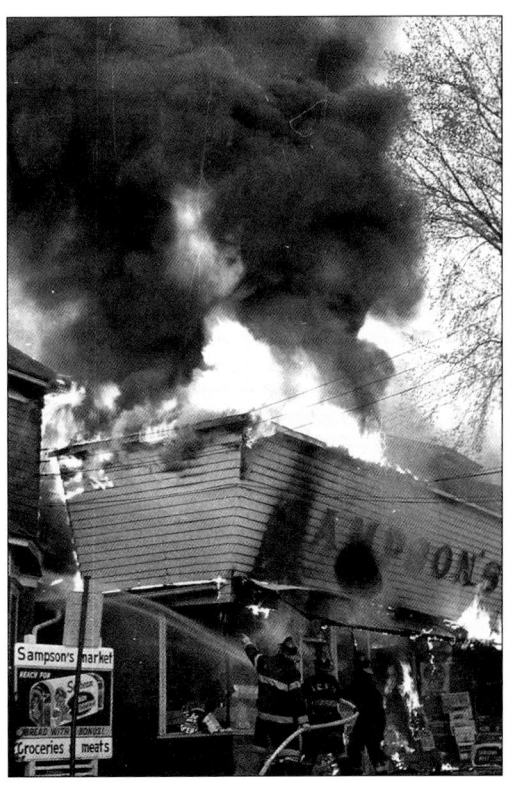

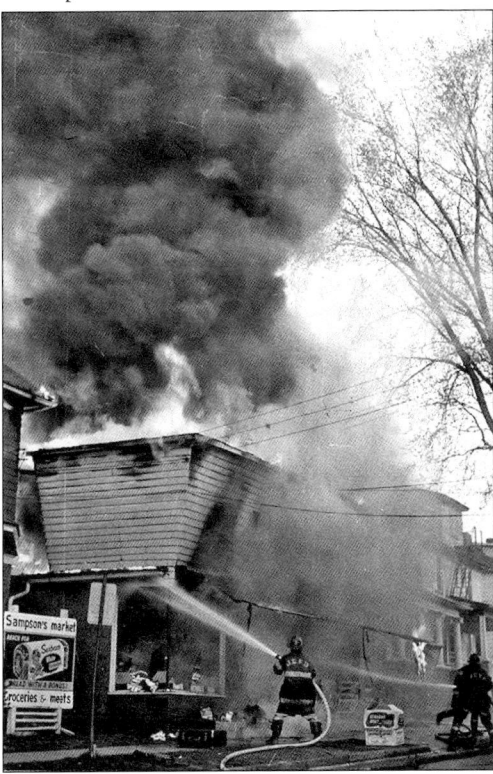

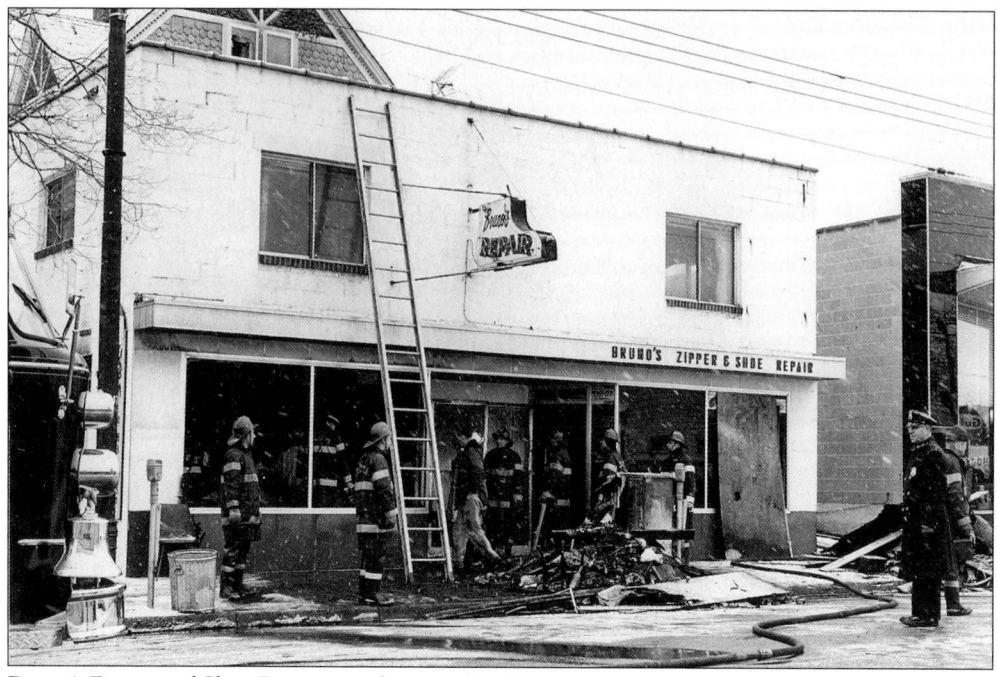

Bruno's Zipper and Shoe Repair was destroyed by fire on January 20, 1965. The building, originally located on Main Street, had apartments above and behind, and neighboring structures very close. As with any fire, cold weather hampers firefighting and makes things very uncomfortable for those fighting the fire. Although the business was lost, the structure was saved and later used for other businesses, as well as rental apartments. The structure was later demolished in the 1990s, and today a parking lot occupies the site. The building to the immediate right of Bruno's Zipper and Shoe Repair still exists and is being used today.

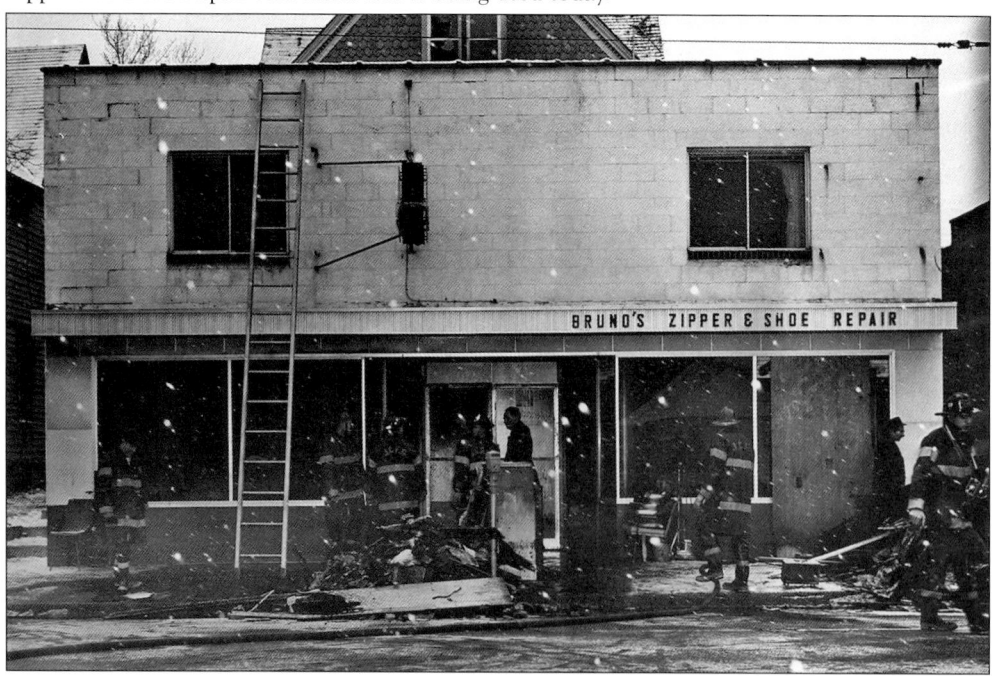

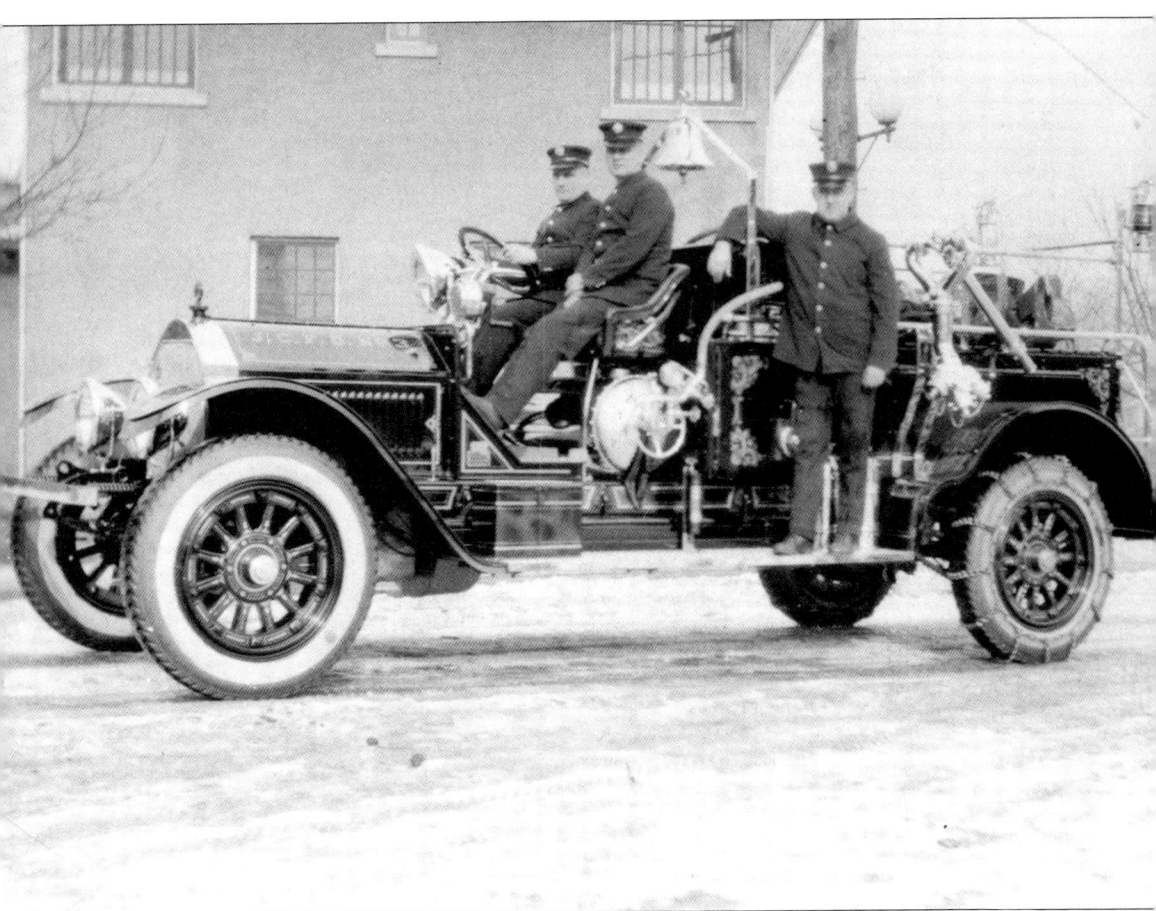

This c. 1921 photograph shows three Johnson City firemen on one of the early motorized engines. The only man identified is Clarence W. Moran, seated in the passenger seat. At age 17, Moran entered the U.S. Navy during World War I. After the war and his discharge from the navy in 1919, he joined the Johnson City Fire Department. In early March 1922, he resigned from the Johnson City Fire Department and accepted an appointment to the City of Binghamton Police Department on March 20, 1922. Moran's normal beat in the city was Clinton Street, but on November 30, 1922, he was filling in for another officer on another beat district. This was the Prohibition era, and as he was leading a person out of a speakeasy on Henry Street, officer Moran was shot in the back and killed. A suspect was arrested but never convicted for the crime. It was believed that he was shot due to mistaken identity. Officer Moran, at the age of 28, left a young widow who never remarried and lived into her 80s.

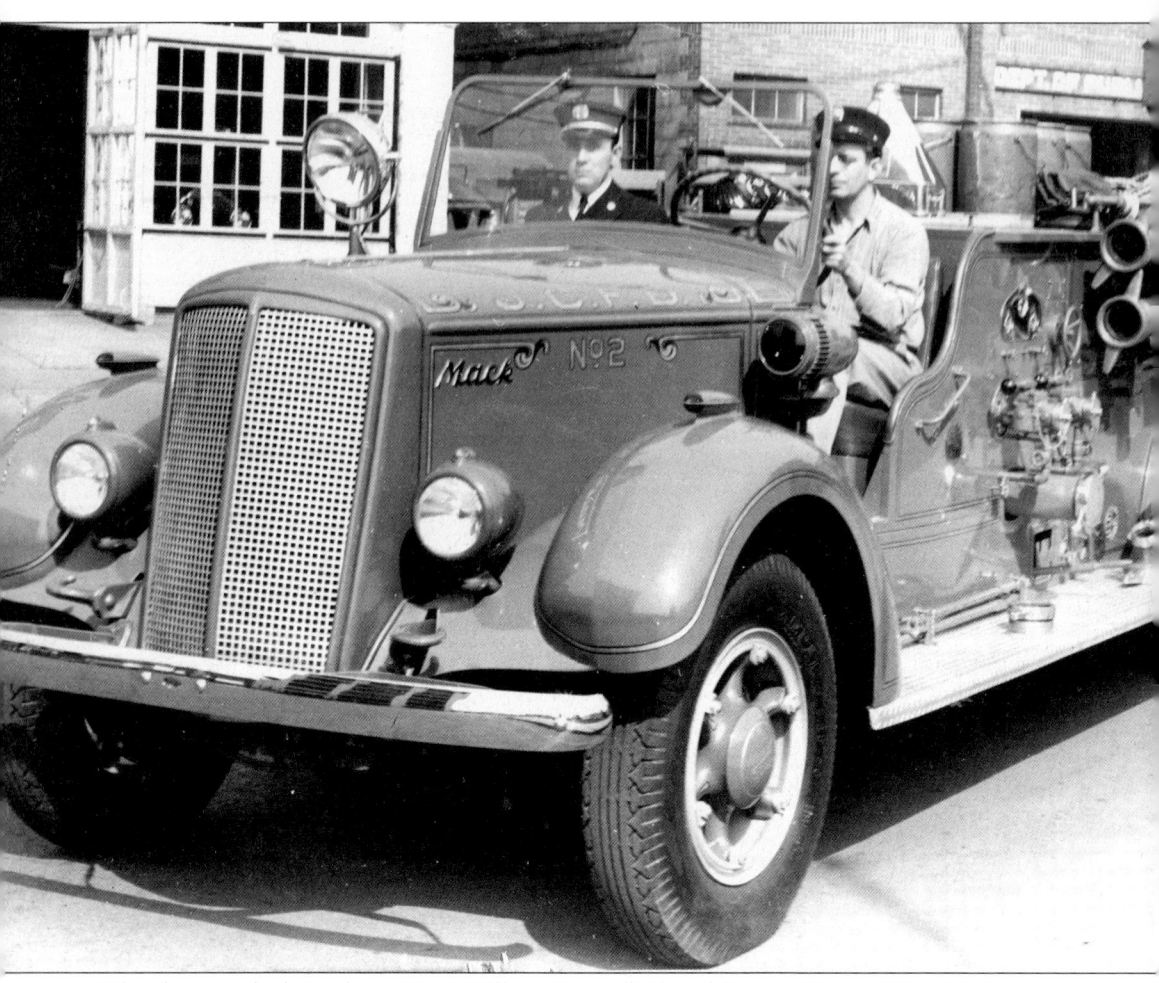

The photograph above shows Capt. William Grace (left) and fireman Francis Krivicich in the new 1942 Mack pumper that was donated to the Johnson City Fire Department by the Johnson City American Legion Post 758. Mack trucks ran an advertisement in magazines for their fire engines using a photograph of this pumper that had been donated to the Johnson City Fire Department.

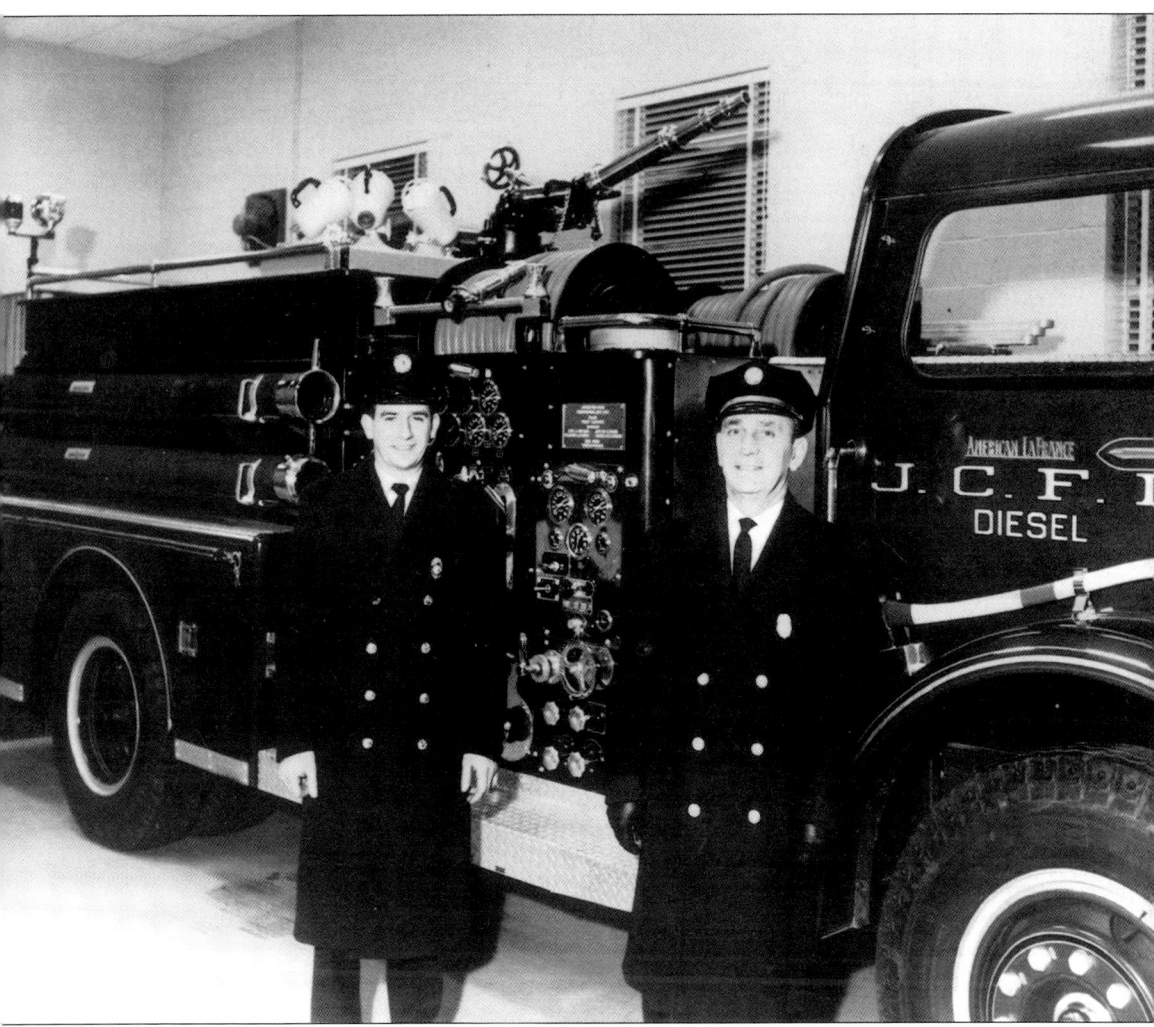

This c. 1960 photograph shows fireman and department mechanic Francis Krivicich (left) and Chief William Grace with a new American LaFrance engine, inside of the Harry L Drive station. Johnson City had the first diesel-powered fire engine in the state of New York. Soon after, diesel engines became more and more popular with fire departments.

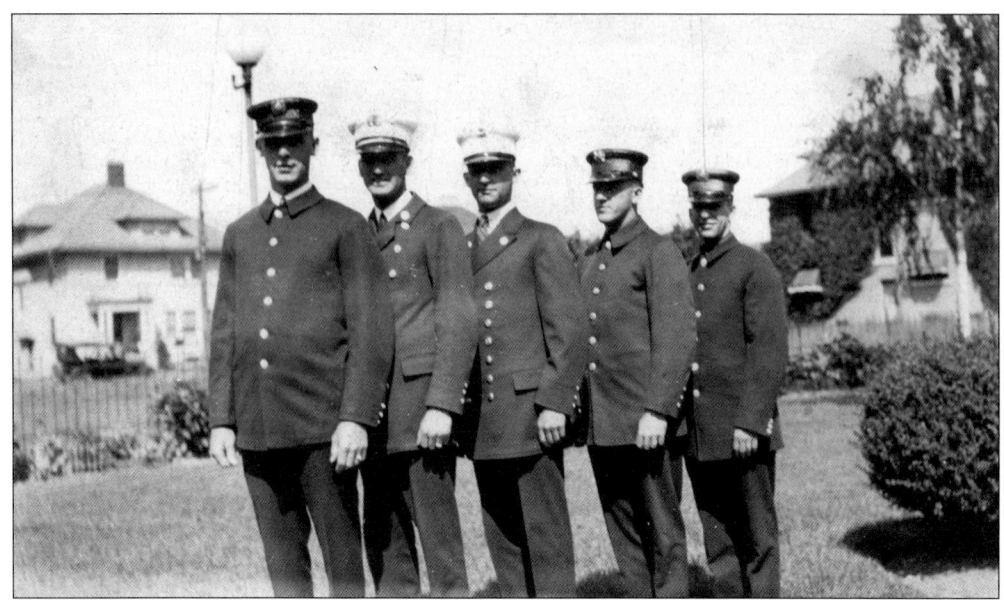

Standing across from the old Central Fire Station are the following members of the Johnson City Fire Department, from left to right: Fred Aug, Capt. Earle Reno, Lt. William Rickert, Lawrence Jukoskie, and George Schutt. Below, the men are seen on one of the early motorized fire engines in Johnson City. None of the men on the engine are identified. One can see that the dress hats worn by these men are much the same as those worn by firefighters today, but the rest of the uniforms have changed quite a bit over the years.

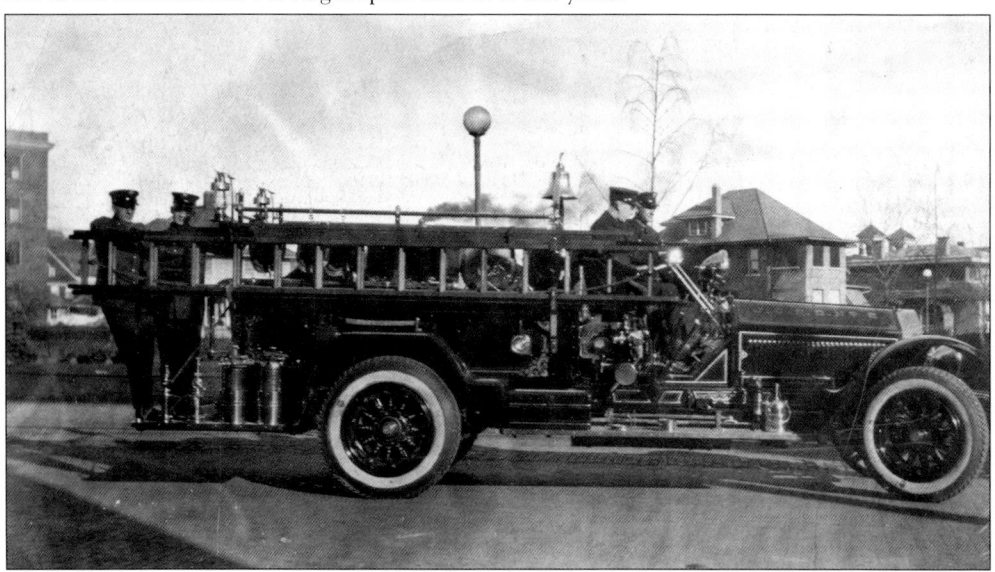

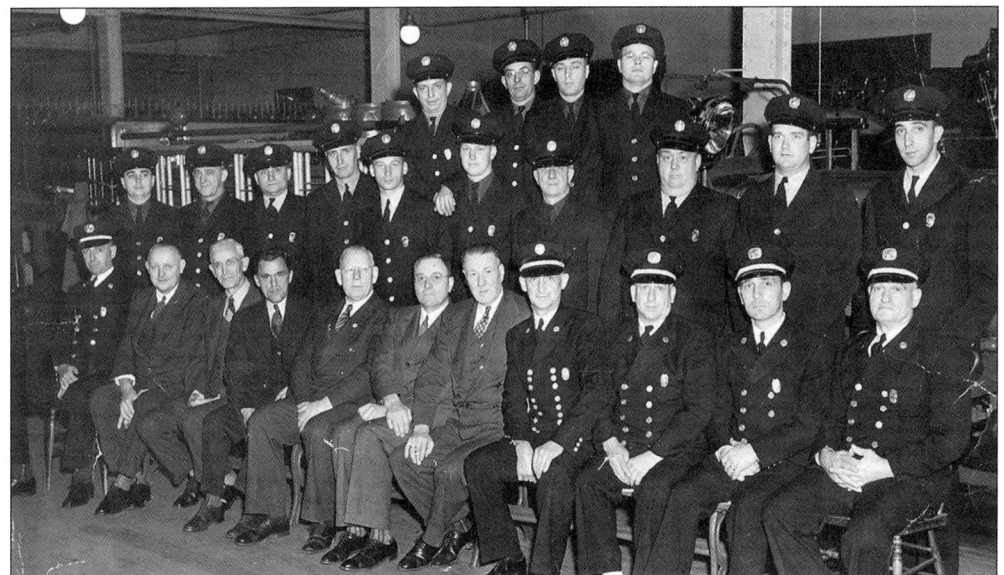

This photograph was taken inside the old Central Fire Station in the truck bays, sometime in the 1940s. From left to right are (first row) Capt. George Hannon, three unidentified village trustees, Mayor Winters, unidentified, unidentified, Chief William Rickert, Capt. George Schutt, Capt. William Grace, and Captain Davis; (second row) ? Roberts, unidentified, Steven Drahos, Clarence Hayes, Marcellus Rezmersky, Willard Lamphere, unidentified, Arthur Griswold, Leslie Genthner, and unidentified; (third row) unidentified, unidentified, Justus Stull, and William Decker.

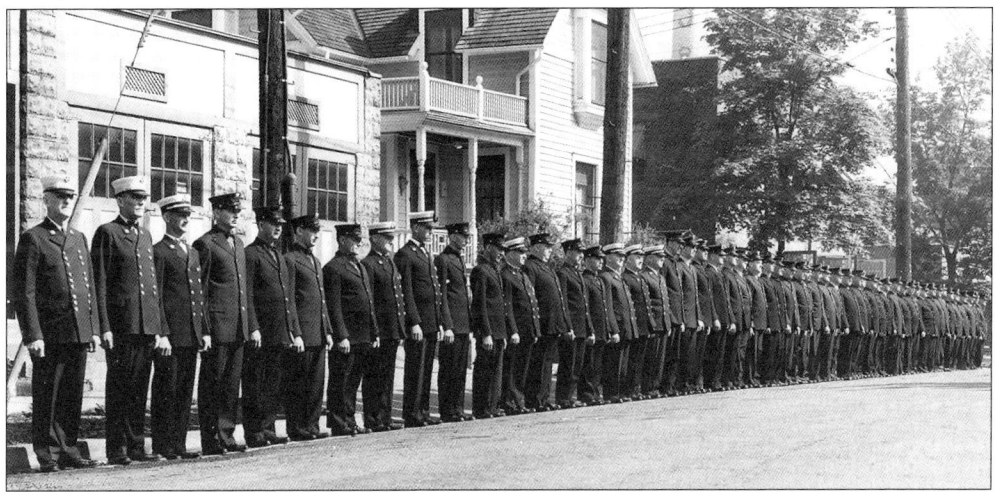

This was a contingent of both Johnson City Fire Department and Endicott Johnson Fire Prevention men lined up on Avenue B. Included in this c. 1930 photograph are, from left to right, Johnson City Fire Department and Endicott Johnson Fire Prevention chief James Eldridge, Johnson City Fire and Endicott Johnson Fire assistant chief Harry Shannahan; (the following all of Johnson City Fire) Capt. William Rickert, Herman Garrison, John Damoni, Lawrence Loyd, ? Baker, Lt. Dodger Davis, Capt. George Hannon, unidentified, ? Fritch, Lt. George Schutt, Arthur Griswold, unidentified, and William Grace; (the following all of Endicott Johnson Fire Prevention) Capt. John Stern, Lt. Jerry Day, Lt. Jess Campbell, Earl Ackley, John Chill, Harry Rezmerski, Fred Ockerman, Bert Chamberlain, Harry Kimble, and William Quinn.

Onlookers gather to watch the Hamlin's Drug Store blaze on the corner of Willow Street and Main Street. When Johnson City was in its peak of manufacturing, Main Street was always full of shoppers and quality stores. Now many of the shops seen here are long gone. Most have been replaced by dollar stores and vacant buildings.

This parade took place in the early 1960s in downtown Johnson City. Several vehicles from the village fire and police departments were in it. Many, if not most, of the buildings in this photograph still stand today. A few of the businesses seen in the photograph are still in existence.

This group of firefighters takes turns running the hose line up a ladder and into the window where the fire is located. The heavy smoke condition made it very difficult to fight the fire. Each firefighter needed to take his turn at the top of the ladder. The invention of the self-contained breathing apparatus made this task much easier. This was at the Hamlin's Drug Store fire.

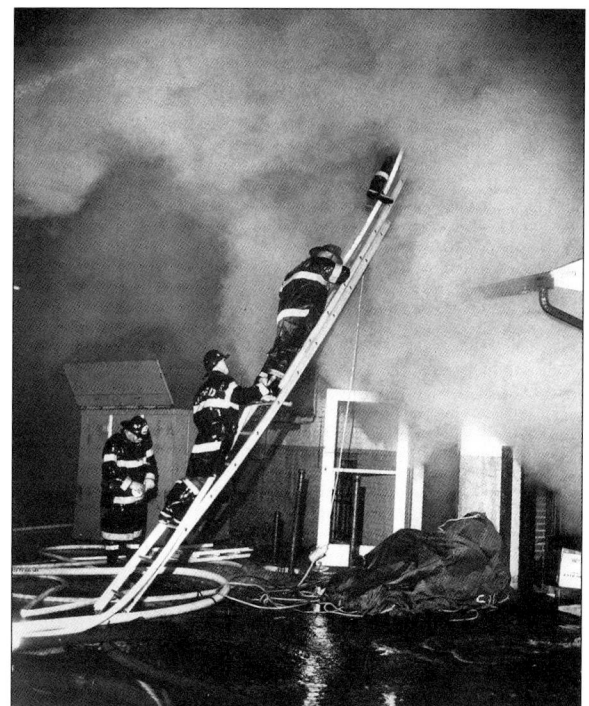

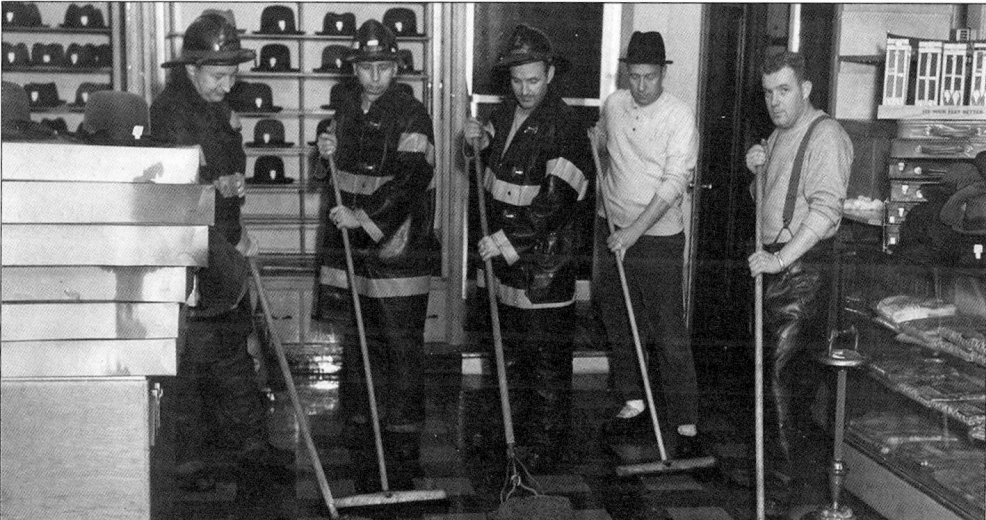

From left to right, Johnson City firefighters Homer Mead, Thomas MacBlane, George Michaels, unidentified, and Jerry Toner help clean up after a fire at a men's clothing store on Main Street. Mead is the only firefighter in Johnson City history to die in the line of duty. He was connecting a fire hose to a hydrant and collapsed from a heart attack. The station on Floral Avenue houses a plaque honoring the memory of Mead that reads, "Dedicated to Homer G. Mead, firefighter, Engine Company Three, who made the supreme sacrifice protecting the lives and property in the Village of Johnson City at box 3-1-2 on January 8, 1974." When a firefighter or police officer is killed in the line of duty, a full-dress funeral is given in their honor. Quite often, firefighters and police officers from all over the region and neighboring states will attend these funerals to pay their respects for those killed in the line of duty.

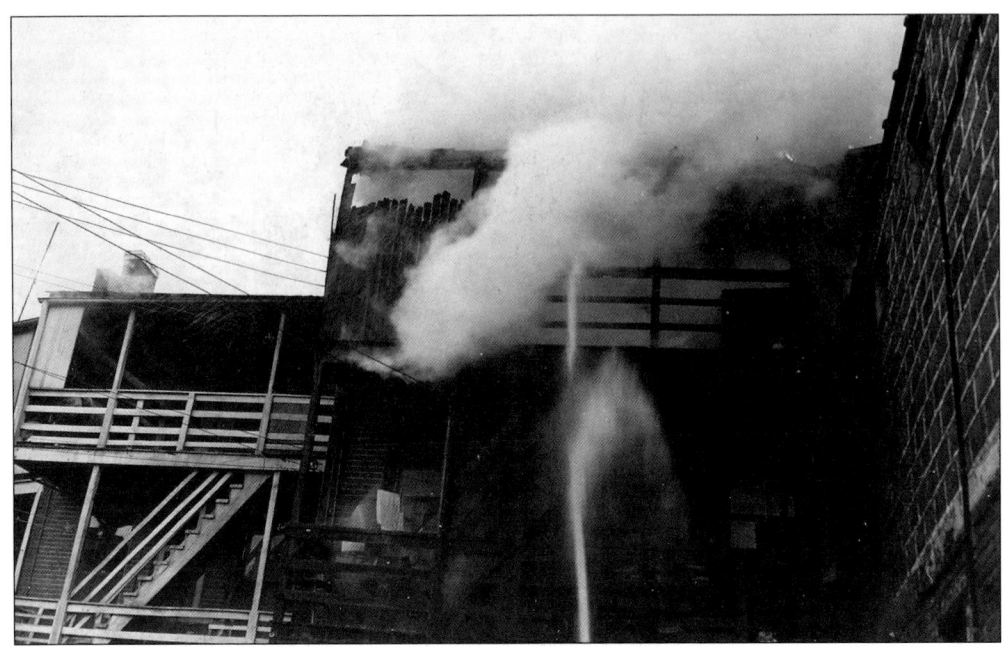

This was a fire on the rear porches of a Main Street building. Extensive wooden porches were common on the rear of these Main Street buildings years ago, and many still retain them. Due to the construction of these types of porches, it did not take much fire to destroy them, and much of the firefighting had to take place from the exterior to get at the fire. The firefighting crews gained entrance to the front of the building and then had to gain entrance into each of the apartments to make sure fire had not extended into the interior of them. As technology has evolved, so has the ability to fight fires. Tower ladders and self-contained breathing apparatus have made firefighting much easier. Now thermal imaging cameras help to locate hot spots so the firefighters can more easily eliminate rekindling of the fire. There have been numerous Main Street fires over the years involving these wooden porch-type structures.

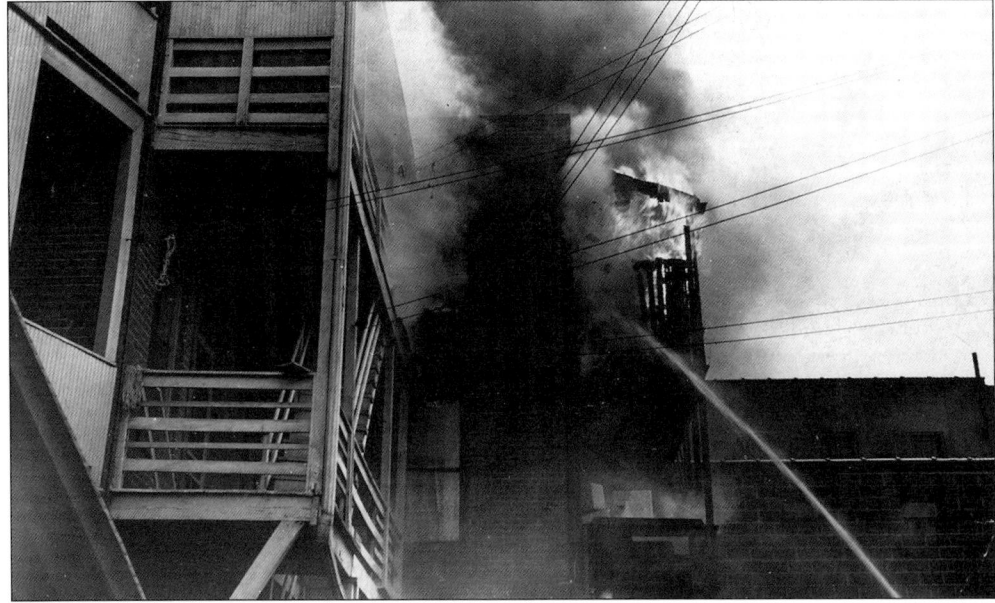

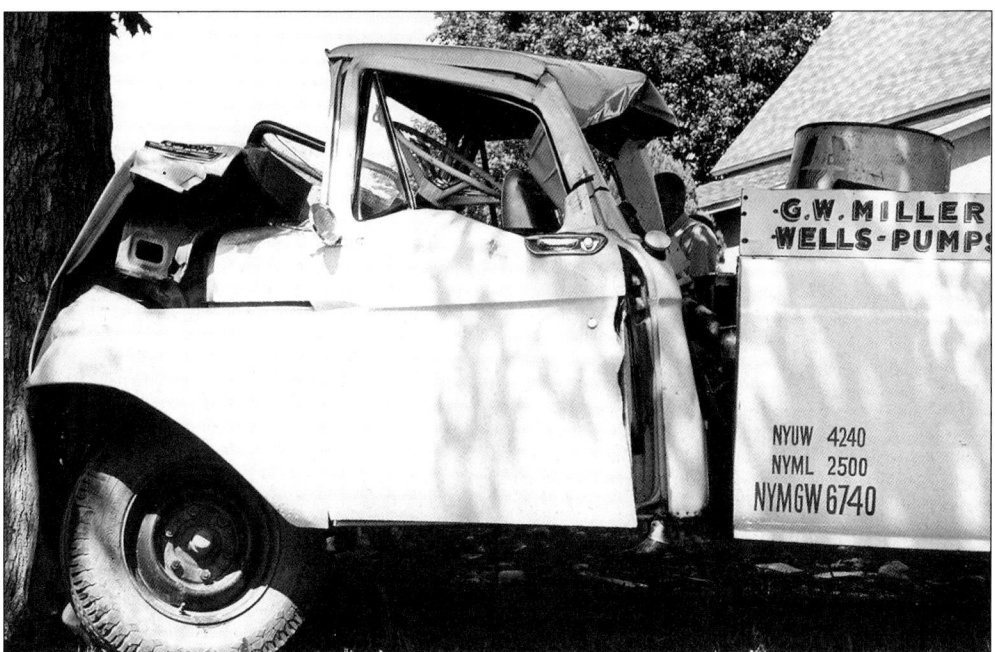

Car accidents have become more frequent mainly because there are more vehicles on the road. However, in the 1960s, accidents of this type were a challenge to firefighters. As can be seen in the above photograph, the steering wheel was pushed into the driver's seat. Air bags and Hurst tools were not even thought of yet, so removing the victims was much more difficult. In the photograph below, fireman Harry Shannahan looks over the vehicle and scene of the accident prior to the pickup truck being removed from the accident scene. Today motor vehicle accidents are handled by the fire department much differently due to the extensive training made available to the firefighters.

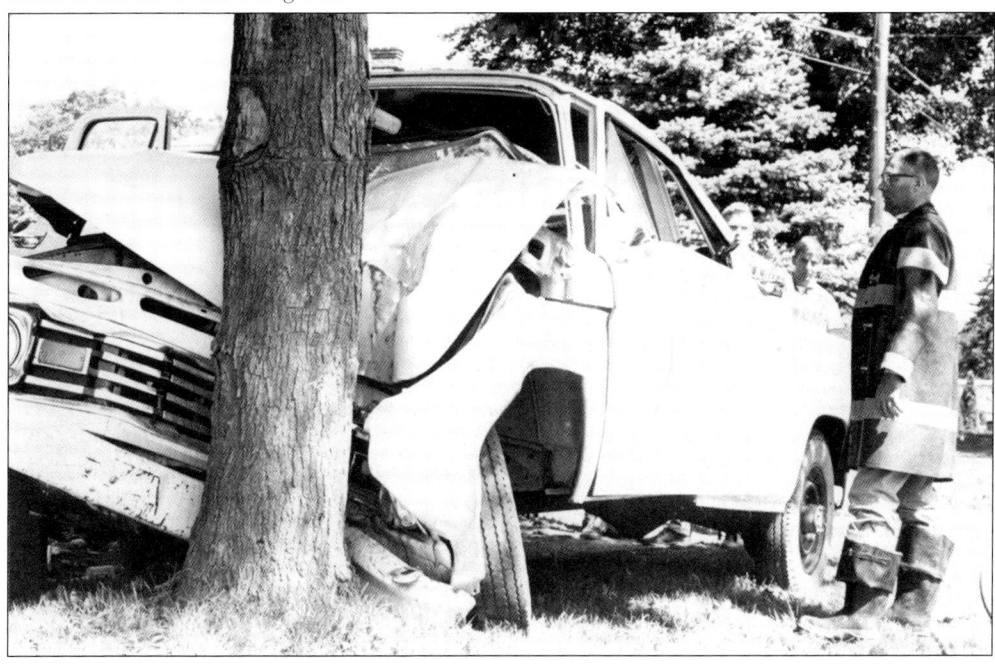

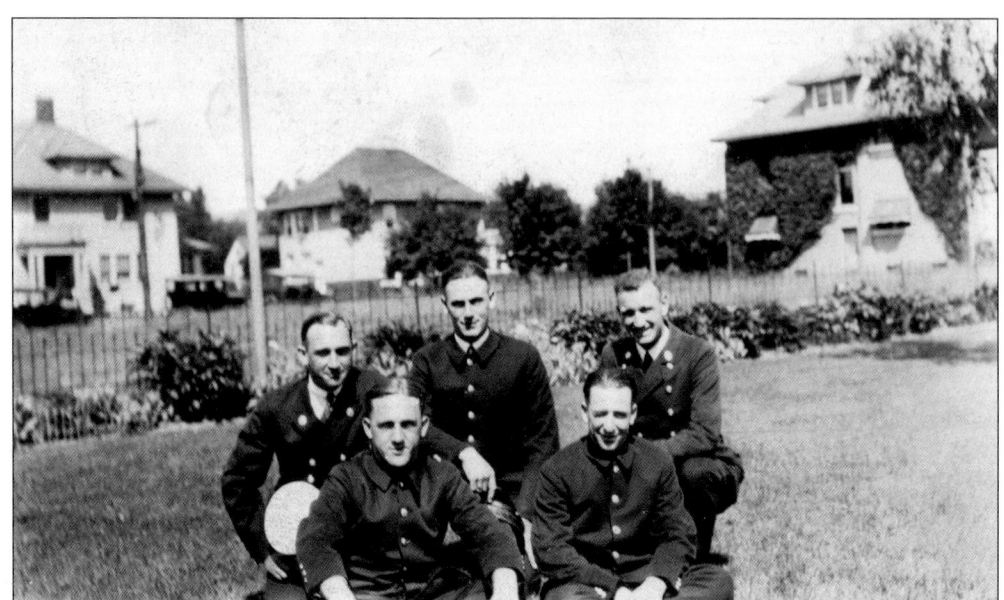

In the c. 1920 photograph above, a few of the Johnson City firemen pose for a photograph in the park across the street from the old Central Fire Station on Willow Street. From left to right are (first row) Lawrence Jukoskie and George Schutt; (second row) Lt. William Rickert, Fred Aug, and Capt. Earle Reno. The photograph below was taken in 1939 at the American Legion on Main Street in Johnson City. It was most likely taken after the clambake in July of that year. Pictured are C. Fred Johnson standing center in a suit coat, and to his right and in front, is Johnson City chief William Rickert looking directly at C. Fred, and on the far right is Endicott Johnson Fire Prevention assistant chief Harry Shannahan.

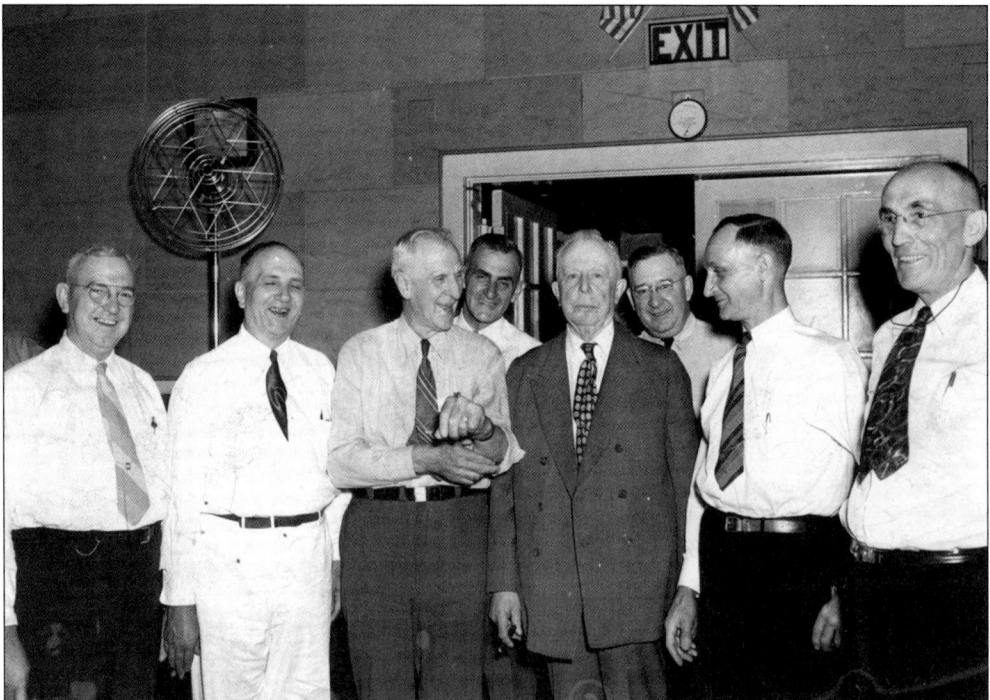

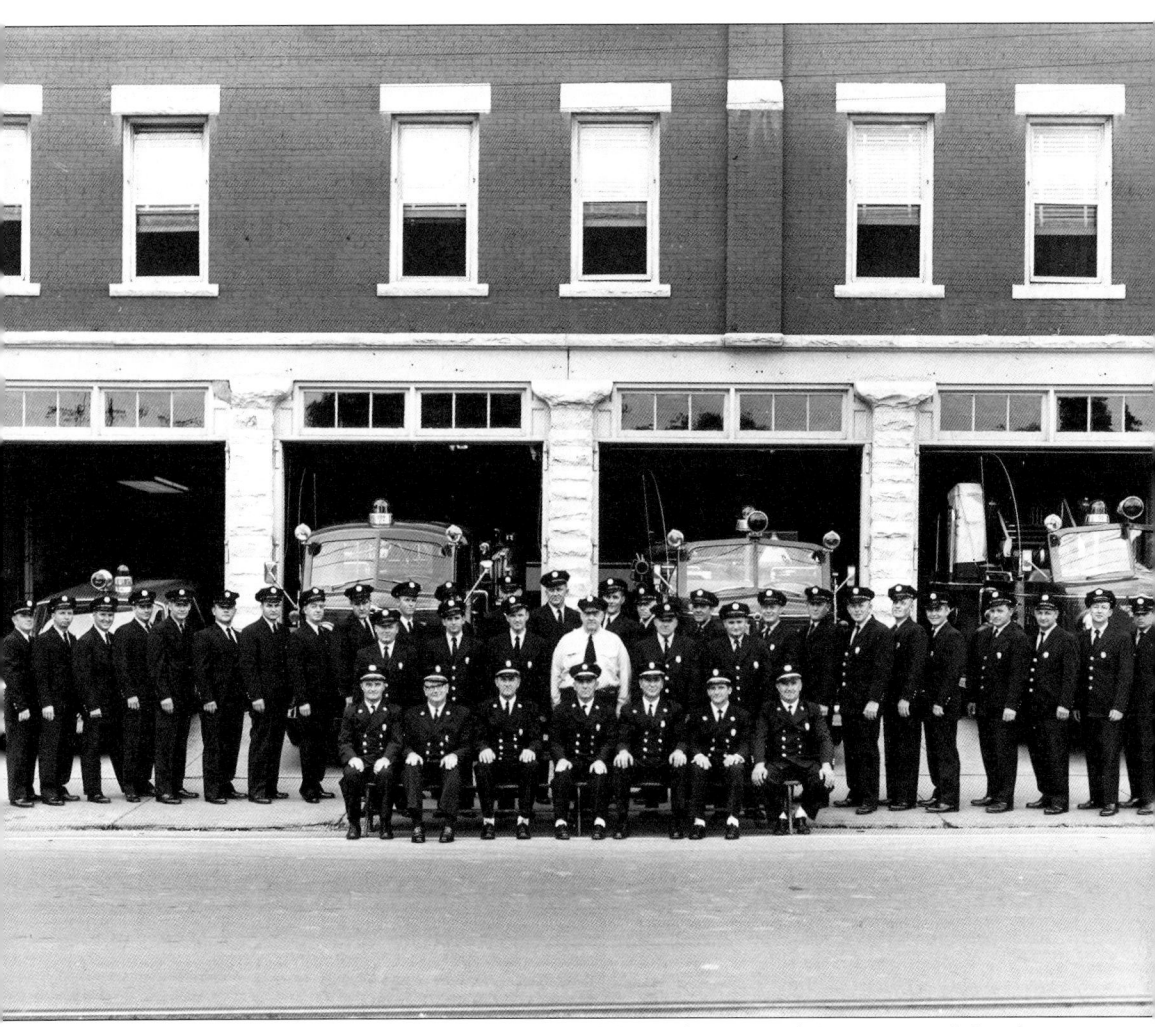

In 1961, Johnson City Fire Department personnel from the Central Station posed for this photograph. At the time, there were 37 men assigned to the station. The Central Station was closed down in the late 1970s with the equipment and personnel being shifted to the Floral Avenue and Harry L Drive stations. Although the work load has increased tremendously for the department, today the department consists of only 45 men, down from a high of 61 men in the mid- to late 1970s. From left to right are (first row) Capt. Frank Slahucka, Lt. Leslie Genthner, Lt. John Okenica, Chief William Grace, Lt. Joseph Waskovicks, Lt. Frank Dohnalek, and Capt. George Major; (second row) Gerald Gardner, Francis Krivicich, George Michaels, Arthur Griswold, Walter Miller, and Steven Drahos; (third row) Gerald Toner, Thomas MacBlane, unidentified, Eldridge Garms, William Blabac, Bert Wright, John Patinka, James Clark, Robert Rabert, three unidentified, John Stasko, Harry Shannahan, Carl Thrasher, John Waters, unidentified, Joseph Dancho, Carl Hahn, Walter Glanville, John Macinski, Steven Moschak, Homer Mead, George Johnson, and Thomas Fedorchak.

Firefighter Robert "Soggy" Rabert stands inside of station No. 2 located on Harry L Drive. The half wall he is leaning on has been replaced by an entire room. This was done because of the long-term effects of breathing diesel fumes every time the fire engine was started up. Ventilation systems have also been added for each vehicle, where exhaust fumes are ventilated directly to the exterior of the stations. Smoking inside the public building has been banned as well.

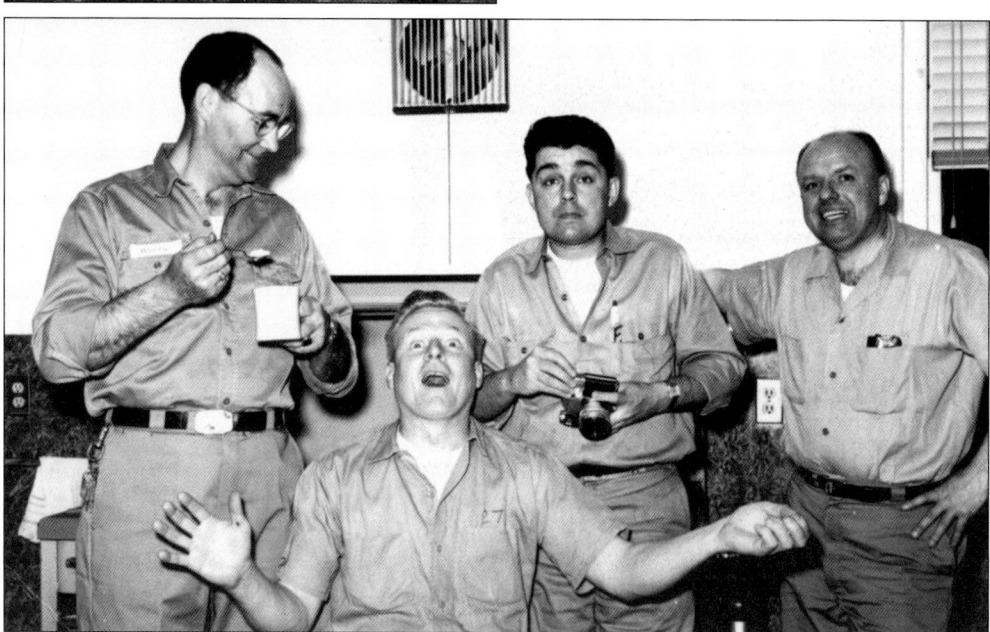

Clowning around in the old Central Fire Station kitchen was common. From left to right are Harry Shannahan, Walter Glanville, Thomas Fedorchak, and Walter Miller. When other duties did not call, the kitchen was a good place to congregate to chat, joke around, and have some good old-fashioned firehouse coffee. The men in this photograph were wearing the work uniforms called grays. Blue-colored uniforms would be instituted later.

Maintenance crews work with a crane to deliver a new air handler onto the roof of the old Central Fire Station in the 1960s. It was always a chore walking up to the flagpole. The junior firefighter had to walk up four or five flights of stairs and then through a small doorway leading onto the roof in order put up or take down the flag every day and evening.

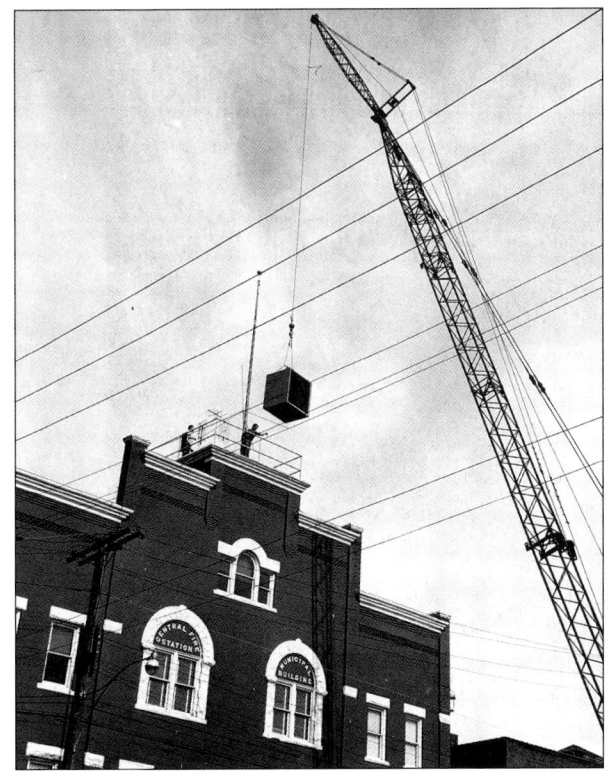

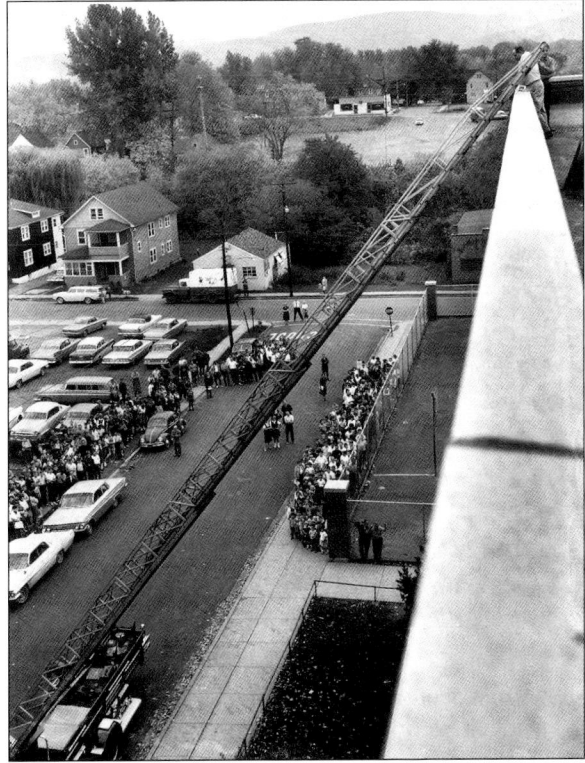

Johnson City's ladder truck was set up for a demonstration for the children of the C. Fred Johnson Middle School located at 100 Albert Street. The ladder was extended to the roof to see how long it would take to rescue someone from the roof if needed. The building is still standing, but it is no longer used as a school.

The population in Johnson City continued to grow in the 1960s. Many new homes were being constructed on the north side hill in 1965. This growth brought a need for a new station located on the corner of Harry L Drive and North Hudson Street. The picture above illustrates the front of the building, while the photograph below shows the engine bay in the rear. A plaque on the front states the station was dedicated in 1965. It was rededicated later to honor the former fire chief William Grace in 1991. When the main offices for the fire department were relocated to this station in 1999, the additional tower bay was dedicated then. It is currently known as station No. 2 and houses most of the department's vehicles and equipment.

Hose testing and pump training are regular events for firefighters. Annually each length of hose that the department owns has to be stretched and tested at 200 pounds per square inch to make sure they will hold up while being used during a fire. If a hose fails the test, it is taken out of service and either fixed or replaced by a new one. This was the old American LaFrance Engine No. 4. Chief William Grace is seen below with a public works employee at the village garage. The chief was showing off his new chief's car in the early 1960s. The traffic cones, along with road flares, were to be placed in the trunk for future use at fire scenes as well as vehicle accidents.

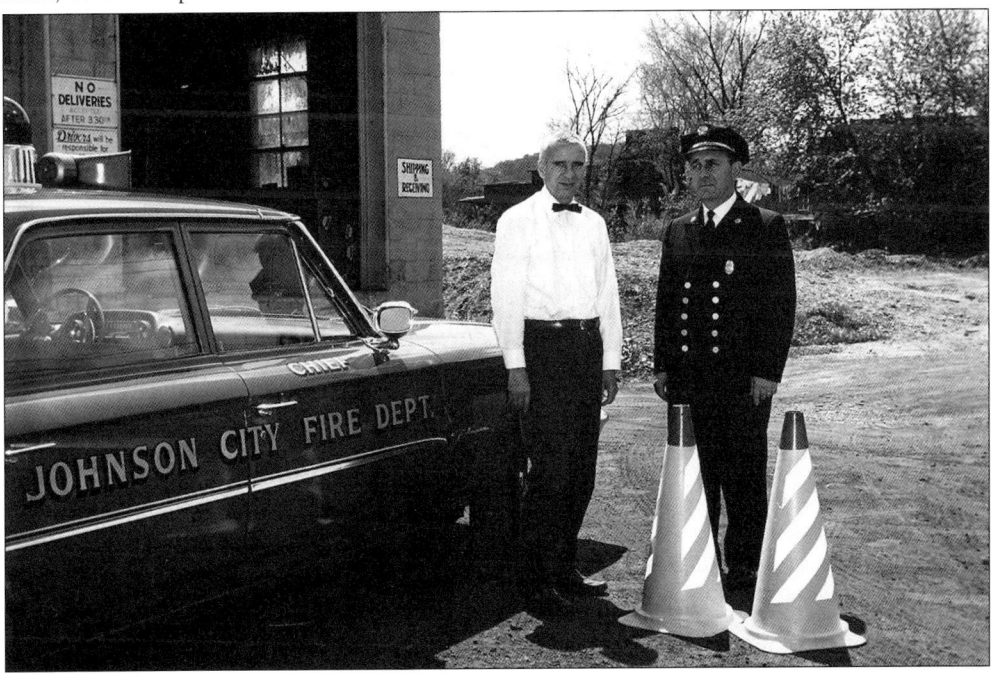

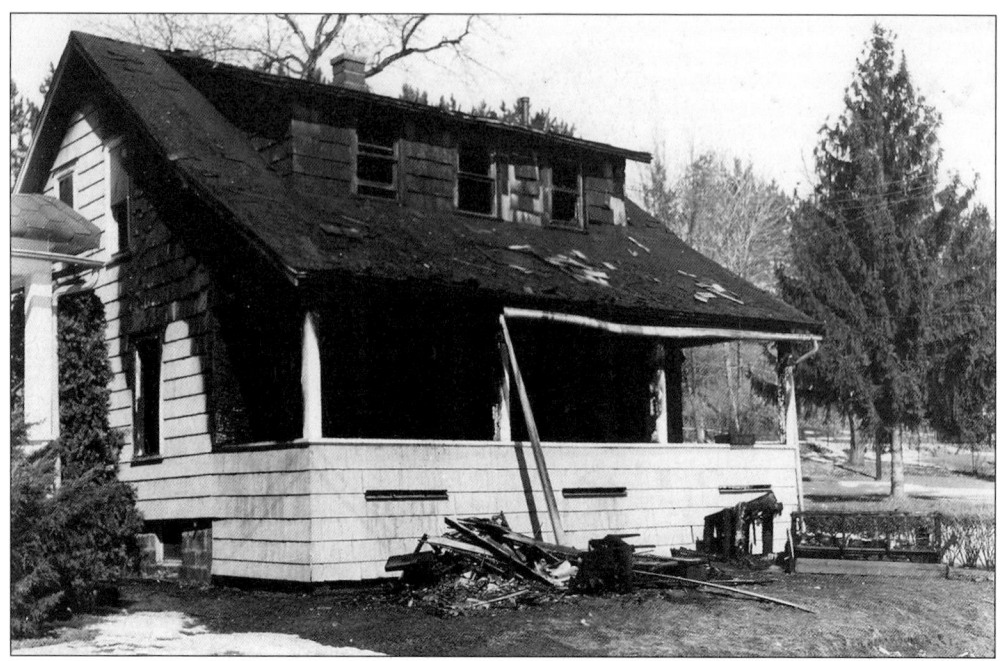

This house, located at 21 Oak Street in the Fairmont Park section of Johnson City, was heavily damaged by a kitchen fire on March 8, 1962. The fire quickly spread throughout the entire home. Most of the damage was to the front of the house. This was an arson fire where an accelerant was used to aid in the spread of fire.

Businesses often have residences attached to them. Whether they are apartments used as a source of income, or if the owners live near their businesses, these living quarters can be a common area for fires to start. Many fires begin either in the kitchen or near a heating unit, and these types of residences usually have two of each.

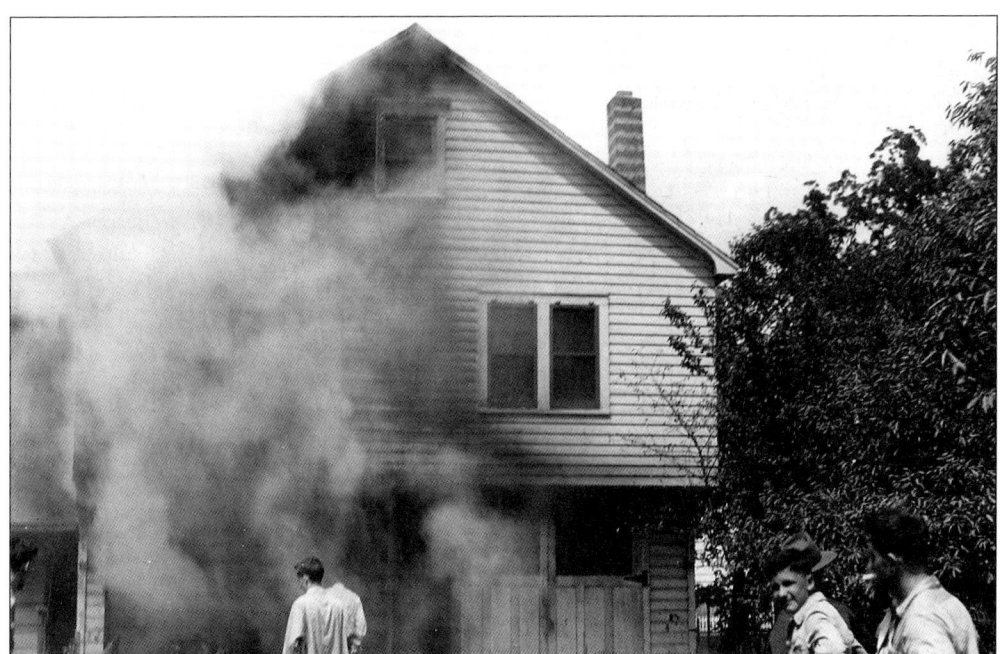

People have always been fascinated by fire and destruction. Here neighbors gather to witness a house on their street go up in smoke. Firefighters are busy on the front and left sides of the house desperately trying to save this residence. Unfortunately, their efforts could not rescue this structure from demolition.

The fire in this picture is actually behind this house. However, because the fire was so intense, the neighboring residents were evacuated from their nearby home as a precaution in case the fire was to spread to adjoining properties. Fortunately for these people, the fire was contained and they were able to return to their home.

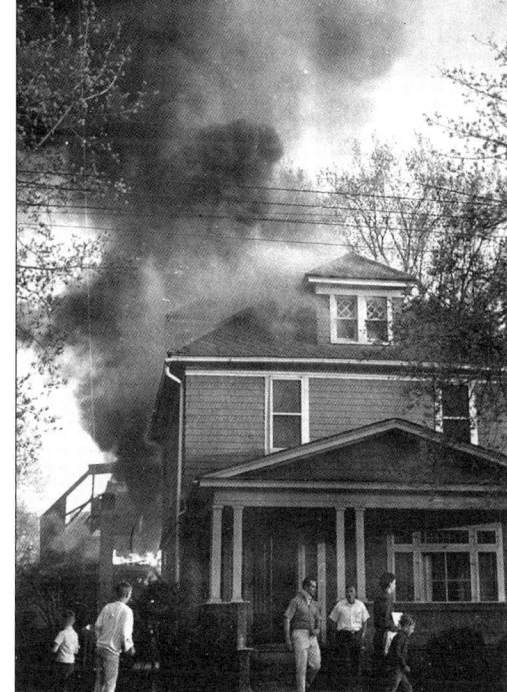

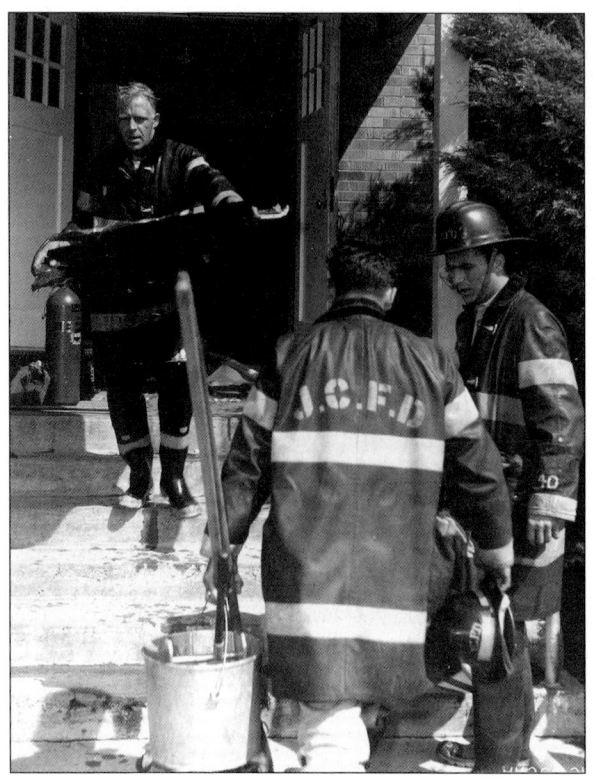

Johnson City firefighters, from left to right, Carl Thrasher, Francis Krivicich, and Jerry Phillips are performing salvage and overhaul at the Blessed Sacrament Church on Riverside Drive. Although the church did suffer some damage from this fire, parishioners were able to raise enough money through contributions to renovate and reopen it quickly.

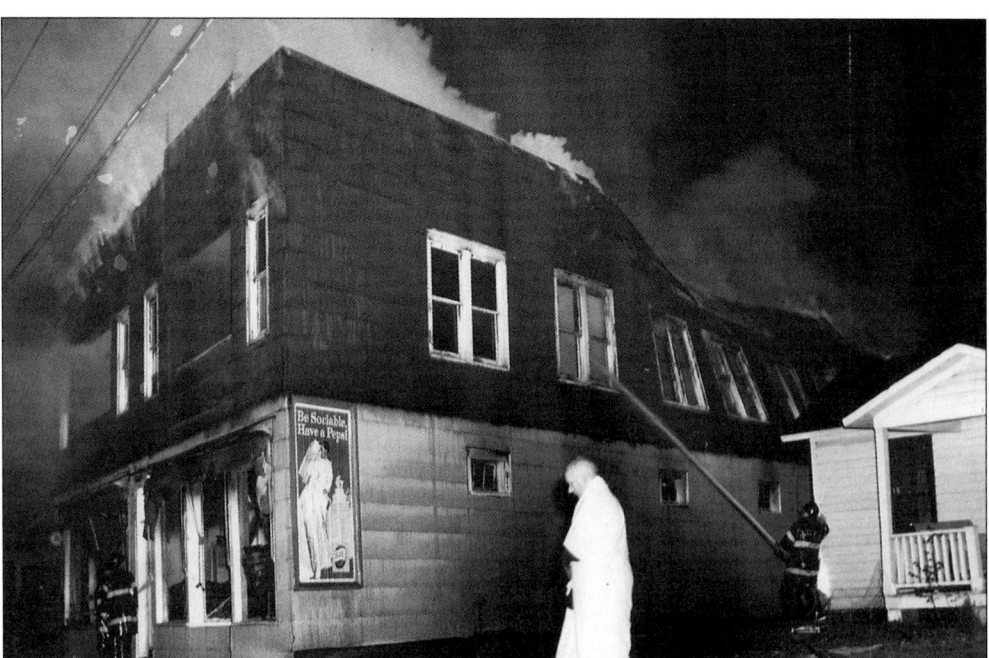

This fire victim cannot bear to watch as his apartment begins to collapse in the early 1960s. When a structure is weakened, fire crews are usually ordered out to make sure they are safe. As can be seen, firefighters had to attack this fire from the outside because of the collapsing building.

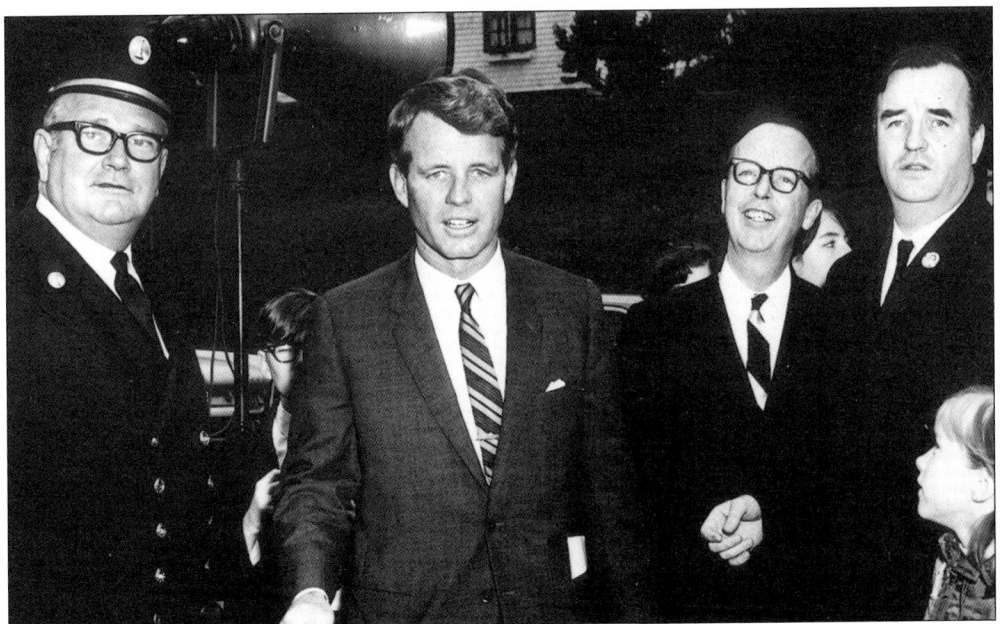

United States senator Robert F. Kennedy attended the dedication ceremony for the new Harry L Drive fire station during a visit to the Southern Tier. Greeting Senator Kennedy, from left to right, are Capt. Leslie Genthner, unidentified, Senator Kennedy, the City of Binghamton mayor William Burns, and New York State Democratic chairman John Burns. This would be Kennedy's final visit to Broome County as he was assassinated at the Ambassador Hotel in California while on a campaign visit.

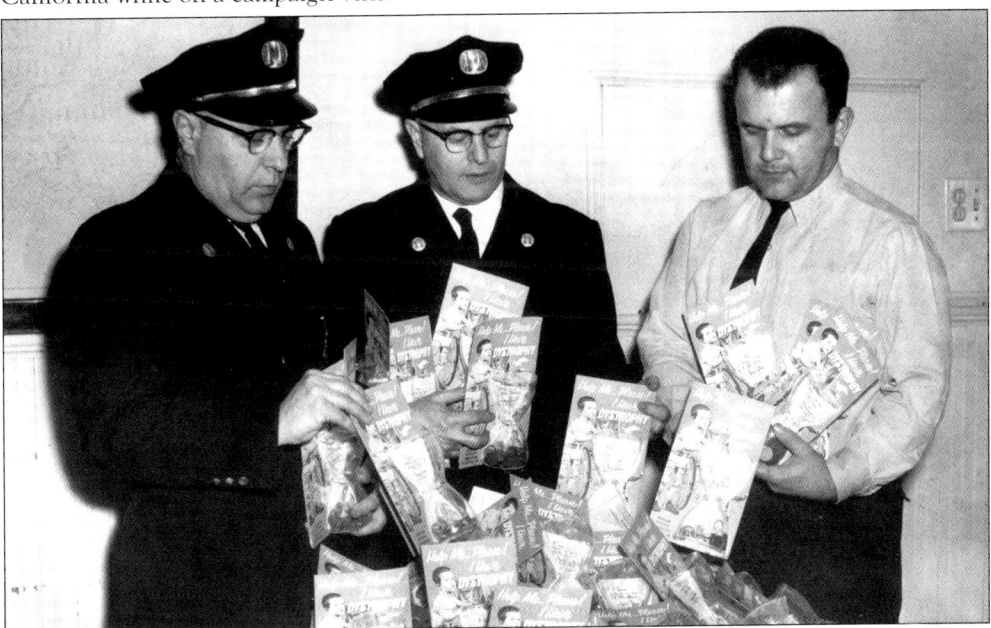

From left to right, Captains Justice Stull and Bill Decker and firefighter Bert Wright show the amount of Muscular Dystrophy Association (MDA) banks collected for the annual Fill the Boot drive to help benefit Jerry's (Lewis) Kids. Every year, firefighters are the largest group of donors for MDA. Most of the money is raised from these drives and private donations.

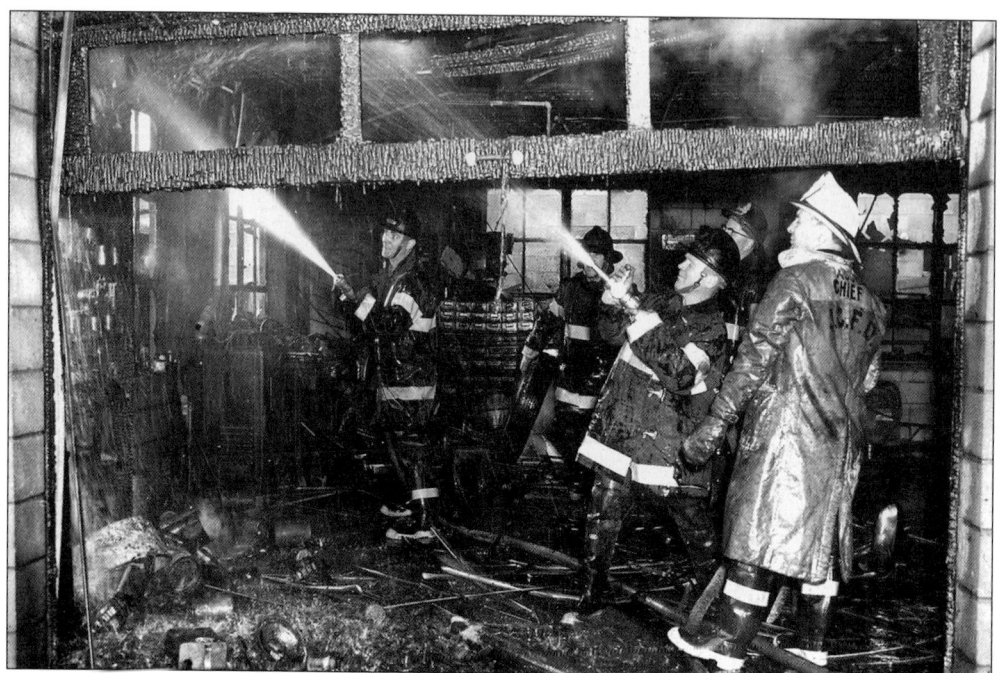

From left to right, Johnson City firemen Harry Shannahan, John Waters, Gerald Gardner, unidentified, and Assistant Chief William Grace extinguish this fire in a garage. The charred overhead door shows that the fire most likely started in the front and spread across the ceiling.

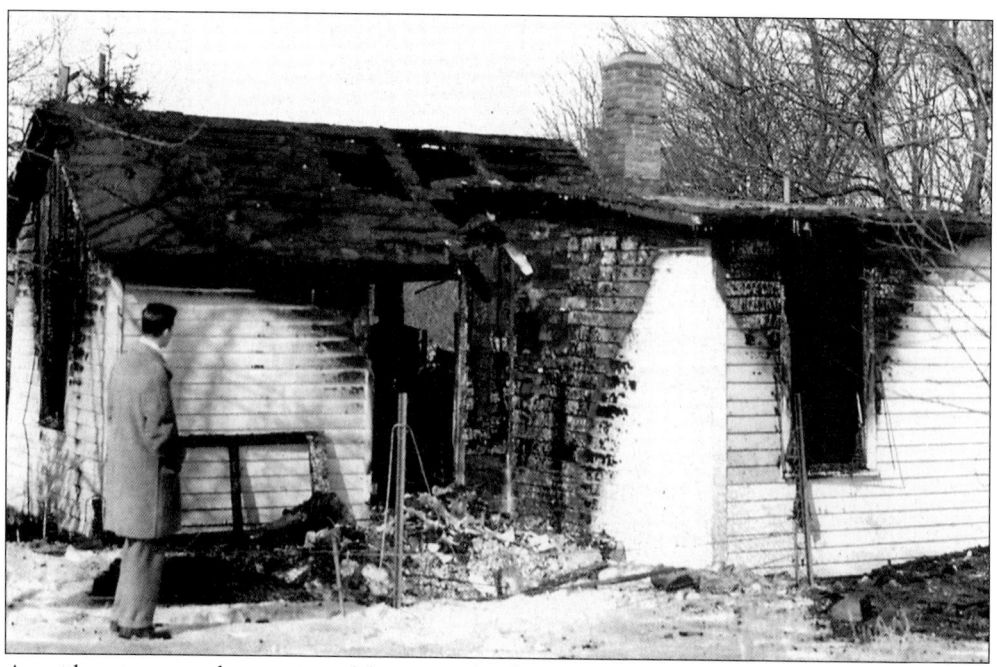

A resident inspects the severity of damage to his home in the mid-1960s. Fire tore through this structure and destroyed the house. One can actually see right through it, all the way to the other side. It appears that the worst part of this fire was in the center, most likely where the kitchen was located.

Firefighter Carl Hahn enjoys some quiet time one evening at the old Central Fire Station. The bunk rooms at most fire stations have several bunk areas in a large room. However, the former station No. 3 on Floral Avenue consists of individual bunk rooms for each firefighter and officer. This is one of the last of its kind in New York.

Firefighters Les Genthner (left) and Ray Caprari pose outside of the old Central Fire Station on Willow Street in the early 1970s. The uniforms of firefighters back then consisted of gray pants and shirts. Today firefighters wear dark blue pants and either light blue dress shirts or dark blue golf shirts. This explains the term *blue shirt*, used when referring to a firefighter.

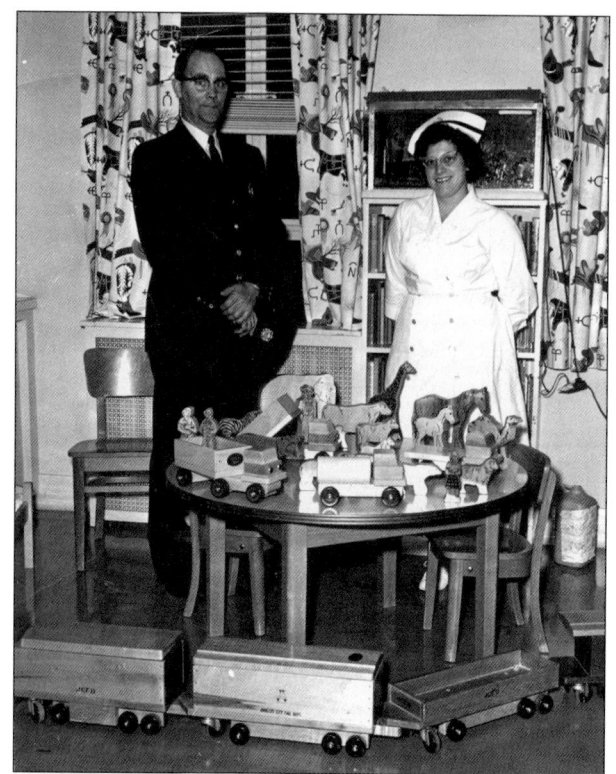

Every year the department would take up a collection from the firefighters prior to Christmas. The monies collected would then be used to purchase toys that were donated to the Wilson Hospital Pediatrics Unit. In the photograph above, firefighter Harry Shannahan poses with a pediatric unit head nurse on the day he and others took the toys over to the hospital. In the photograph below, Fire Chief William Grace poses with a child in the pediatric unit who is showing the chief the new toy he has to play with while being hospitalized. These photographs were taken in the 1960s.

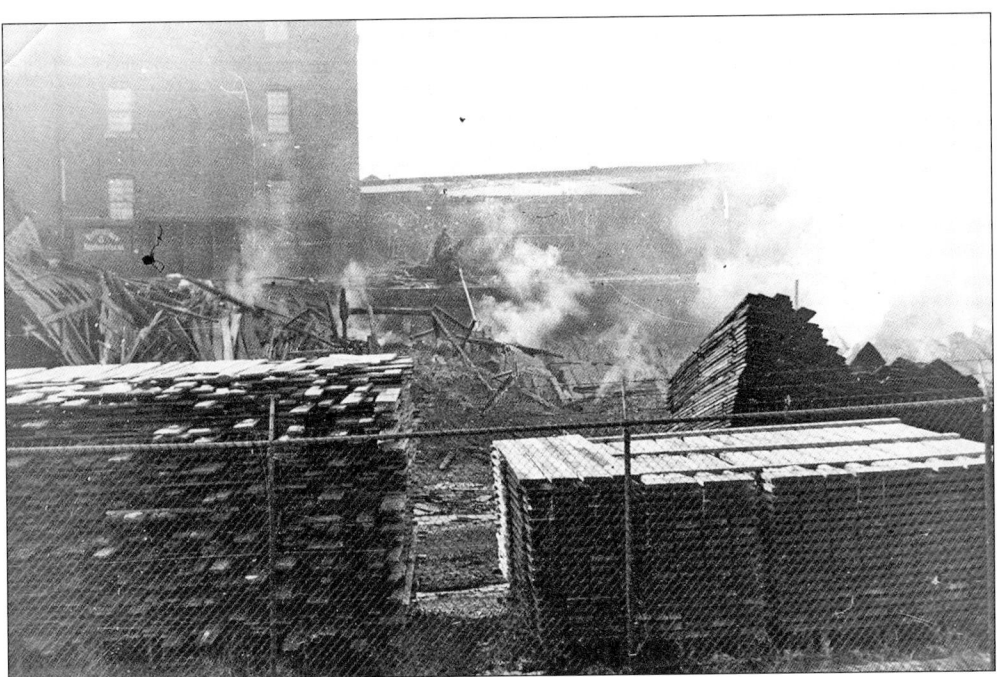

This particular fire at the Roberson Lumber Yard happened on December 6, 1946. A large fire there kept firemen busy for several days. The main part of the fire was put out on the first day. Many of the department's "probies," or new firemen, were used on fire watch. They had to stand watch around the lumberyard and hose down any hot spots that appeared. There were piles of lumber that were ablaze, and heavy equipment was not as readily available then as it is today. Spreading out the lumber piles took a long time, and small fires continued to smolder at the scene. The firemen were on a fire watch continuously for days. The Roberson Lumber Yard was hit by another disastrous fire on November 2, 1968, and never recovered.

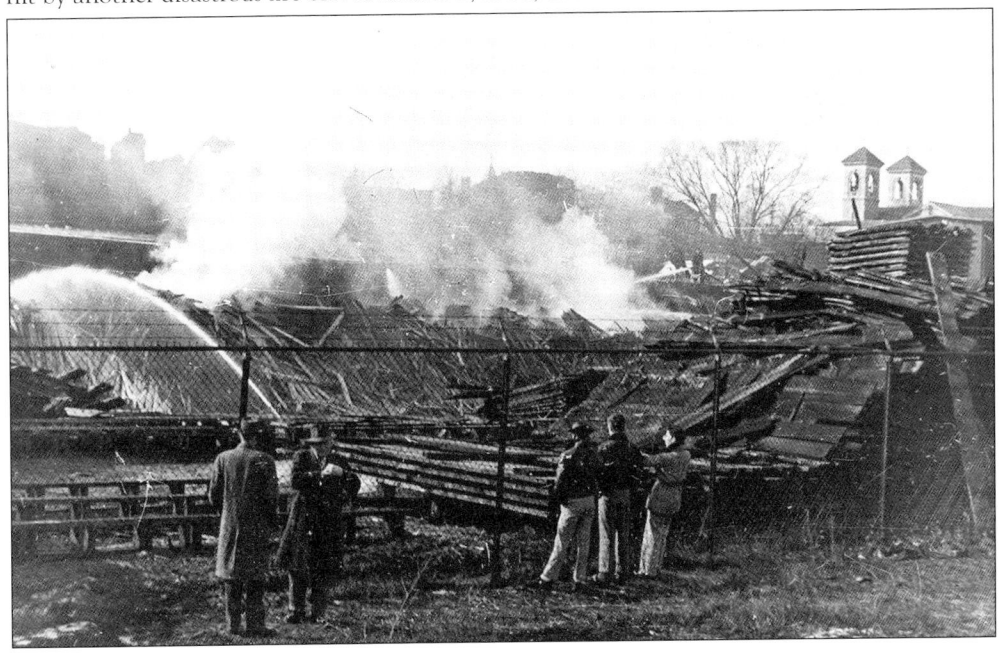

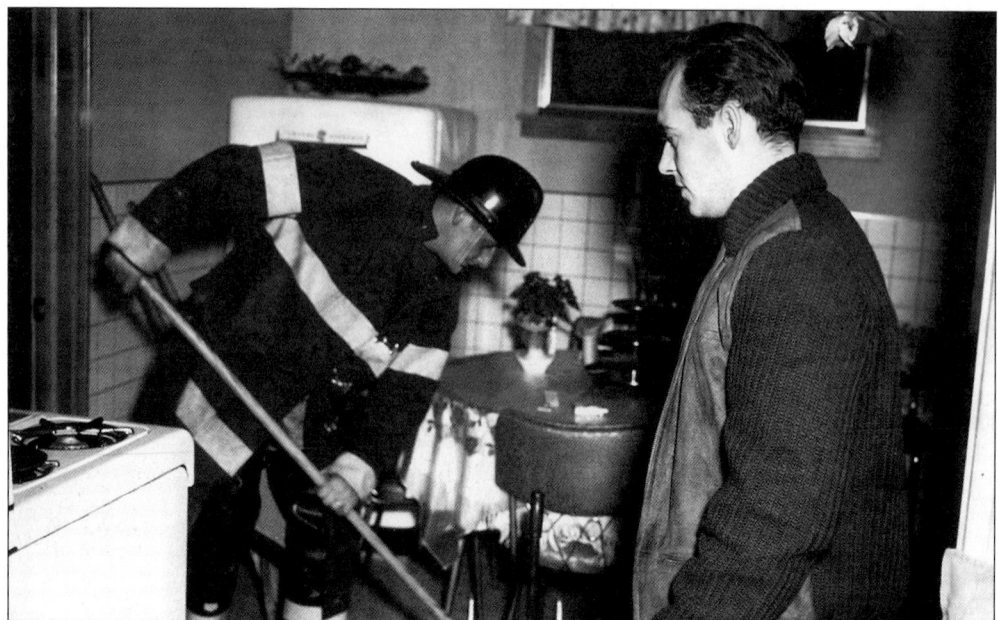

If time allows, firefighters will often assist the homeowners with the cleanup at a fire scene. In this undated photograph, firefighter Thomas Latavish helps mop up a kitchen after a fire. It appears only minor damage was sustained here and the residents were able to move back in right away. Many times, due to the severity of the fire and or smoke, residents cannot move right back into their homes.

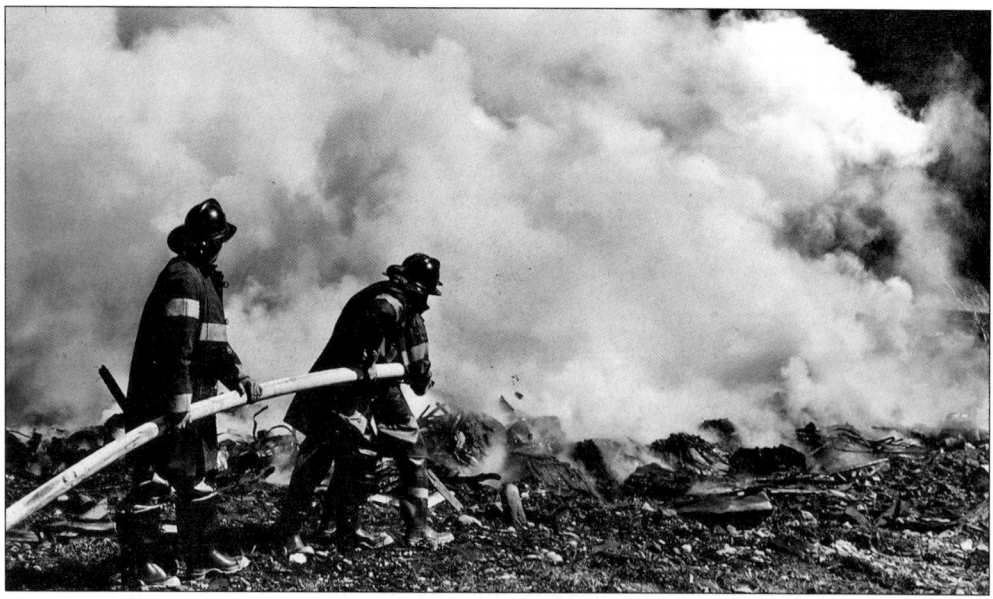

On the north side of Johnson City, in particular, there were many old dumps. These dumps were the scene of many fire calls years ago. Dump fires were common and sometimes would require days to finally extinguish. In this undated photograph, several unidentified Johnson City firefighters work the ground with a lot of water. The secret to getting the dump fires extinguished was lots of water and turning the debris over as much as possible. The dump fires could smolder for days.

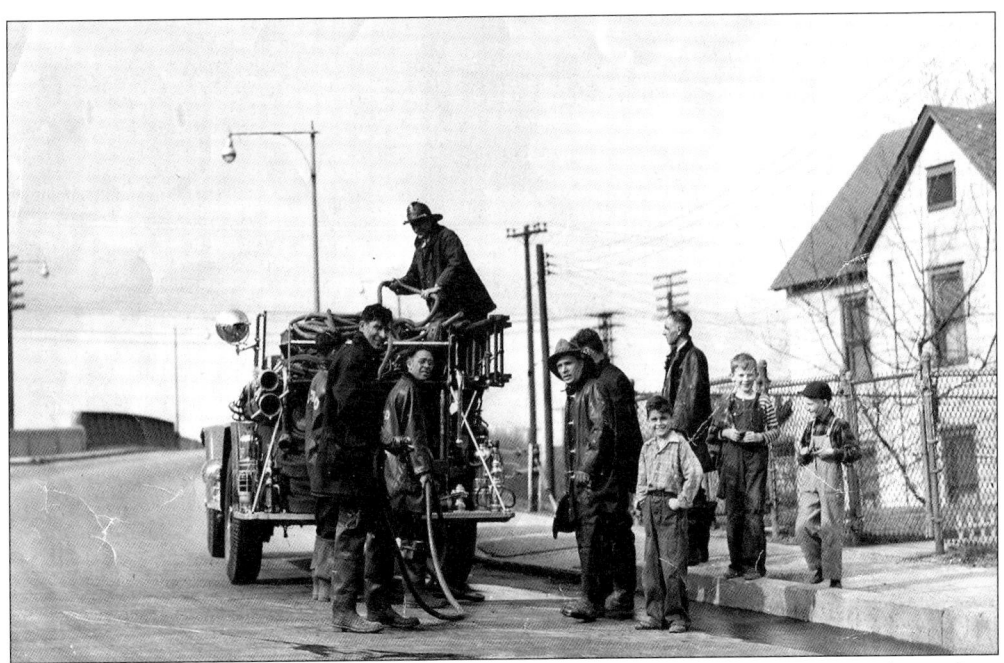

Just as they do today, even back in the 1920s and 1930s, fire trucks and firemen always drew the attention of kids. If there is a fire truck around, boys will be found. This photograph shows several kids that had to be where the action was on Willow Street near Grand Avenue. Smiles abound, not only on the little boys, but on the big boys too.

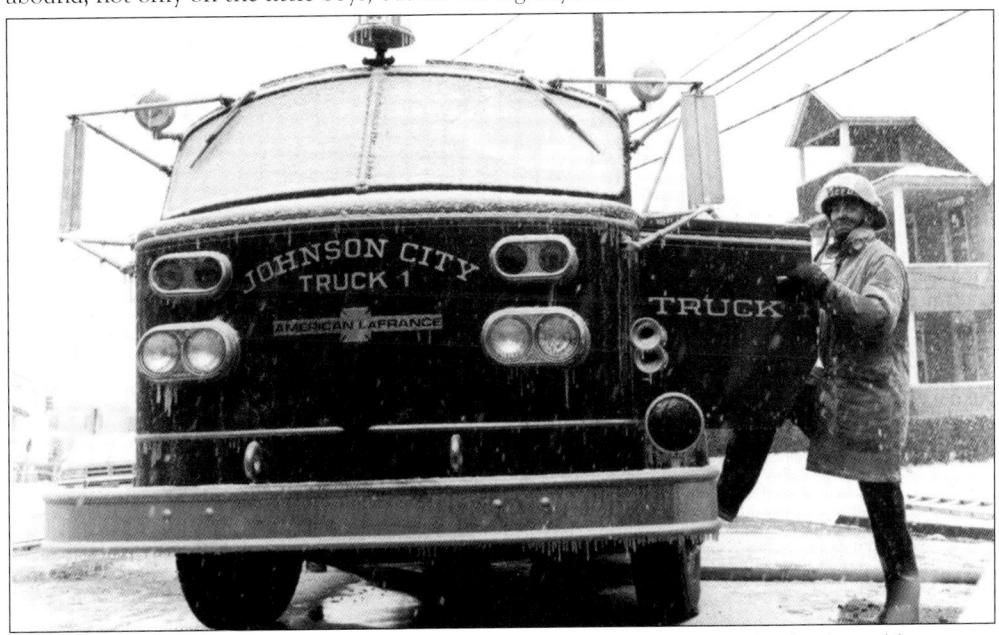

Winter always makes fighting fire tough. The cold and ice do not make for favorable or easy working conditions. The streets and ladders ice up from the water being used, making for very hazardous walking conditions for the firefighters. In this 1960s photograph, firefighter Harry Shannahan seems to be taking things in stride as he is about to climb into the open cab of truck No. 1.

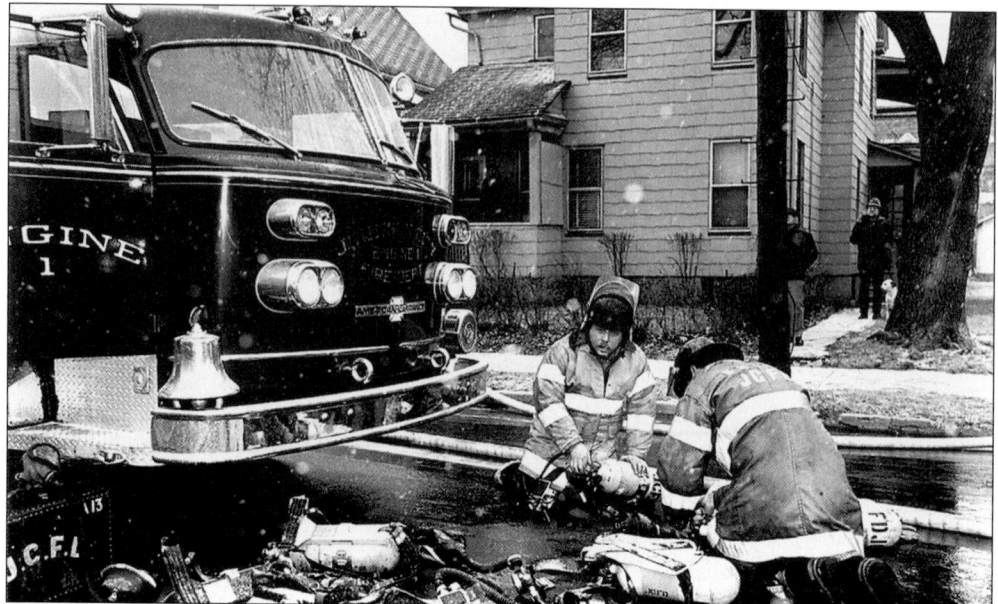

The use of self-contained breathing apparatus has greatly aided firefighters in being able to enter buildings to reach the seat of the fire for extinguishment, not to mention the tremendous health benefits for the firefighter. At this Grand Avenue fire in 1980, firefighter Bill Doney works with his engine partner to change air bottles and get the breathing devices back into service for use at the fire. Each piece must be inspected for damage and cleaned after every use. If something is wrong with the airpack, it is taken out of service until it is repaired.

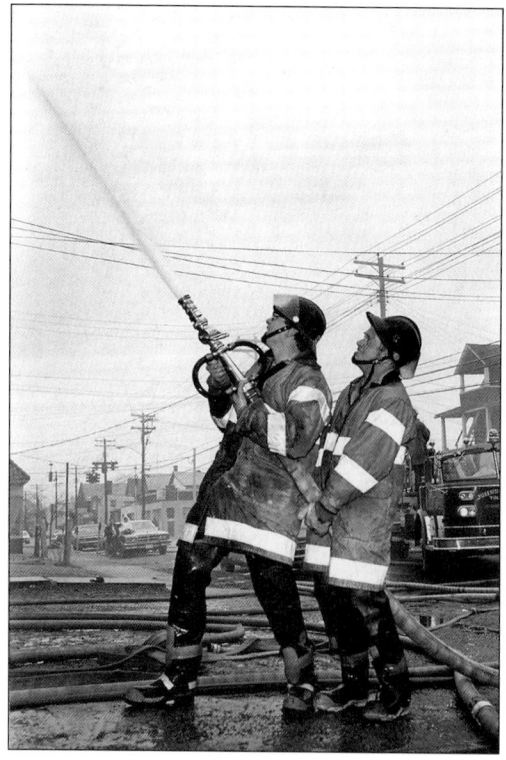

Firefighters Peter Dyman (left) and Lawrence Campbell handle a hose line at this fire at 190 Grand Avenue in 1980. This was a two-and-a-half-inch hose line pouring water out of a straight tip nozzle with quite a bit of pressure behind it. Handling the big hoses like this was not easy and normally took at least two men. Using two-and-a-half-inch hand lines like this usually meant there was a big fire to deal with.

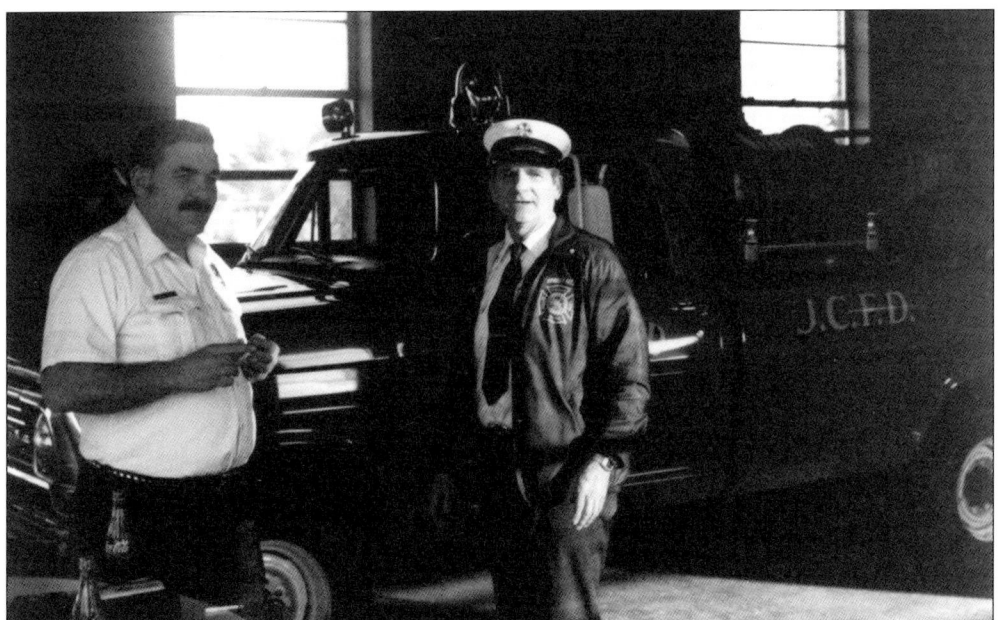

Lt. Gary Hall (left) receives his daily orders from Assistant Fire Chief Frank Dohnalek at the north side fire station. Behind them is the old utility truck. This vehicle was used as a brush truck, aiding in extinguishing grass fires. With four-wheel drive, it had the capability to be driven into fields to reach the outlying areas of the village.

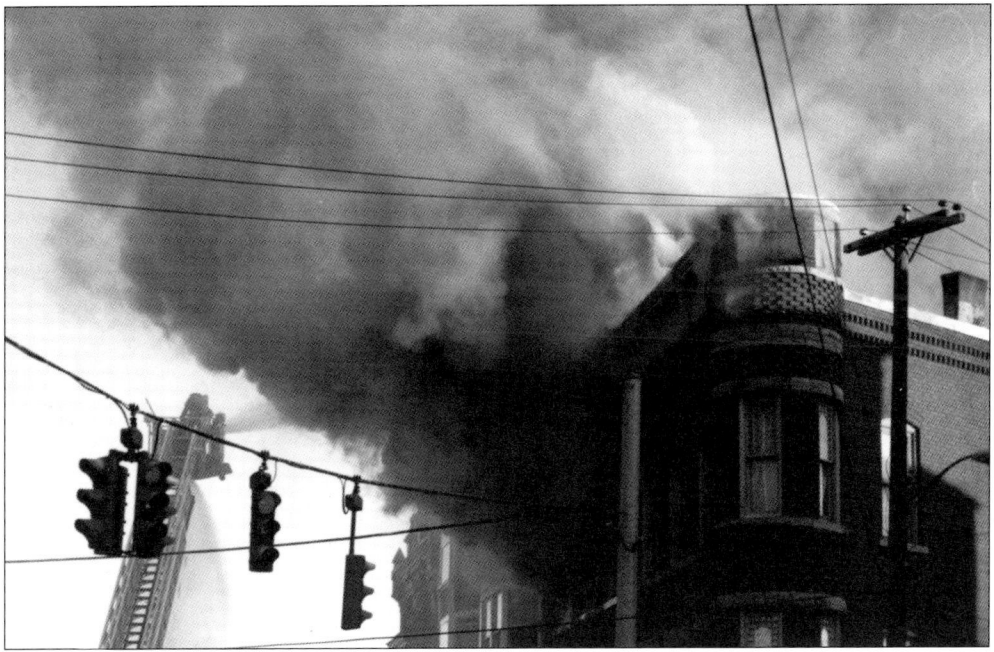

This fire on the corner of Main Street and Arch Street forced several families from their homes. The danger of this building is that it is connected to several other buildings. The potential for fire spread is greater when buildings join each other. These types of buildings are often found in downtown districts.

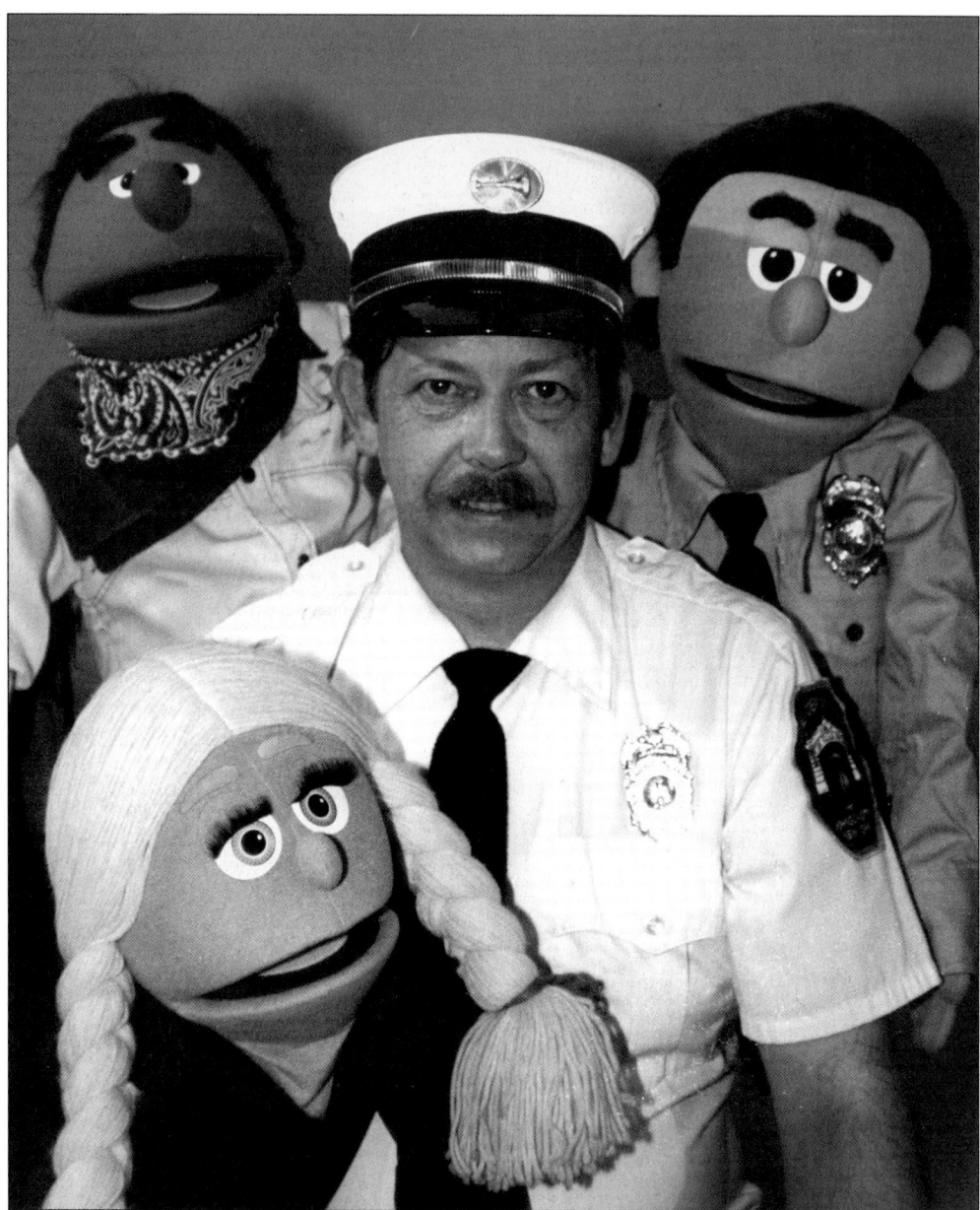

Lt. Robert G. Blakeslee is shown with his new Lieutenant Bob's Fire Safety Puppets—Melissa (front), Firefighter Frank (right), and Cowboy Jim (left)—in 1986. When Blakeslee was still a firefighter, he became very involved in fire prevention programs and activities. He brought the Sesame Street Fire Safety Project to Broome County in the early 1980s. Through community groups, he was able to purchase the puppets and then traveled to area schools where the puppets would teach the children fire safety. Lieutenant Blakeslee then obtained state grant money through assemblyman Richard Miller and was able to obtain the Freddy the Firetruck robot, which was used at schools and places of assembly in conjunction with the puppet program. In the mid-1990s, as fire marshal, he instituted the Juvenile Firesetters Intervention Program in Johnson City. After his retirement, his programs are still being used by the department. Prevention is the key to success.

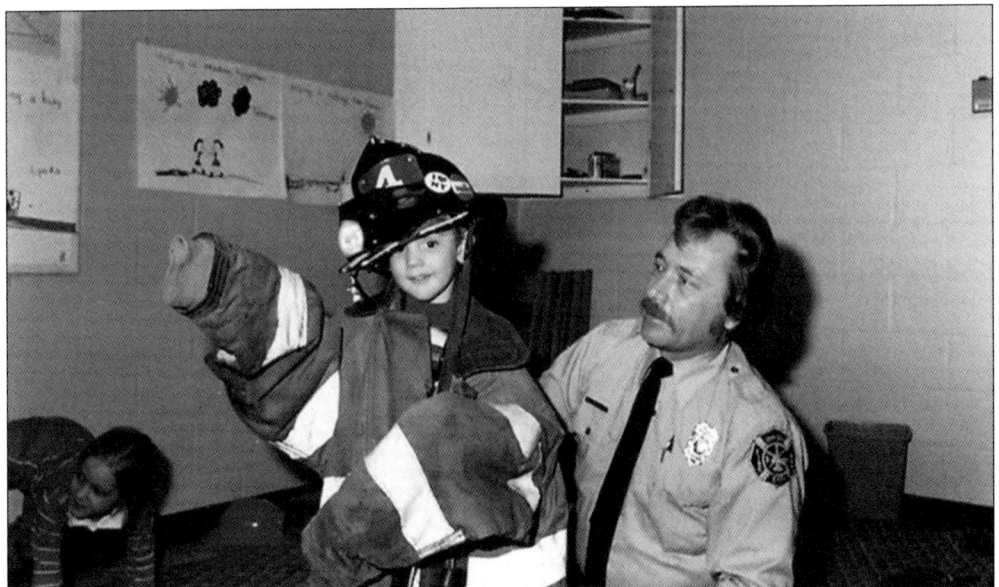

Firefighter Scott Furman has a student from the Harry L Johnson Elementary School try on his bunker gear after a fire safety class. Furman was very active in fire prevention programs and helped to bring the Sesame Street Fire Safety Project to many children in the area. Quite often, firefighters travel to schools and day care centers to teach children about the dangers of fire. The kids learn what to do if they are ever in a fire. Some of the techniques used include "Stop, Drop, Cover and Roll" as well as "Stay Low and Go."

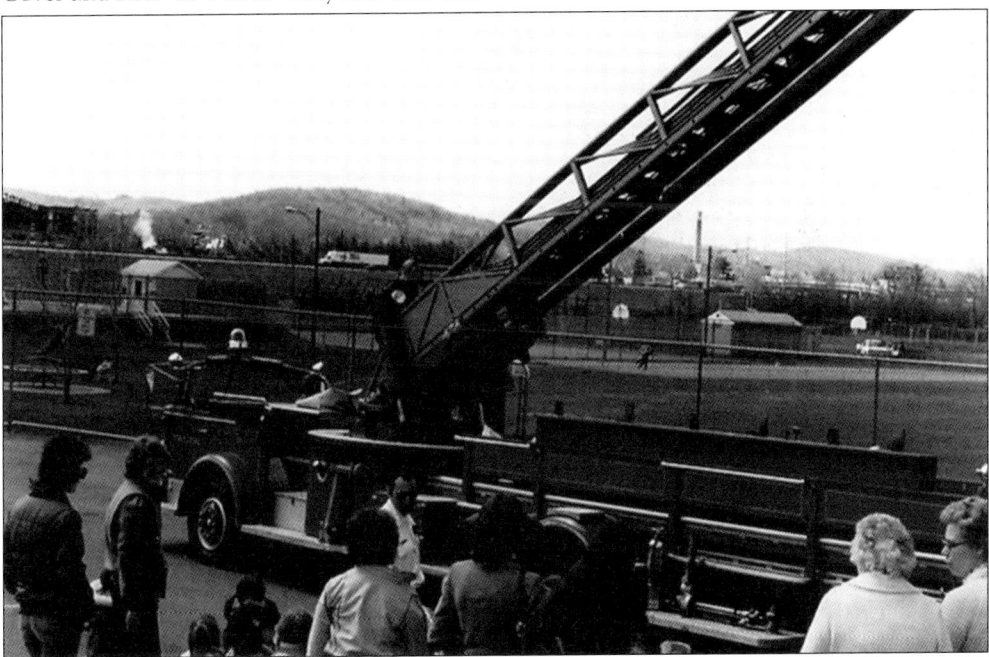

Lt. Markus Smith talks to a group of schoolchildren as some of the firefighters in his group operate the ladder truck. Young children are always fascinated by the fire department's ladder truck. Schools will often set up field trips to the firehouse to learn the daily routine of the department.

Freddy the Firetruck robot was unveiled by the Johnson City Fire Department in 1988. Freddy is used in conjunction with other department fire safety programs to teach children about fire safety. Present for the dedication were, from left to right, firefighter Cliff Stewart, firefighter Bob Garey, firefighter Jim Malonis, state assemblyman Richard H. Miller, Fire Chief George Maney, firefighter Brian Matuszak, Fire Marshal Frank Carro, and Capt. Robert Blakeslee.

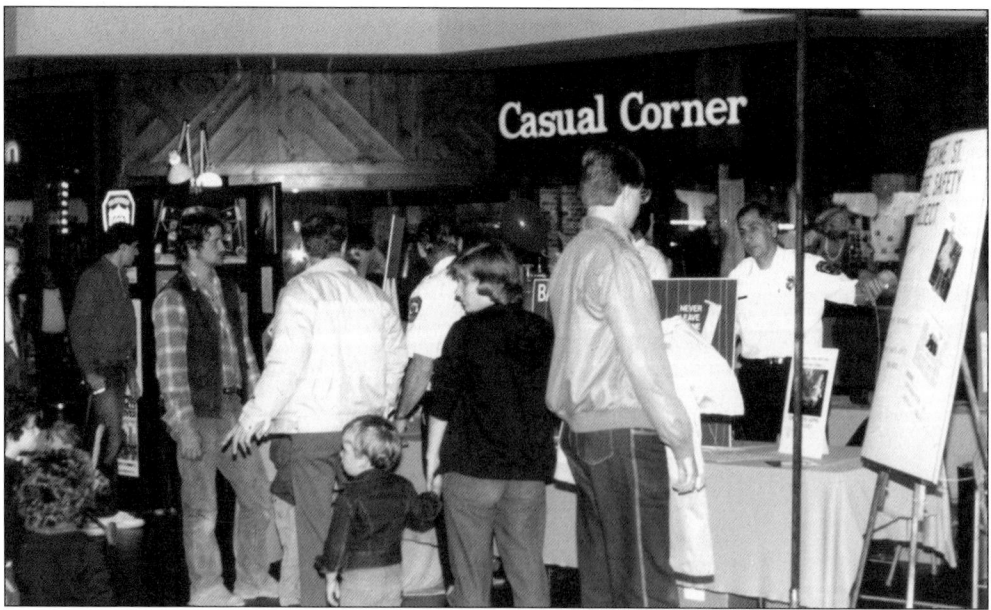

In the early days of fire prevention, Johnson City displays at the Oakdale Mall in October always had the most extensive and best-looking setup of any department in the county. In the 1970s and into the early 1990s, there was never a shortage of personnel willing to help out and man the display setup for many hours. Assistant Chief Frank Dohnalek (left) and Fire Marshal Frank Carro are shown taking care of the display in this photograph.

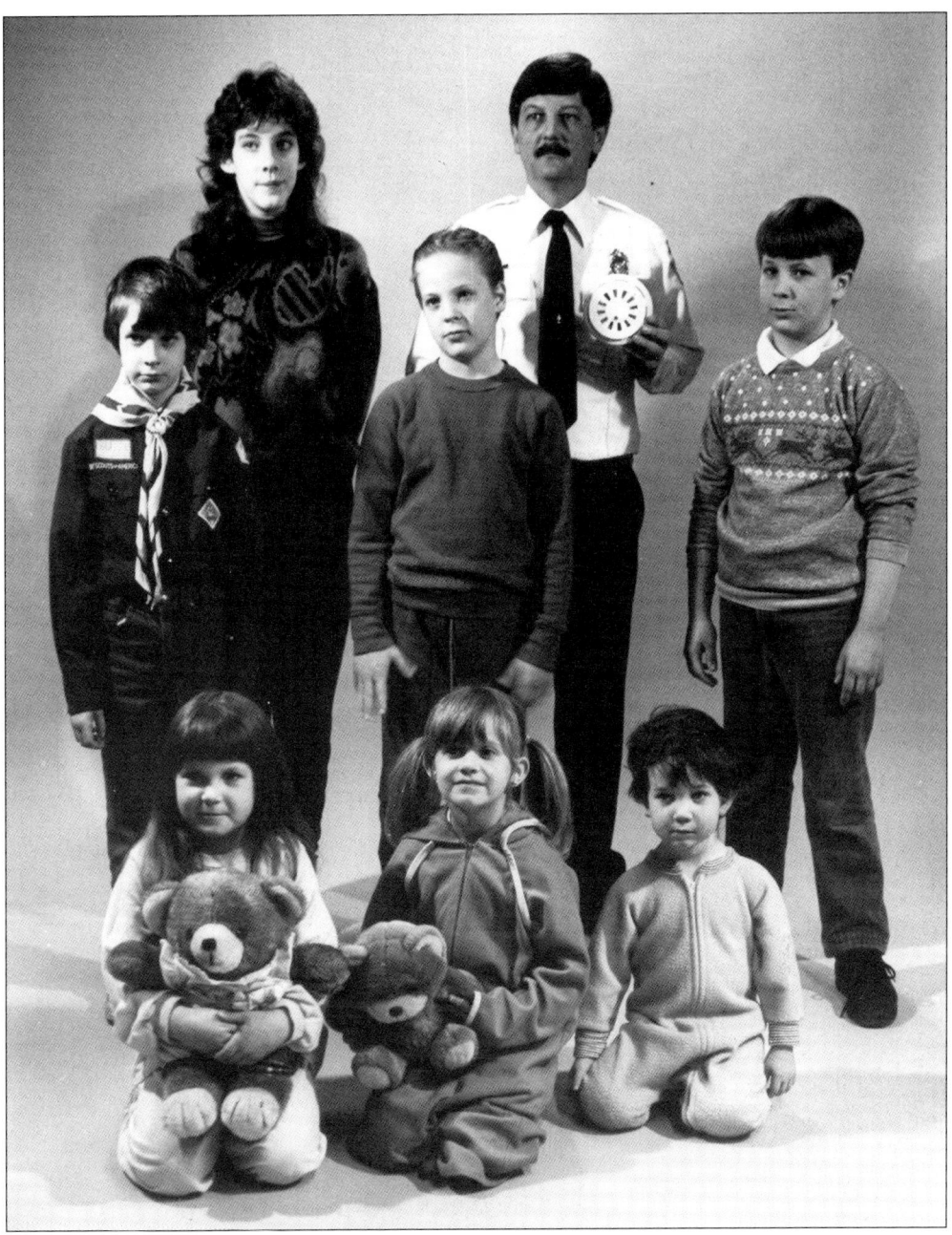

When the department started to become heavily involved in fire prevention, there was only a budget line item of approximately $200 per year for fire prevention items. With so little money to provide fire safety and prevention messages, the department had to create their own, one of them being large posters. This poster photograph was taken in the basement of the Floral Avenue fire station by Lt. Robert G. Blakeslee. It was then printed in limited quantities and posted in windows of local businesses to promote the installation and use of smoke detectors. The models in the photograph are, from left to right, (first row) Katie Maney, Melissa Blakeslee, and Michael Blakeslee; (second row) Robert S. Blakeslee, Karen Maney, Gregory Maney, Fire Chief George R. Maney, and Michael Maney.

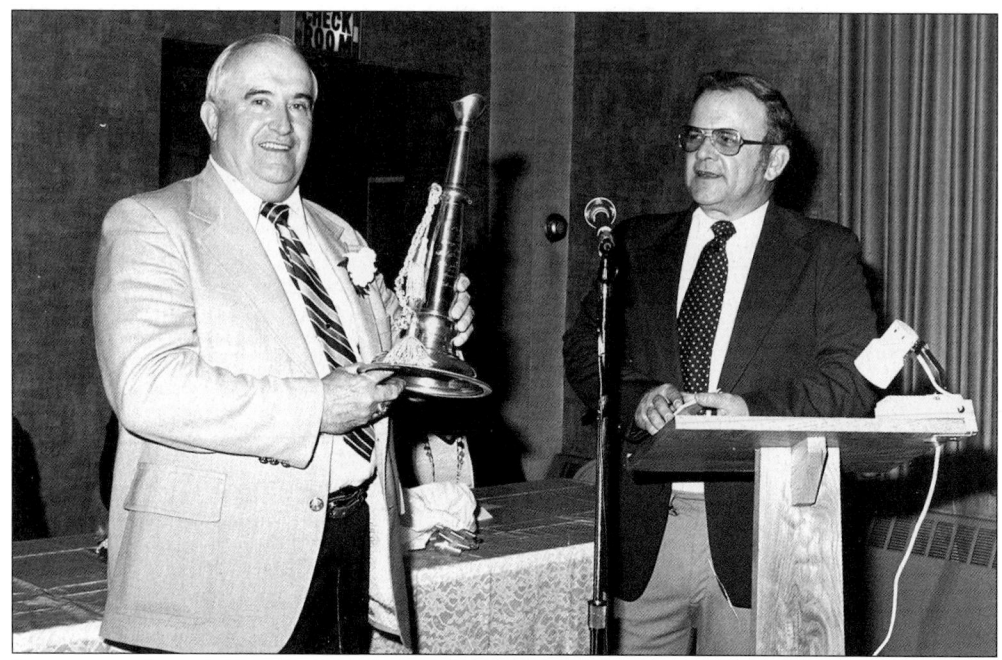

Retirement dinners are commonly given for retired chief officers. Fire Chief George Major (left) is shown giving a thank-you speech to those present after being given a fire trumpet as a retirement gift. Fire Chief Bert A. Wright was the host of the retirement dinner, and it was his job to see that everything went as planned for the newly retired chief major.

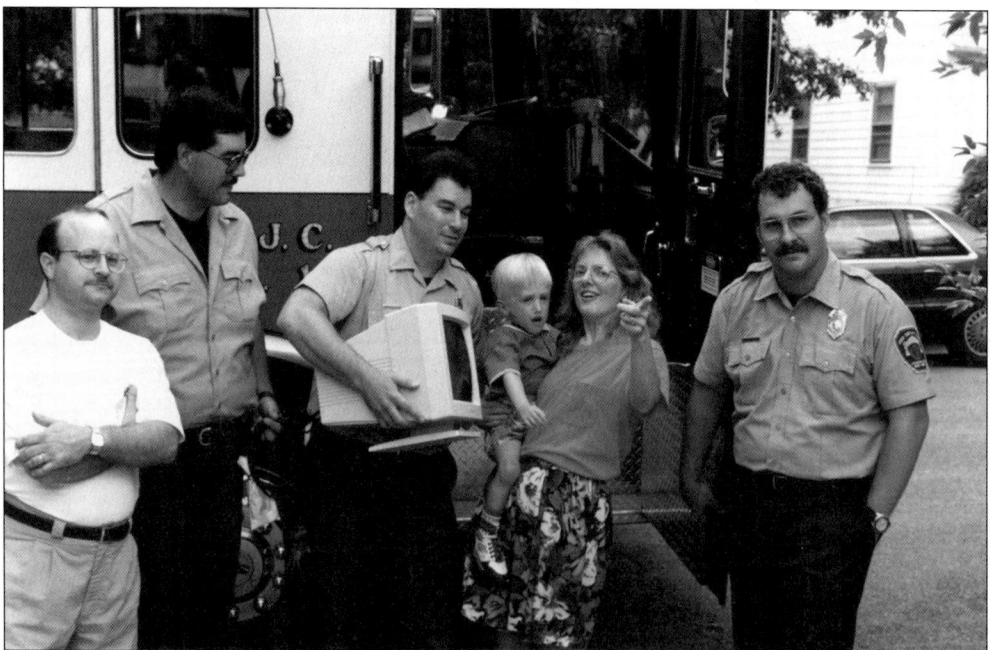

In 1993, the Make-A-Wish Foundation came calling for the assistance of the Johnson City Fire Department. Pictured here, from left to right, firefighters Peter Sobiech, Andrew Peters, and David Nugent, who helped fulfill the wish of Stephen Krome, are seen with his parents. Krome had his new computer delivered to him by a fire engine.

Firefighter John Thompson takes a breather after fighting a house fire. The airpack he was using was an early example of the breathing device known as a self-contained breathing apparatus, or SCBA. This airpack used a heavy aluminum bottle. Today airpacks have a fiberglass-wrapped bottle that is about half the size and weight of the old airpacks.

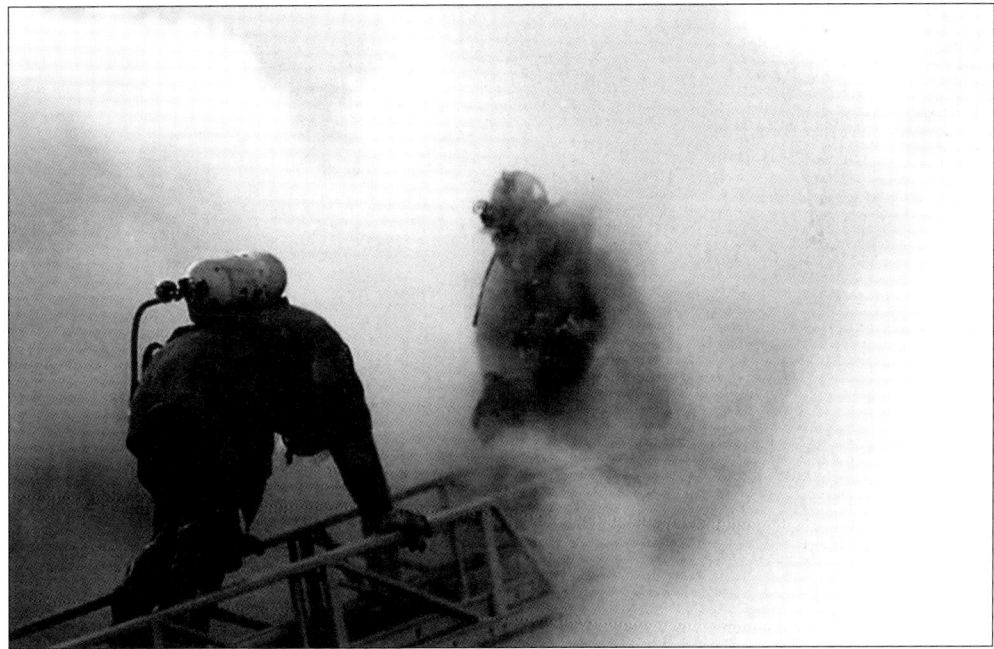

New recruit firefighter Robert Dempsey works his way down the ladder truck for a new air bottle at this Main Street fire in September 1986. An unidentified firefighter makes his way up the ladder to take Dempsey's place at the top. A firefighter's air bottle will only last about 10 to 12 minutes before it has to be changed.

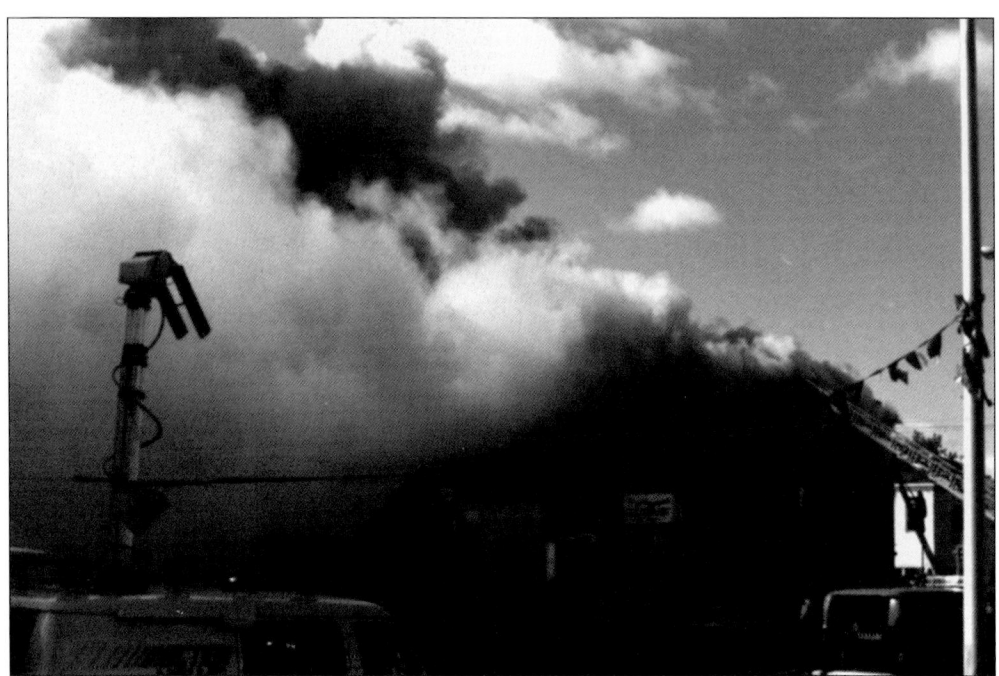

These photographs illustrate the heavy smoke conditions that affect the entire neighborhood during a big fire. This two-alarm fire occurred on Main Street in September 1986. A perimeter had to be set up to keep people out of the way. Neighbors to this building had to close their doors and windows because the smoke was so thick. The weather can also be a hindrance at a fire like this. If there was a strong wind and embers were rising up, they could help ignite other fires to surrounding houses. Once the thick, black smoke starts to change color to a more grayish-white, it means that water is finally dowsing the flames. The water converts to steam, resulting in the lighter color.

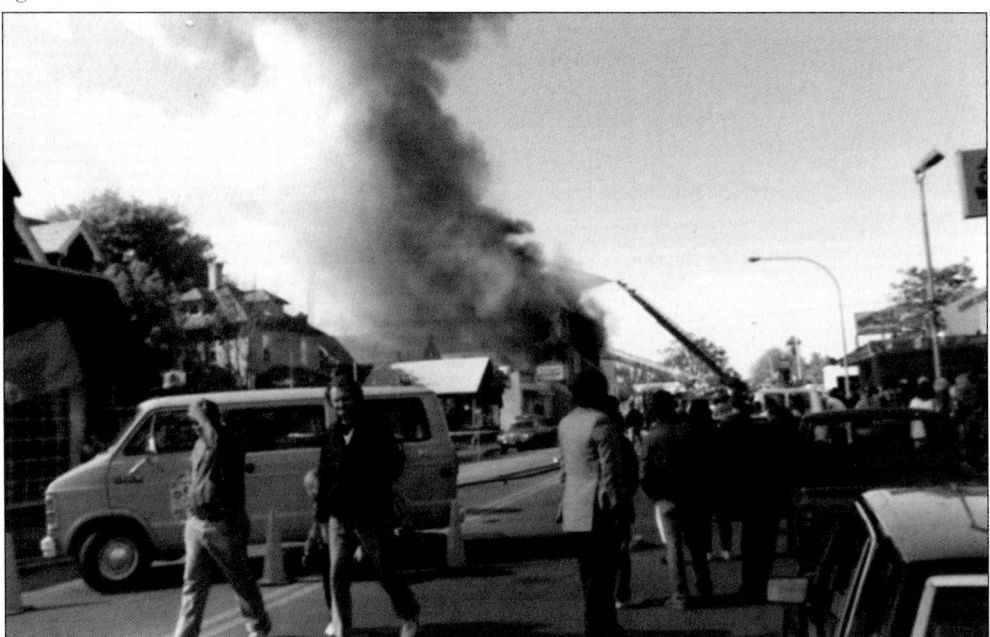

Firefighter Robert Dempsey shows the foamy remains of a fire at an electrical substation on Robinson Hill Road. Foam is used for battling electrical and fuel fires. It is mixed with water, by way of an inductor, to form a thick, foam blanket that smothers the fire. Once the fire loses its supply of oxygen, it will die out.

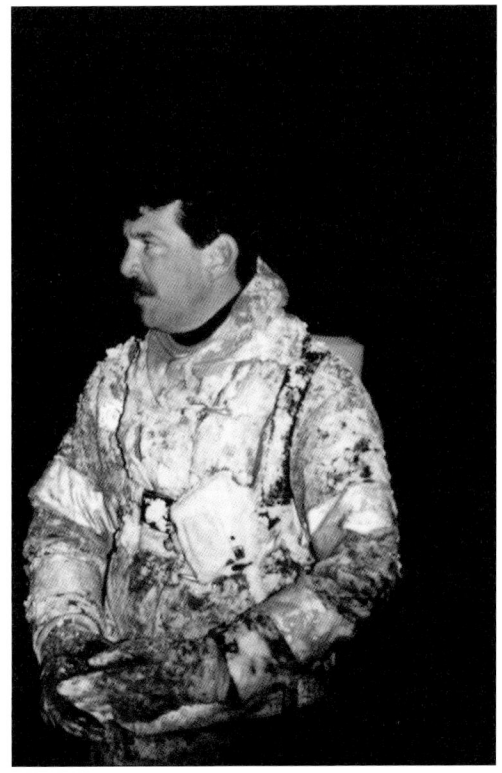

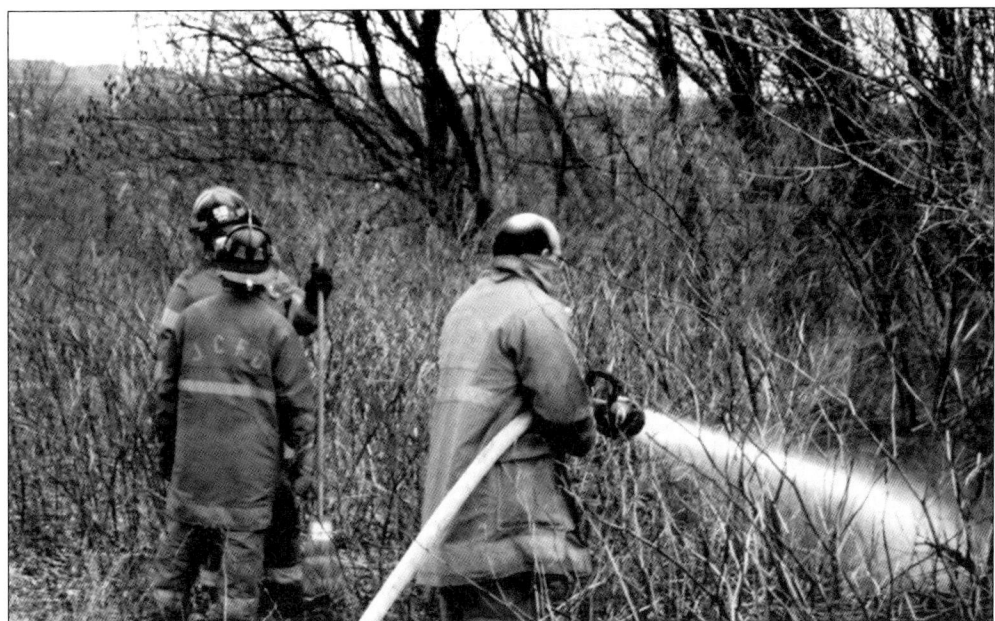

Firefighters David Smith (facing camera) and Brian Matuszak get to rake a brush fire as Capt. Henry Michalovic sprays down some hot spots. Grass and brush fires are common in the hot weather. Usually a careless smoker will discard a lit cigarette that ignites a dry area of grass or brush. Fortunately, Johnson City is a suburban area and the chance for fire spread from this is not high.

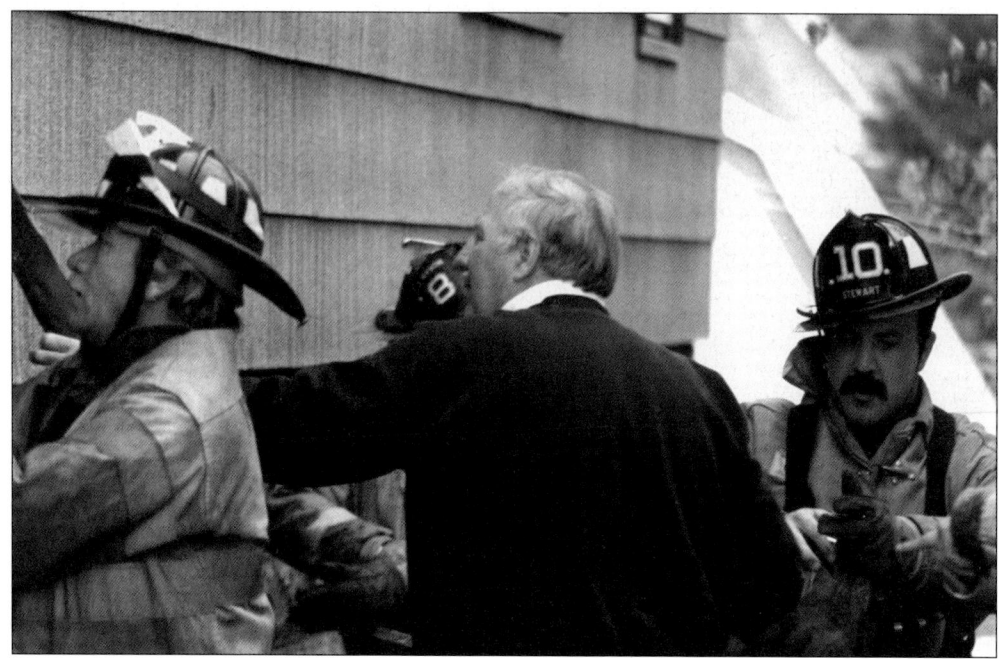

Capt. Mike Moran (dark sweater) leads members of his group during overhaul of a house fire. Lt. Scott Furman (left) and firefighters Tim Moran (No. 8) and Cliff Stewart (No. 10) listen to the advice of their captain as they search for hidden fire behind the siding and window frames of this house fire in 1985.

Firefighters Marty Meaney (left) and Tom Novobilski carry out the Hurst tool used for cutting apart cars and extricating victims in accidents. This demonstration was at Northside Park, also known as Greensfield, to teach high school students the perils of drinking and driving. A hearse was also used in the activity given during graduation week.

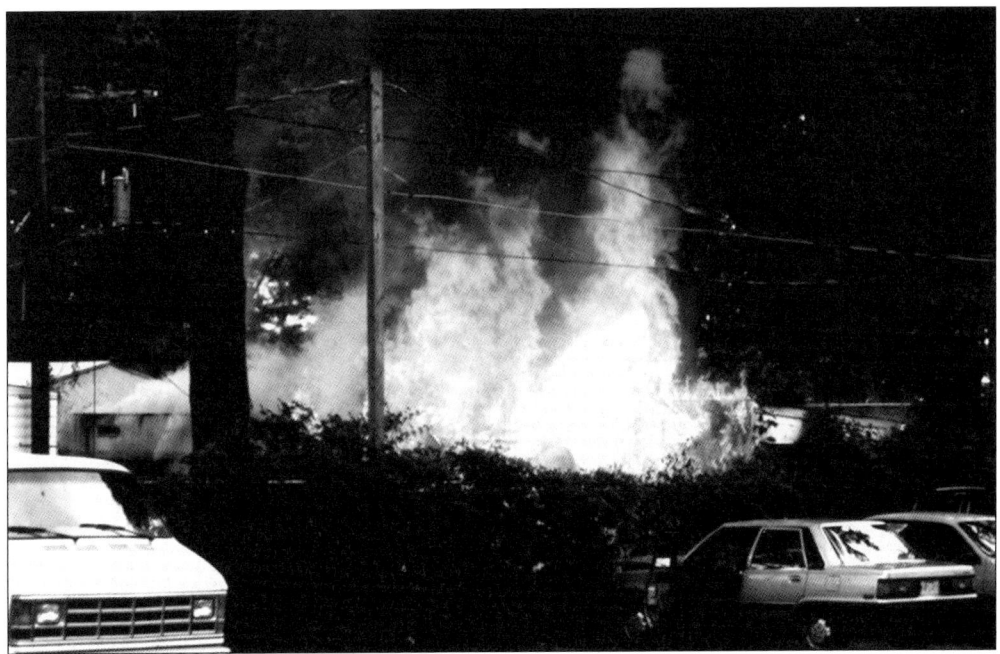
This fire involved a trailer in the mobile home park on Oakdale Road. Trailers are known to burn very quickly and are usually total loses in a fire. Most trailers did not use fire retardant material and also have propane tanks attached to them for their heating fuel. Once the tank ignites, there is really no way to save the structure.

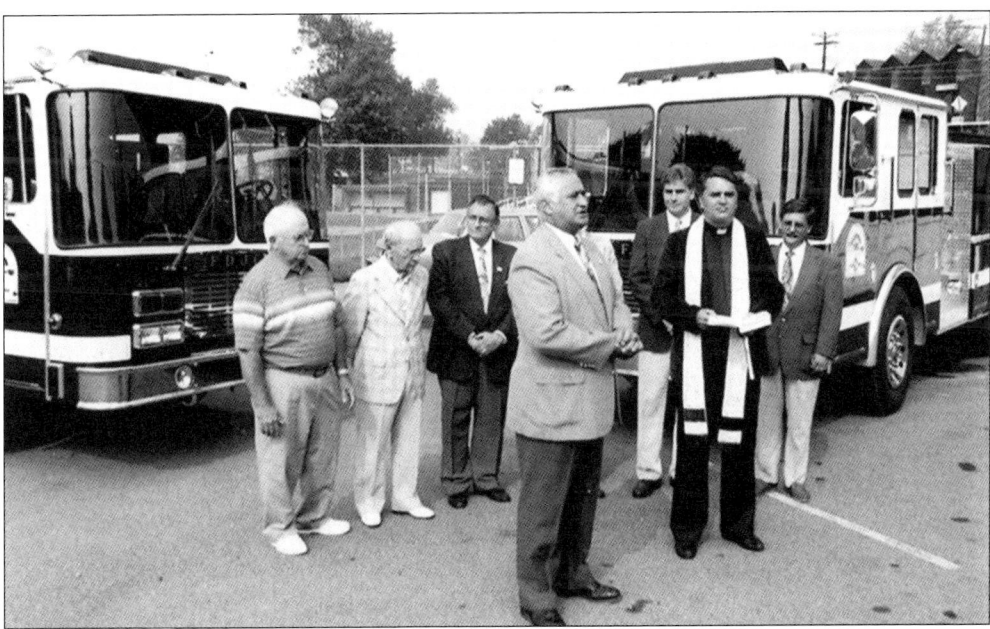
In 1992, Johnson City was gearing up for its centennial. The village purchased two new engines for the fire department. Shown here during the dedication ceremony are, from left to right, retired fire chiefs George Major and William Grace, assemblyman Richard H. Miller, Mayor Harry Lewis, trustee Richard H. Miller II, Fire Chaplain Fr. Dennis Ruda, and Fire Chief George Maney.

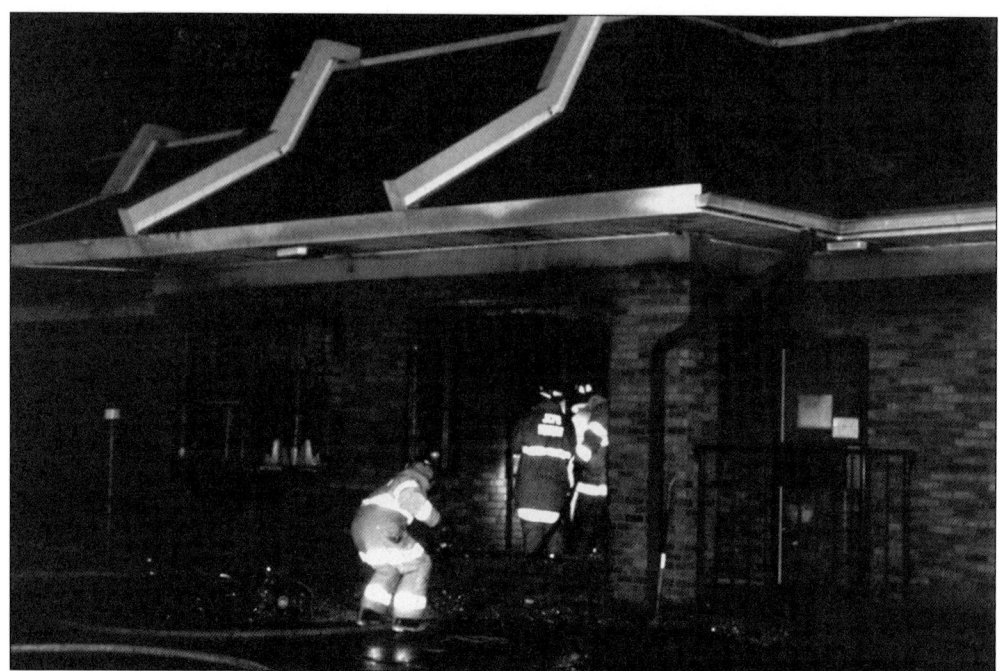

In 1993, this fire broke out at the McDonald's fast-food restaurant located at the corner of Harry L Drive and State Route 201. The fire started in a roof-mounted ducting system and quickly spread through the entire roof area. Above, firefighters are seen entering the front door. Below, firefighters located in the bucket of the ladder truck use the aerial nozzle to extinguish and control the blaze. The water curtain below the bucket is used to protect the aerial crew from the flames and heat. Once the fire was brought under control, the restaurant remained closed for several months. It was renovated and continues its operation today.

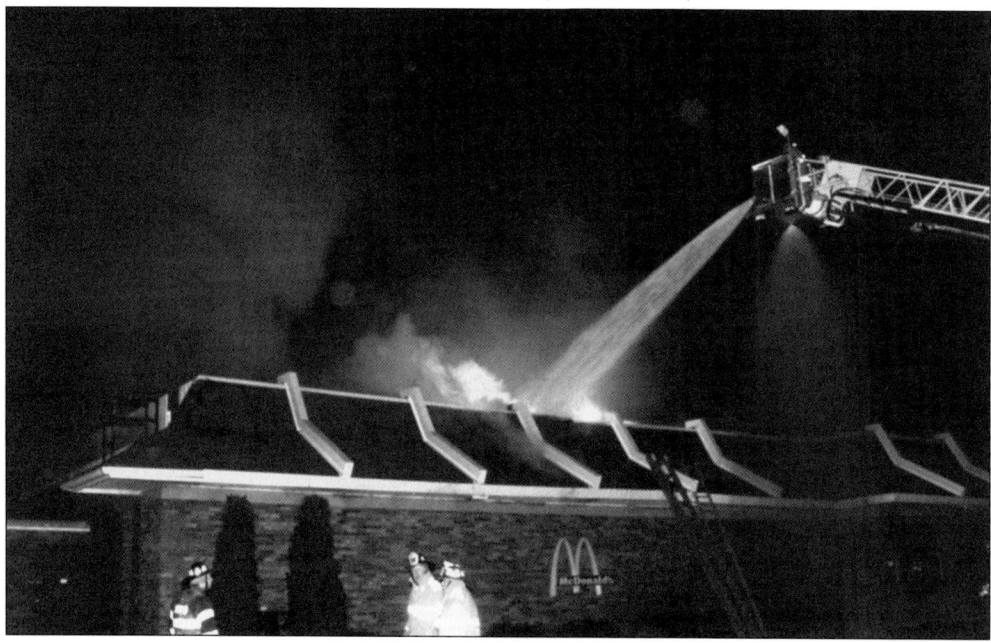

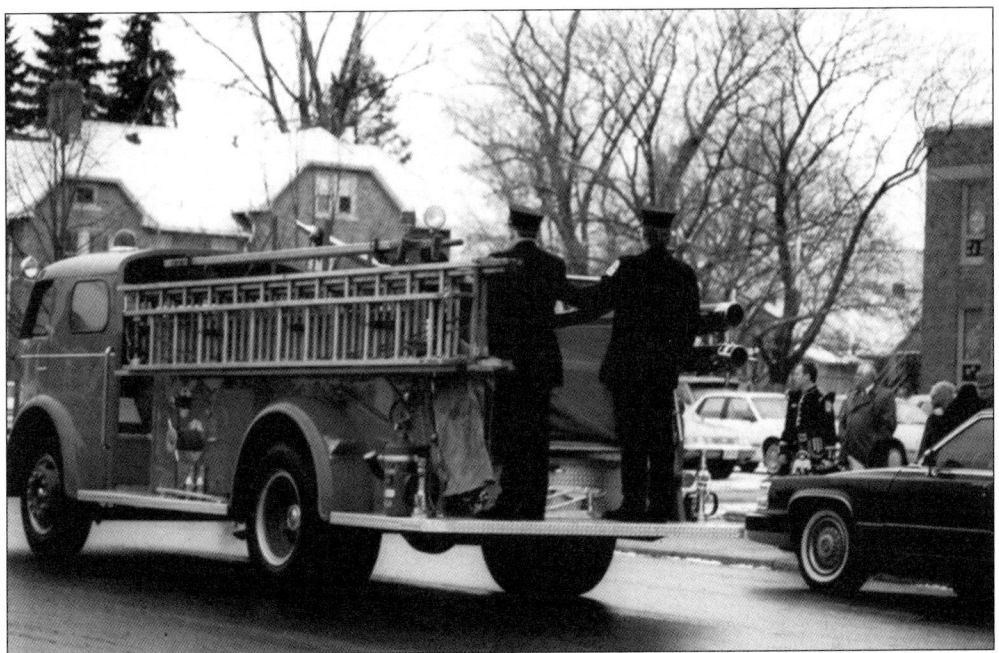

Firefighters Roger Boyer (left) and Tom Novobilski stand guard on the tail deck of engine No. 4 as they honor former fire chief William Grace at his funeral. Since he was a retired chief, his casket was transported on the back of the engine to St. James Church. At the time of his death, his 44 years of service was the longest of any Johnson City fire personnel.

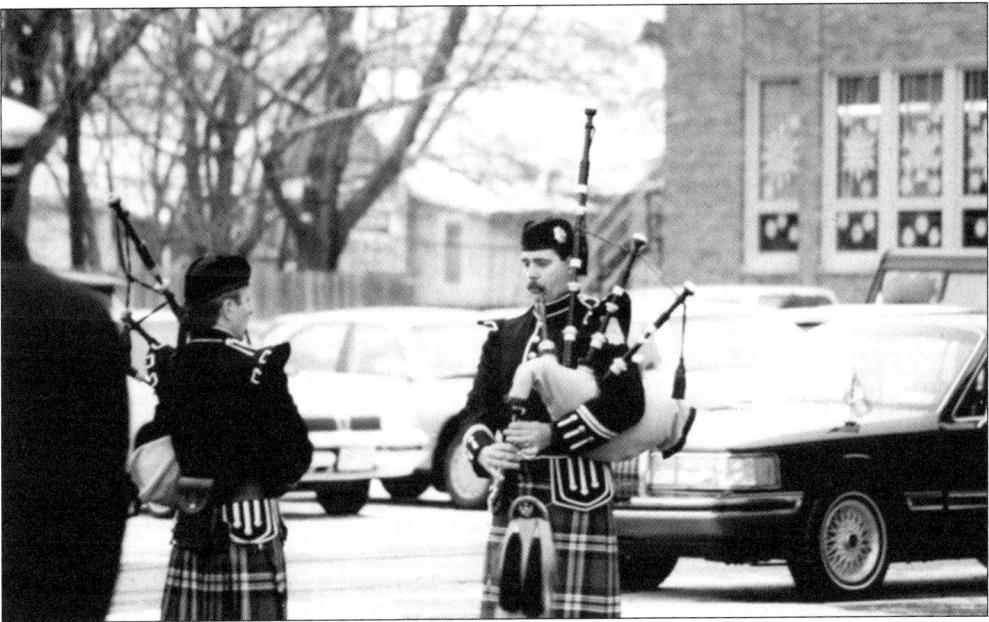

Bagpipers are a common site at fire department funerals. Seen here is firefighter Rich Maloney of the Binghamton Fire Department (left) and firefighter Ken Roe (right) of the Johnson City Fire department playing "Amazing Grace" at Chief William Grace's funeral. Larger departments such as New York City and Philadelphia have their own pipe and drum corps to perform at their funerals.

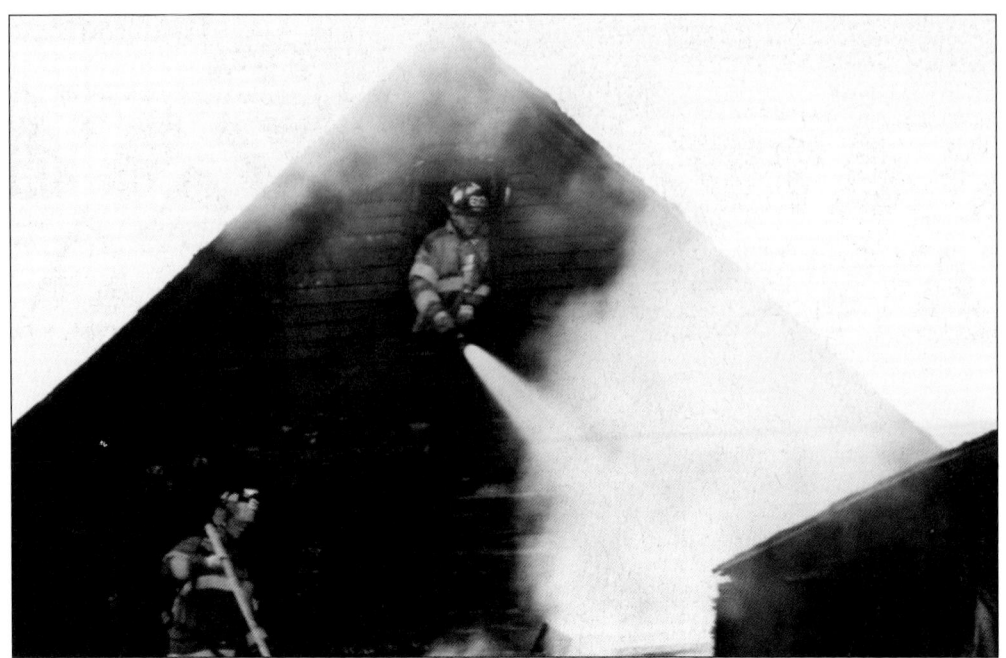

This fire on the corner of Grand Avenue and Farr Avenue was quickly extinguished when crews arrived. Firefighters Greg MacBlane (left) and Billy Giblin (right) continue with overhaul as they search for hot spots and hidden fire under roof shingles. Fire caused extensive damage to the rear of this building.

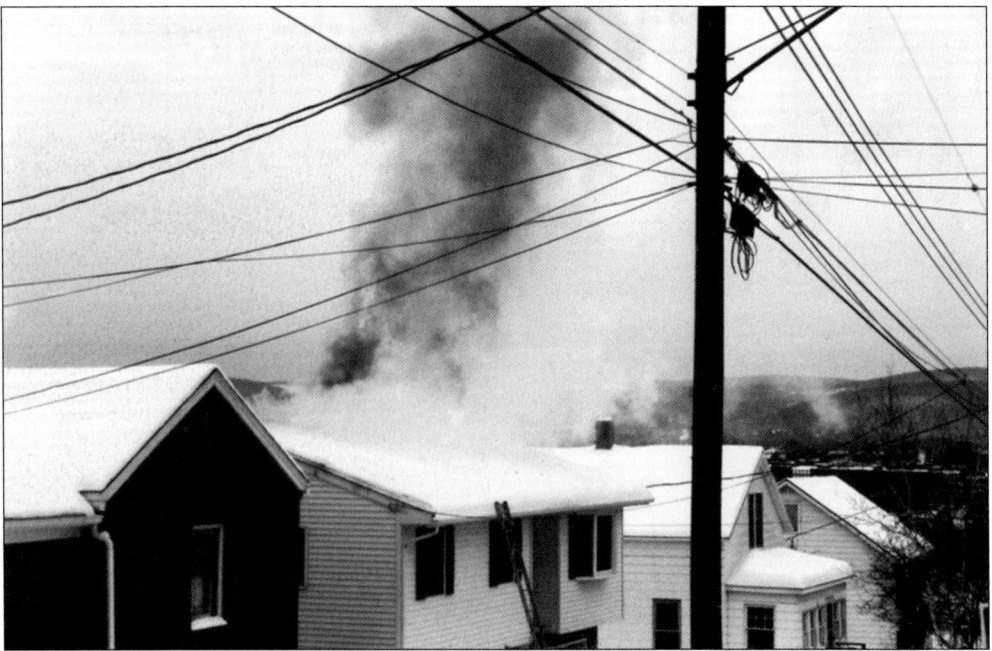

When flames broke through this roof at 120 Pearl Avenue on January 7, 1996, the owners were inside having breakfast in their kitchen. Neighbors alerted them to the fire, and they were able to escape unharmed. This was also the first working structure fire for coauthor Mike McCann. The fire started by faulty heating panels in the attic floor.

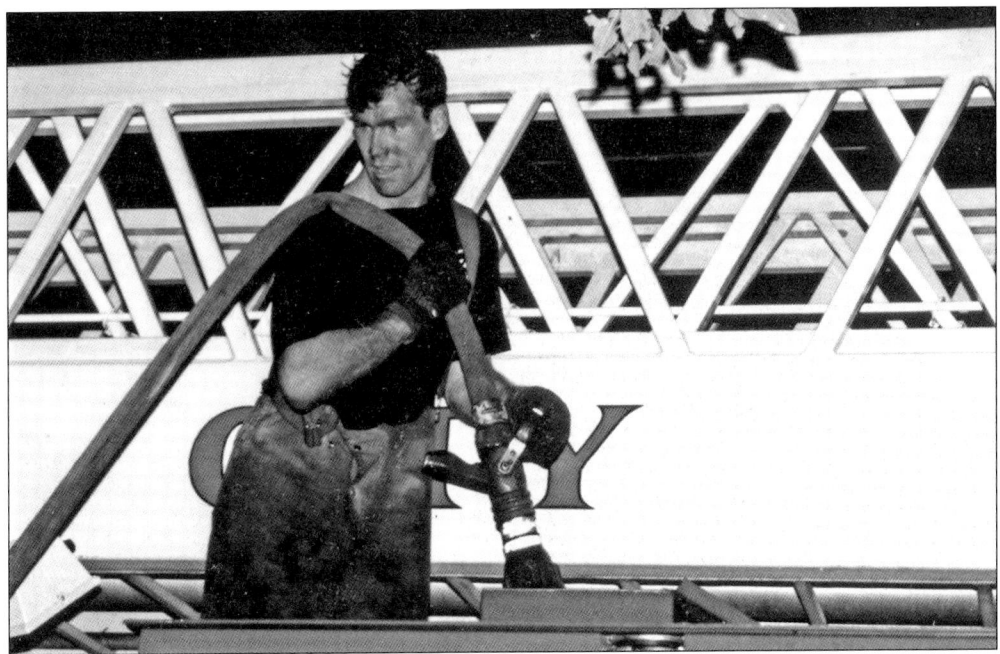

Firefighter Sean Curley shows the signs of a hard-fought fire. Soot and sweat cover his body as he begins the clean-up process. Once the fire is out, firefighters still have to pick up all of their equipment, reload their engines, and be ready to respond to the next emergency when the alarm sounds.

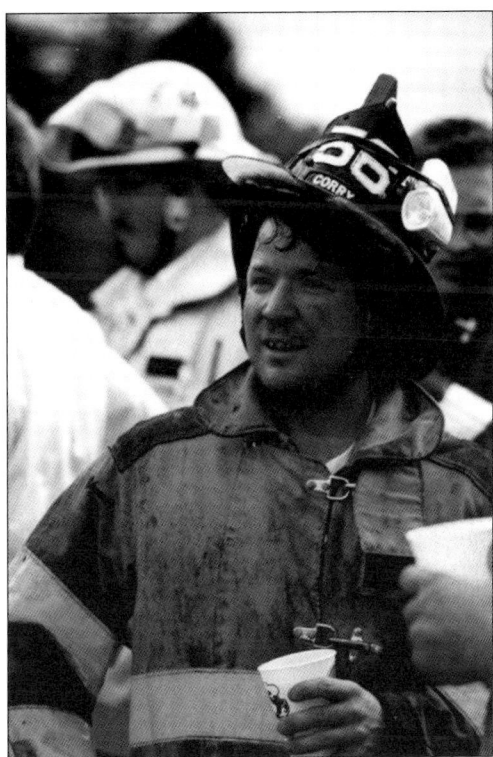

After the fire is knocked down, the first due engine crew finally get a chance to have a breather. Firefighter P. J. Corry shows the results of a hard day of work. Here Corry tries to quench his thirst with a glass of juice. It is important to get a break when one can since one never knows when the next alarm will sound.

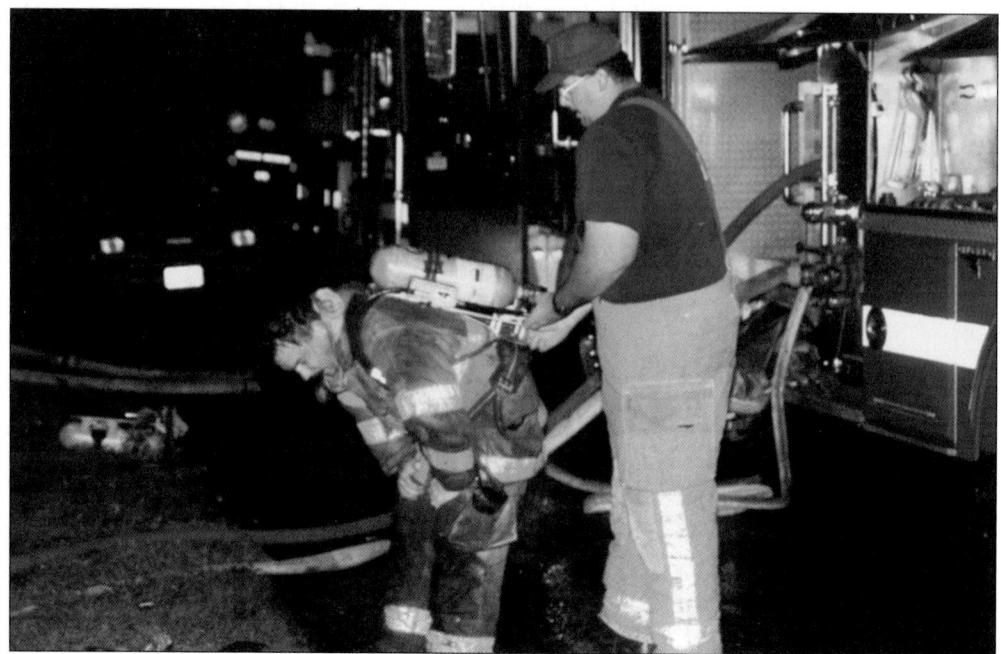

Teamwork is a must at all fires. Firefighter Patrick "Paddy" Cheevers receives a fresh bottle of air from firefighter Peter Sobiech. Sobiech, who was the driver and pump operator at this fire, understands that pumping is not the only job at the fire scene. The pump operator must be ready to supply the crew with tools and fresh air bottles at any time.

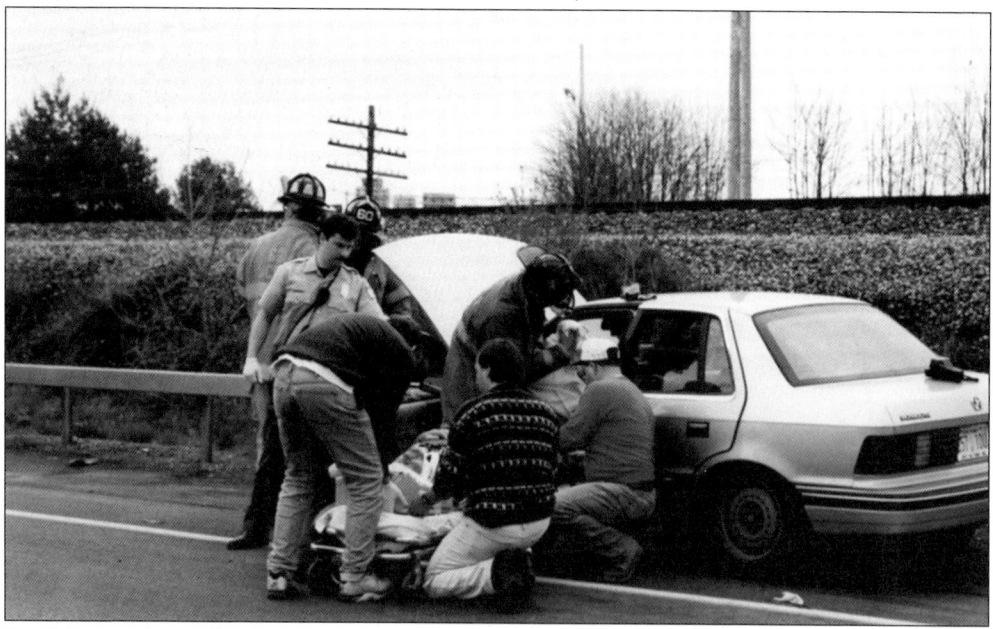

Firefighters John Fuller (No. 63) and Billy Giblin (No. 60) attend to the engine compartment of this car accident. The battery is being disconnected so that there will be no electrical arcing. Firefighters Pat Cheevers and Bob Matuszak work alongside members of the Union Volunteer Emergency Squad while the victim is extricated from the vehicle and transported to the hospital.

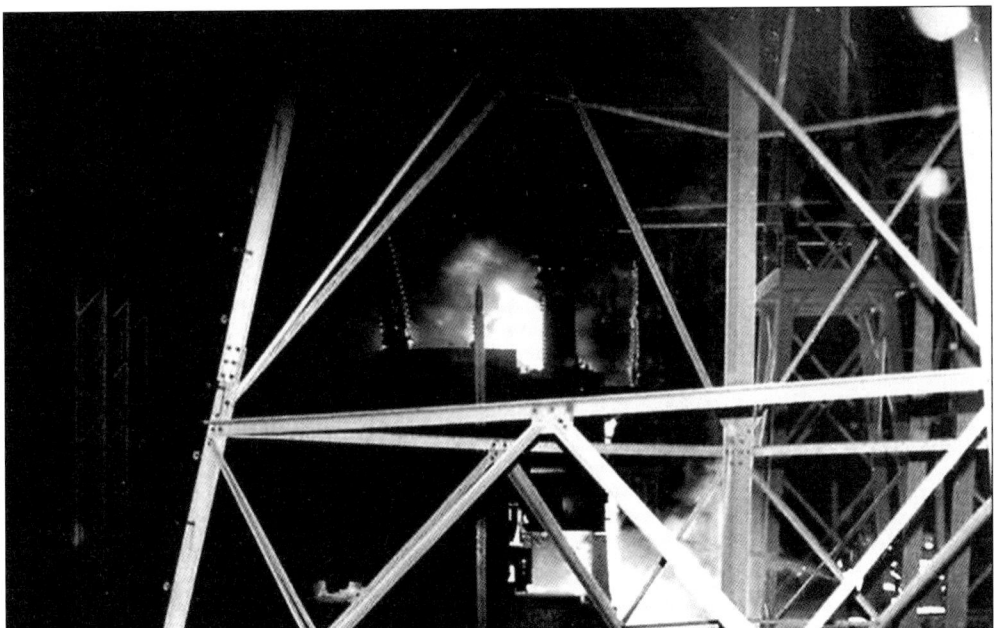

In this photograph, firefighters are battling a transformer fire at a New York State Electric and Gas substation on the border of the village. Obviously, fire is not the only life-threatening hazard at the scene. Foam was used to extinguish this blaze because the use of water would have transported an electrical charge back at the firefighters. This would have caused electrocution.

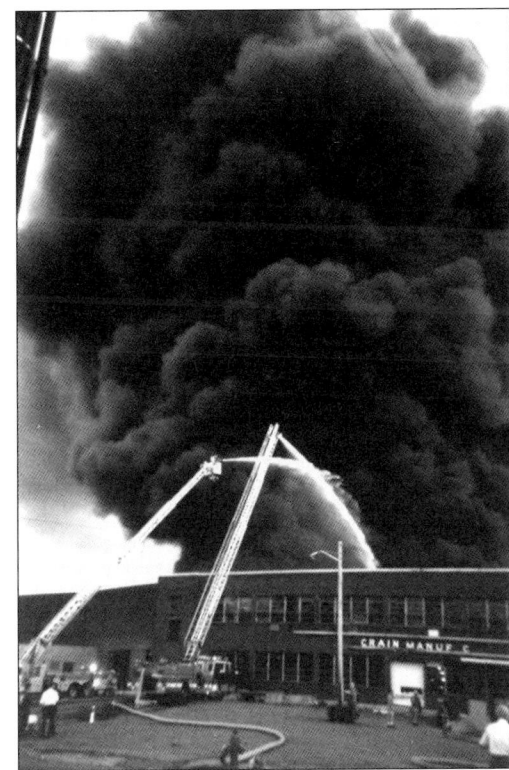

This fire was actually on Clinton Street in Binghamton. The Crain Manufacturing building was destroyed when fire broke out in the warehouse. Johnson City firefighters responded with their ladder truck for mutual aid. The fire was so large that small fires broke out all over the city from embers floating into the air and landing on houses and bushes.

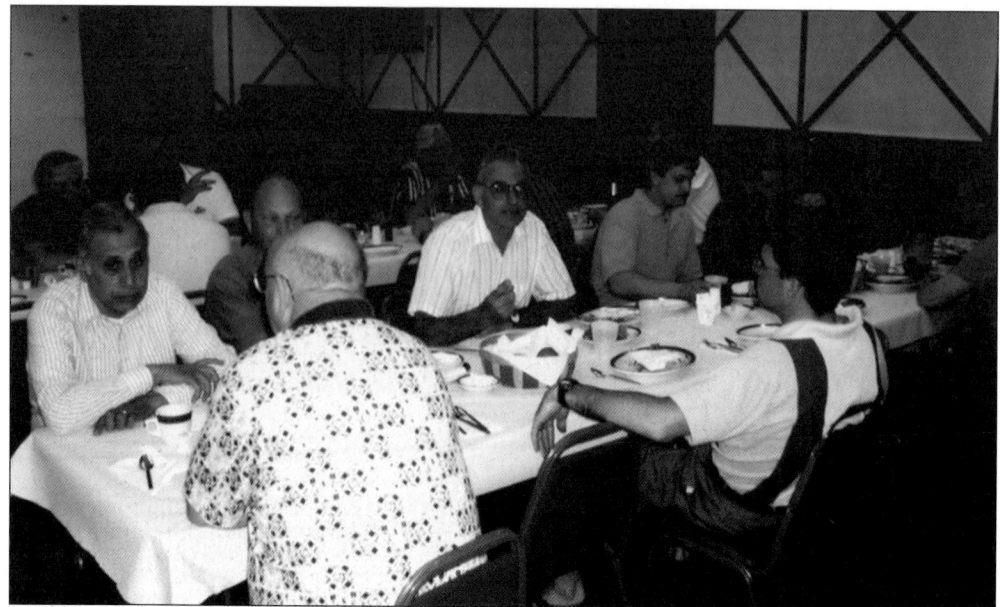

When the work is done, it is always nice to sit back and enjoy time off. The current and retired Johnson City firefighters are relaxing inside Red's Kettle Inn at their annual Spring Fling in May 2001. Above, from left to right, are (facing the camera) Frank Carro (retired), Darryl Krewson (retired), Capt. Markus Smith, firefighter Jim Furman, and Lt. Marty Meaney; (with backs to the camera) Paul Cooper (retired), firefighter Markus Smith, and firefighter John Kozel. Below, from left to right, are (facing the camera) Frank Dohnalek (retired), Don Koval (retired), Capt. Ken Roe, Ray Caprari (retired), and Emerson "Monk" Chandler (retired); (with their backs to the camera) firefighter David Zeitz, inspector Tom Novobilski, and Bill Giblin (retired). The Spring Fling has been a tradition in Johnson City for the retirees to get together with the current personnel and share some food, stories, and laughs.

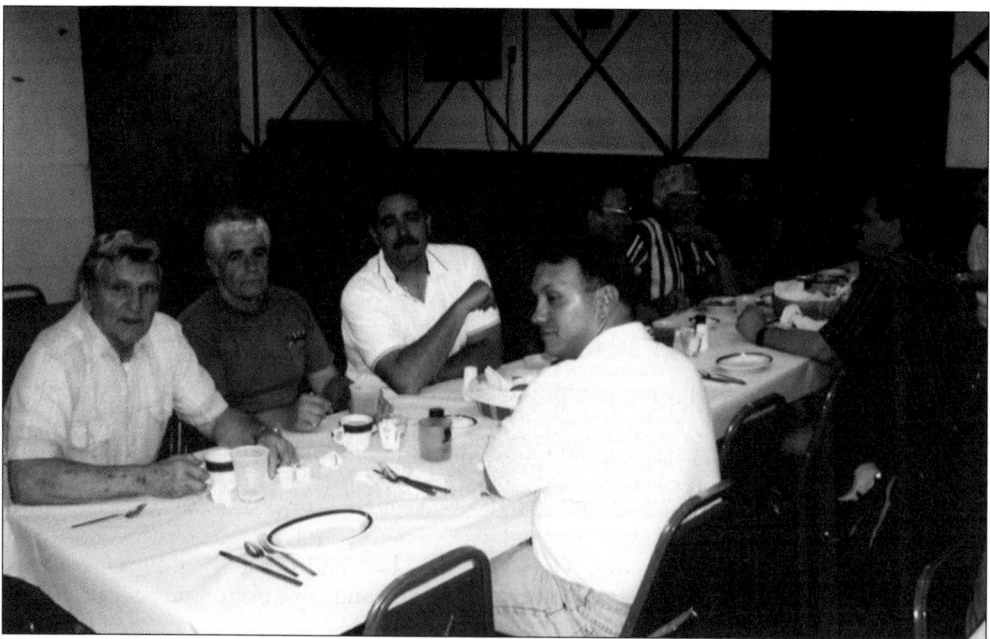

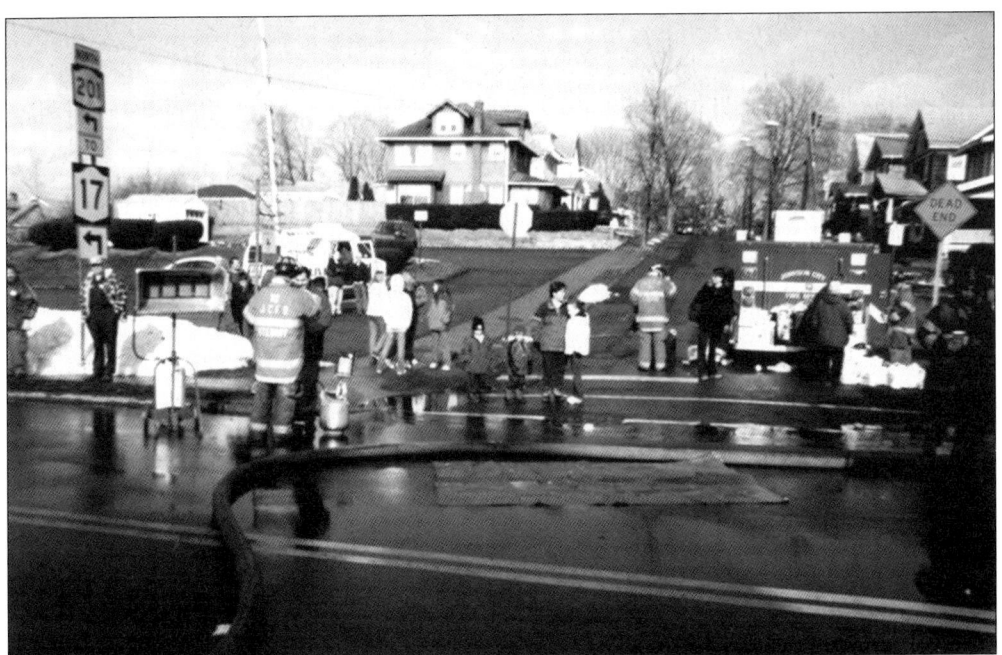

Firefighter Cliff Stewart takes a few minutes to rehab at the scene of a large apartment fire on Main Street in 2002. This fire was so immense that the smoke traveled over one mile across town and filled the halls of the Harry L. Johnson Elementary School with smoke. This caused school to be cancelled for the day in Johnson City.

Lt. Rob Jacyna is trying to resurrect the Freddy the Firetruck robot. This robot is housed in a trailer and it may have gotten wet. The wiring was bad, and it did not work for a while. Lieutenant Jacyna took some time to work on the wiring and controls in order to get Freddy running again.

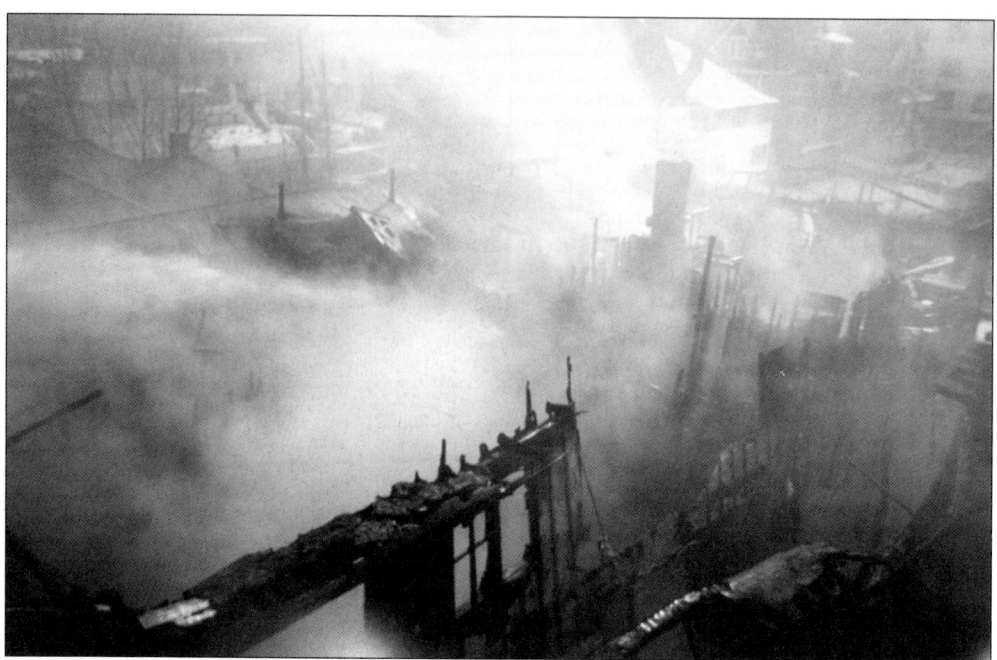

In January 2002, the Johnson City Fire Department fought one of its worst fires in history. It took about two days to completely extinguish and overhaul this arson fire at the Boland Blocks located on the corner of Main Street and Baker Street. The apartment buildings were extremely close to each other. This made it very difficult for firefighters to contain the blaze. These aerial photographs were taken from a nearby building once the fire was knocked down. Two men stood trial for this fire, and each received state prison sentences for their parts in the arson. All three buildings, which house 12 apartments each, were eventually razed. By mid-day, news of this fire had stretched as far as Scotland.

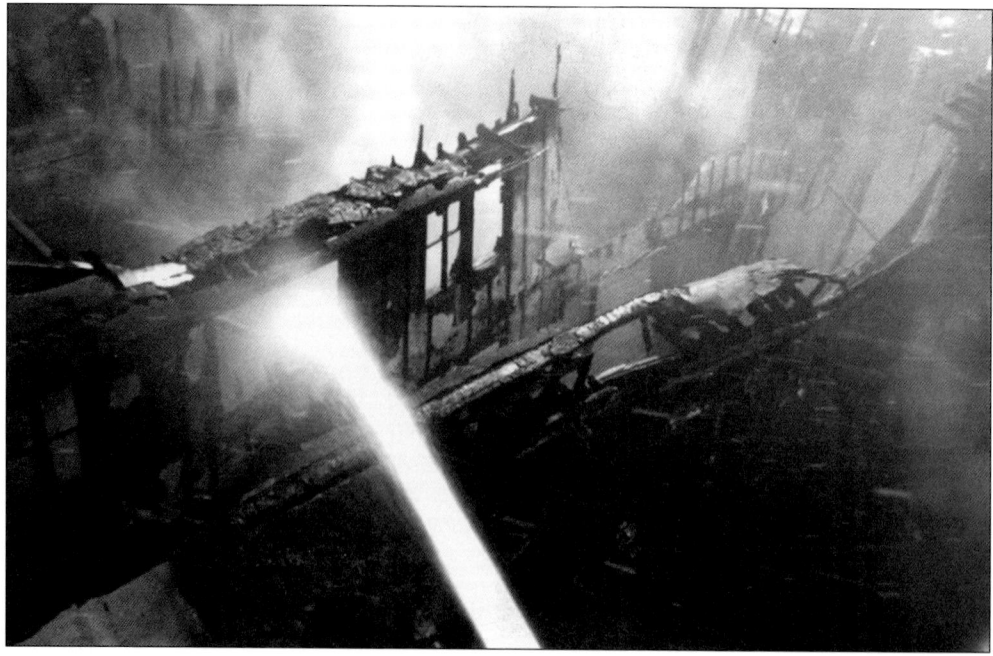

Over Fourth of July weekend 1999, an alarm was received of a house fire on Cherry Street. Fire crews arrived within two minutes of the call to find this vacant building well involved in fire. Duty Chief Robert G. Blakeslee immediately called for assistance from the City of Binghamton Fire Department, and for off-duty Johnson City Fire Department personnel to respond for assistance. Due to the holiday weekend, with many people being out of town, it took some time for off-duty Johnson City firefighters to arrive. The weather on that day was extremely hot, into the 90s, with very high humidity, both taking their toll on the firefighters involved in the suppression operation. The main part of the fire was toward the rear, it then spread into the attic area as seen above. The photograph below shows the close proximity of one of the neighboring buildings. Homes on both sides of this building received little to no fire or heat damage, due to the quick response and control of this extensive fire by the 24-7 fire crews, a major reason for maintaining a paid professional fire department.

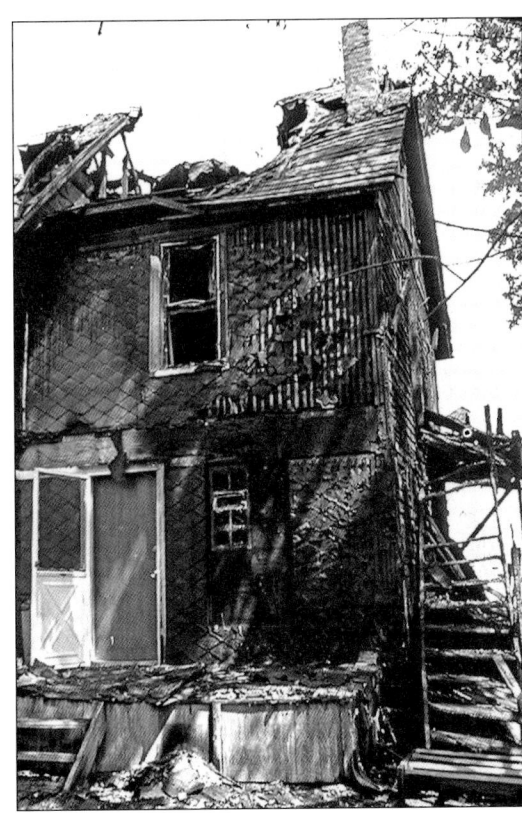

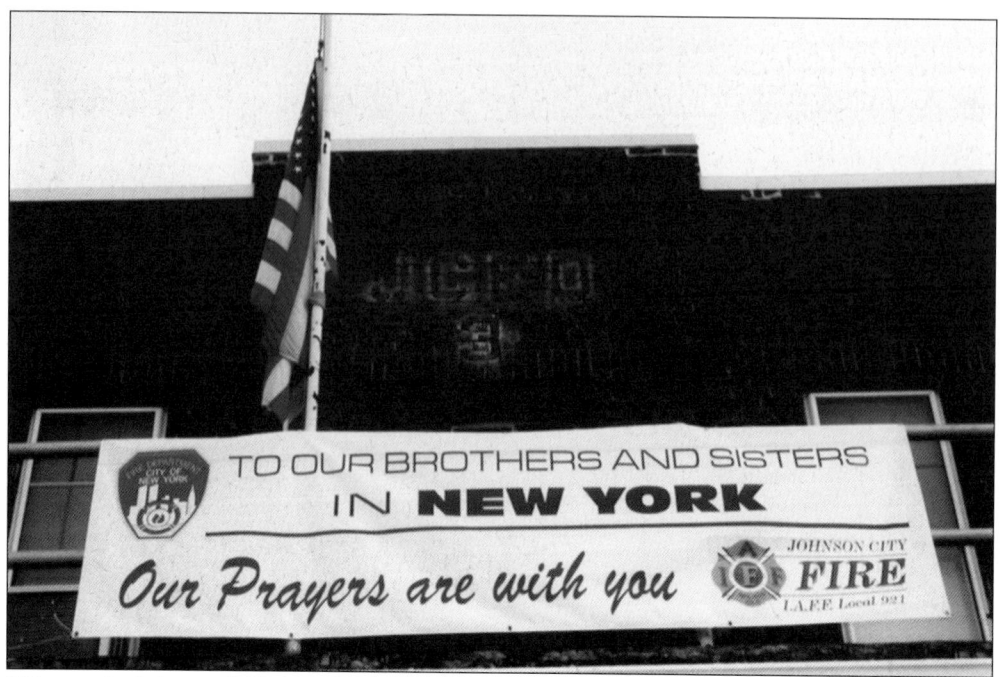

When a firefighter is killed in the line of duty or a national figure (for example, an American president) passes away, fire departments will honor them by hanging the American flag at half staff. When the world changed forever on September 11, 2001, the Johnson City Fire Department decided, because of its close proximity to New York City, to honor them in a more fitting manner. Union members had banners made up for each station, as seen above. Also, they began to focus their efforts on raising money for the Widows and Children Fund for their fallen brothers. Below is a small group of items from a charity auction held to benefit the families of the New York City firefighters who lost their lives in the World Trade Center tragedy.

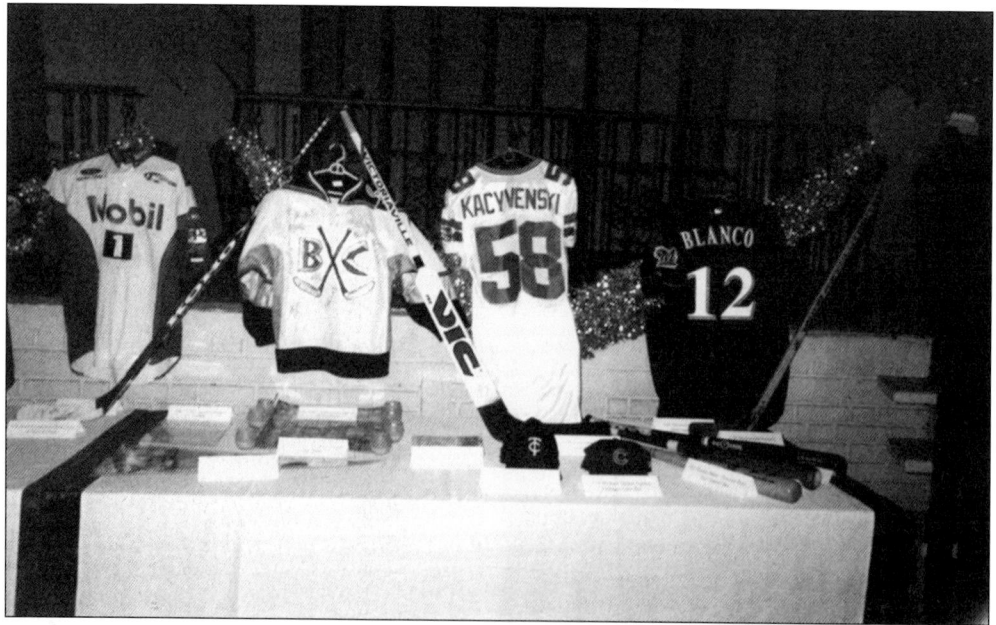

This group of firefighters is enjoying themselves at a retirement party. Pictured, from left to right, are George Blabac, Carl Thrasher, Steve Drahos (standing), Tom Novobilski Sr., Dick Boyea, and Paul Cooper. In the back on the right is Fire Chief William Grace. They were enjoying themselves at Les Gentner's retirement party, celebrated at American Legion Post 758 on Main Street.

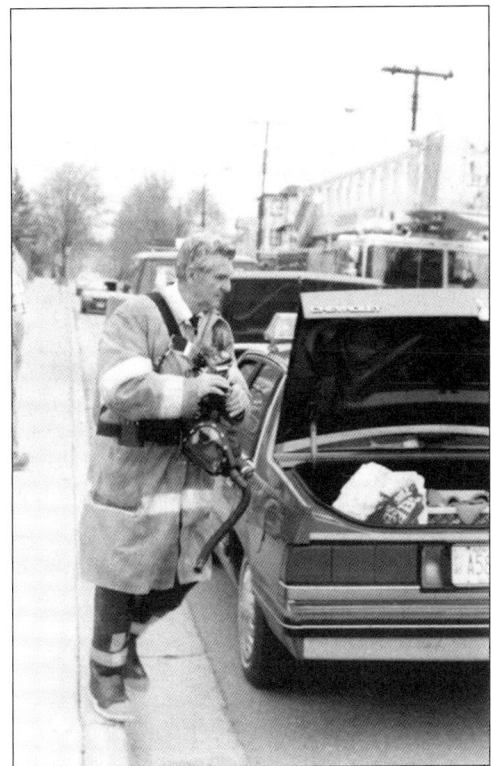

Assistant Fire Chief Frank Dohnalek gets his airpack ready for a fire. The chief officers respond to fires in separate vehicles. They have cars assigned to them because they are on a rotation as the duty chief. The duty chief covers throughout the night and only responds to fire emergencies. Although he is retired now, Assistant Chief Dohnalek keeps close ties with the department with weekly visits.

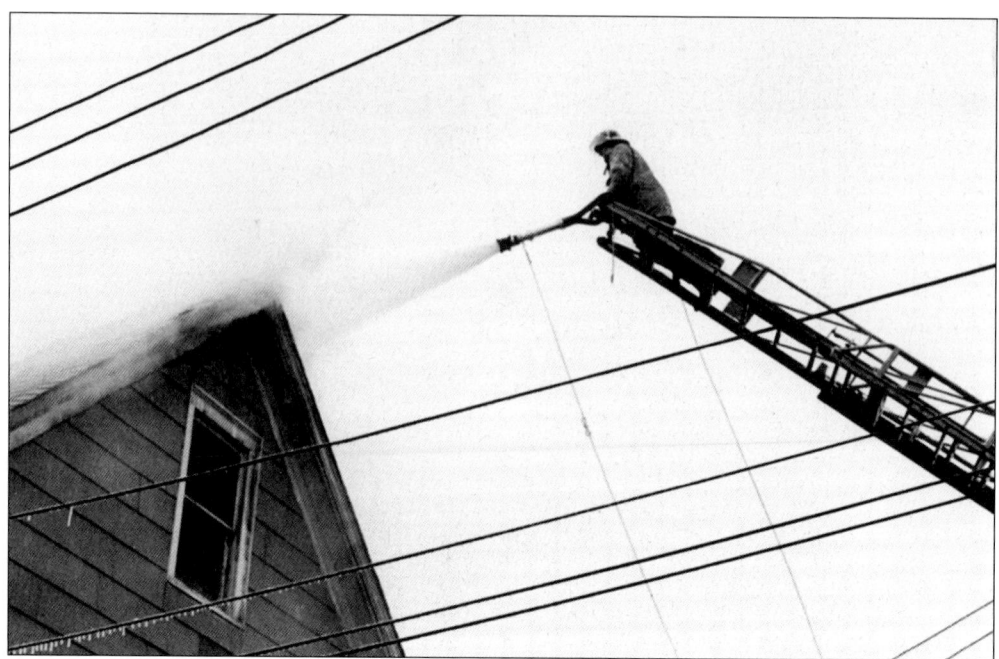
An unidentified Johnson City firefighter is perched atop the ladder truck operating the nozzle while trying to extinguish this fire. The ladder truck is an excellent piece of equipment, but it is not always able to be used. The electrical wires at this structure are out of the way, but that is not always the case. The pump operator should be aware of all hazards before setting up the ladder.

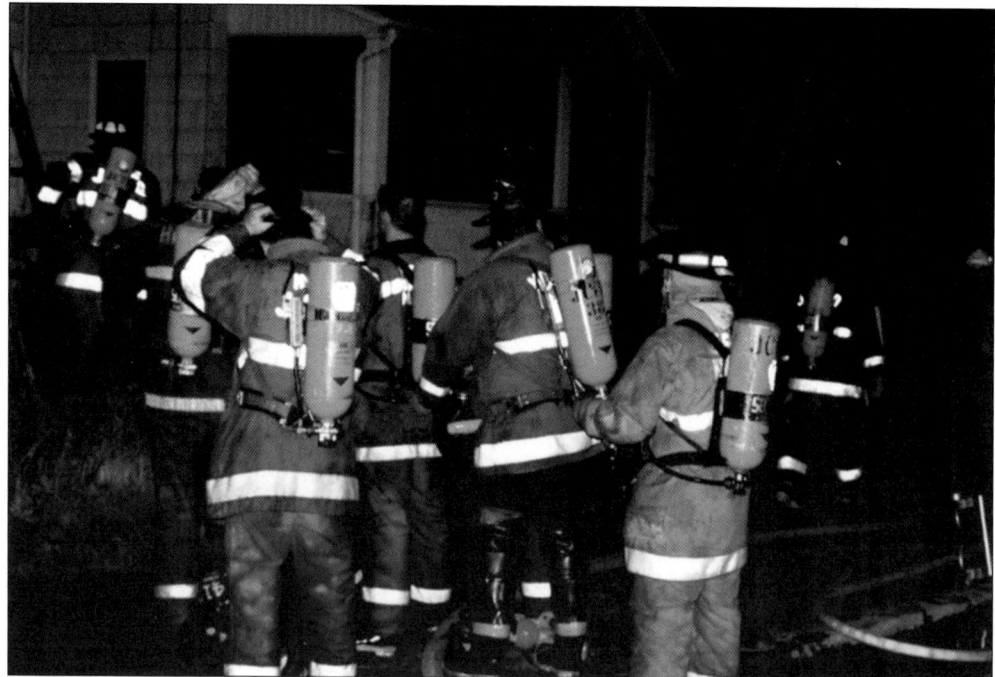
A group of Johnson City firefighters get packed up and ready to go into this house fire. A ladder is already in place for someone to go up to the roof and ventilate the smoke. If one looks closely, a small area of fire can be seen through the front door, inside the screened in porch.

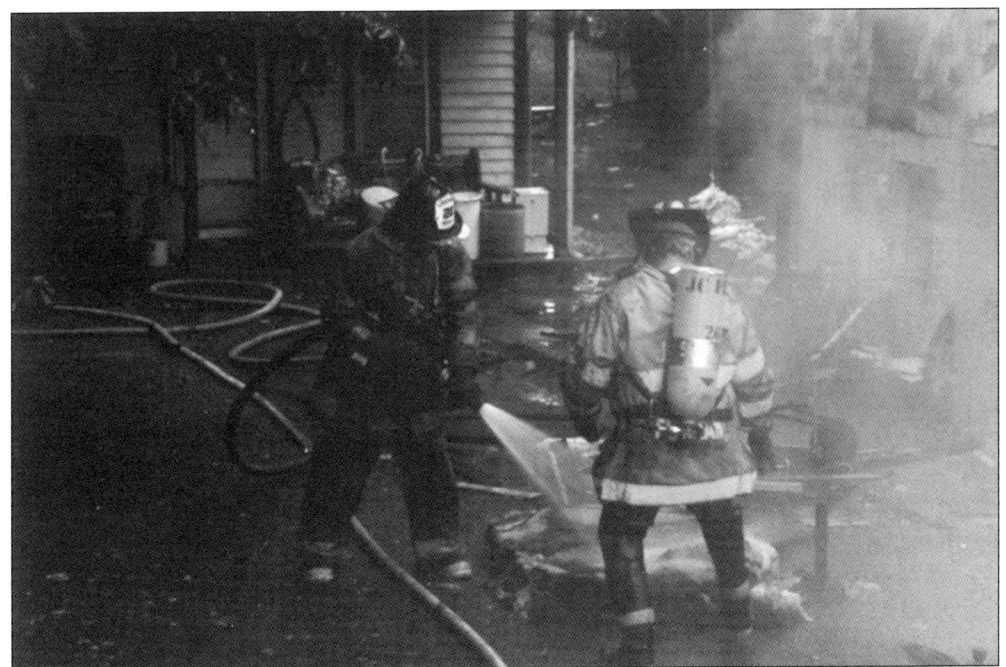

Lt. Scott Furman (back to camera) flips a mattress over while Lt. Andy Peters hoses it down. Most of the furniture from this house needed to be dragged out and hosed down to make sure the fire was out. Overhauling, like this, ensures that the fire will not start up again.

It seems odd that firefighters have to respond to chimney fires, but this is exactly what happened here. A fire started in the chimney of 18 North Street on March 8, 1993. Firefighters will toss down a small bag of dry chemicals to smother a chimney fire. Occasionally they will drop weights down to break up any debris stuck in the chimney.

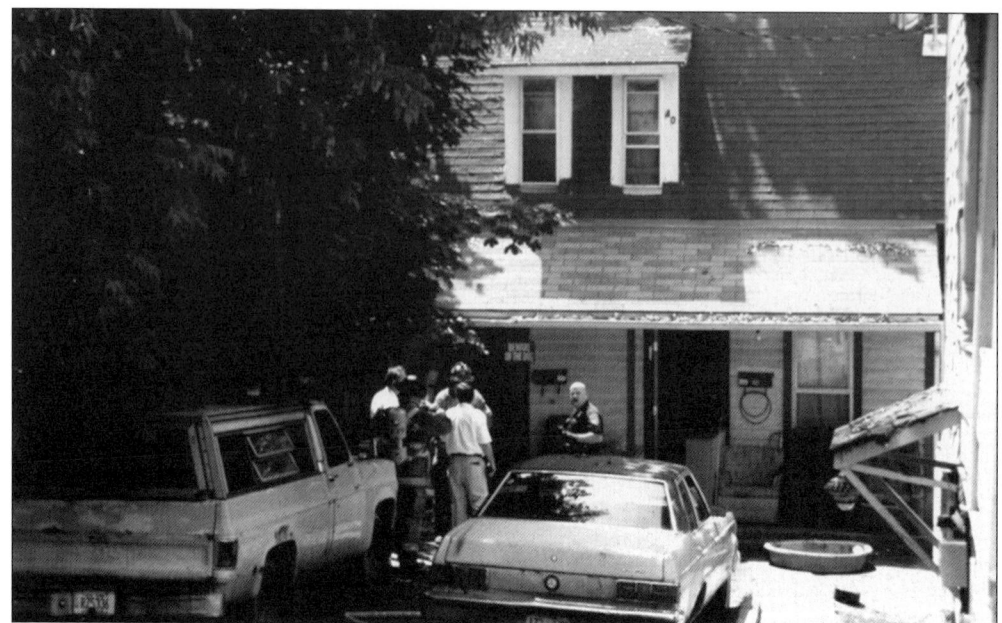

Unidentified firefighters check in with Capt. Markus Smith (far left) and Fire Chief George Maney (center, white shirt) as they investigate this house fire. Johnson City patrolman Gregg Thomas looks on in assisting the investigation. The police department responds to all fires to provide any assistance needed.

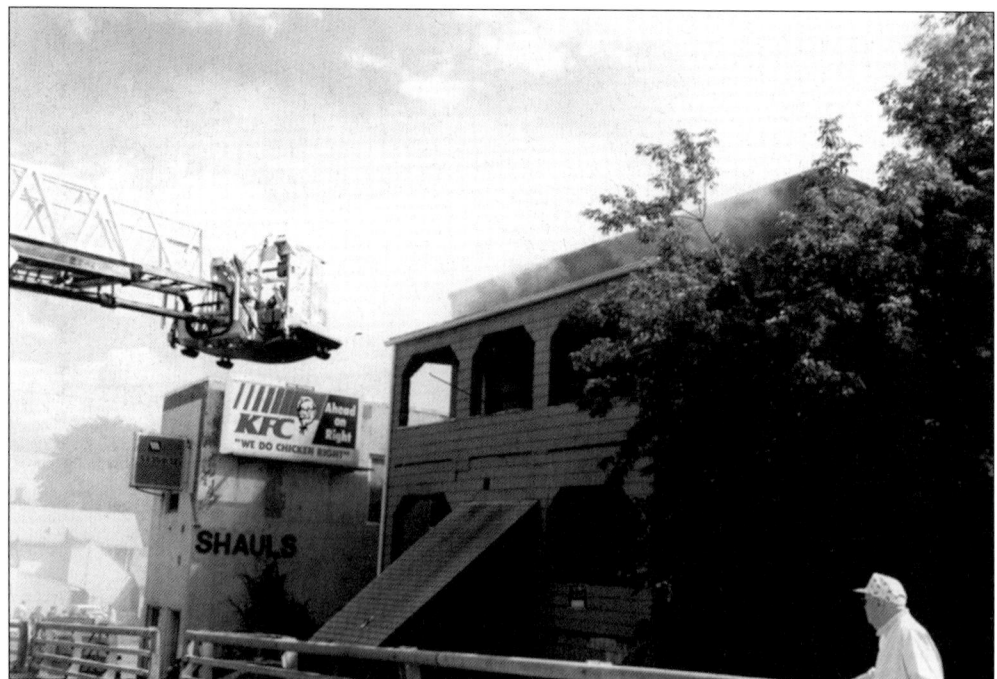

It was a good thing that Johnson City had a long tower ladder. This apartment was very difficult to reach because of the dead-end street. The fire department was able to extend the ladder from the truck over the bridge rail and reach the top floor where the fire was located.

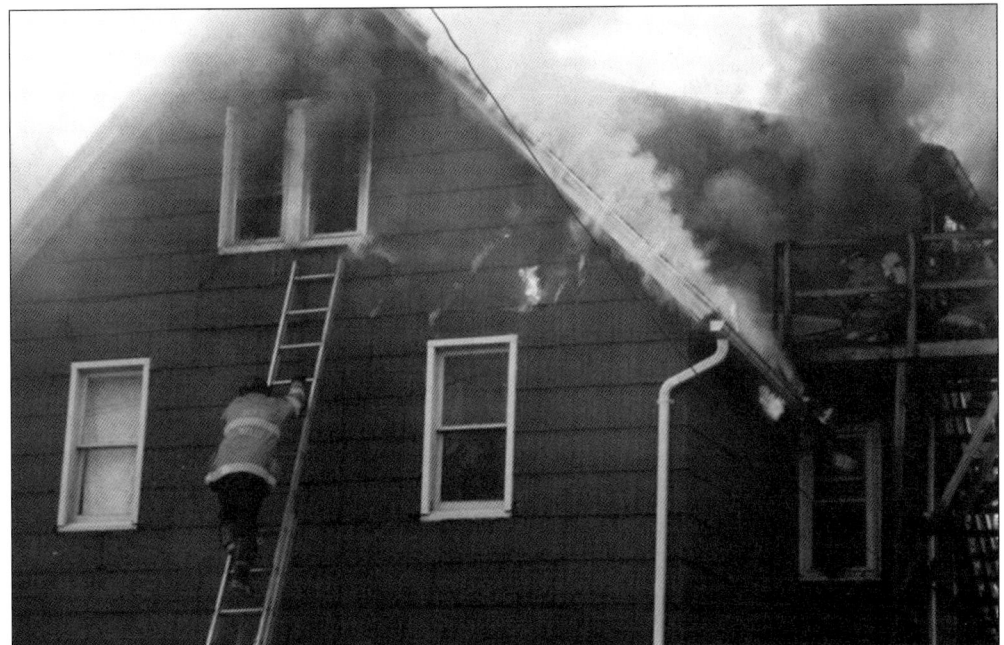

Firefighter Daniel Kelly climbs back down a ladder after he realized the window he had hoped to use to gain entry was being overtaken by the fire. One can see where the fire is breaking through the exterior walls in the room where the fire began. At the right, firefighters begin to push the fire out of the windows that firefighter Kelly just vented.

Firefighter Peter Sobiech calls for additional equipment on the top of the Little European Restaurant. The restaurant was located on Main Street right next to where Johnson City had another large apartment fire back in September 1986. The fire was caused by a buildup of grease in the ventilation system. The fire raced through the ducts and extended into the building, causing tremendous damage. The building was a total loss and was eventually torn down.

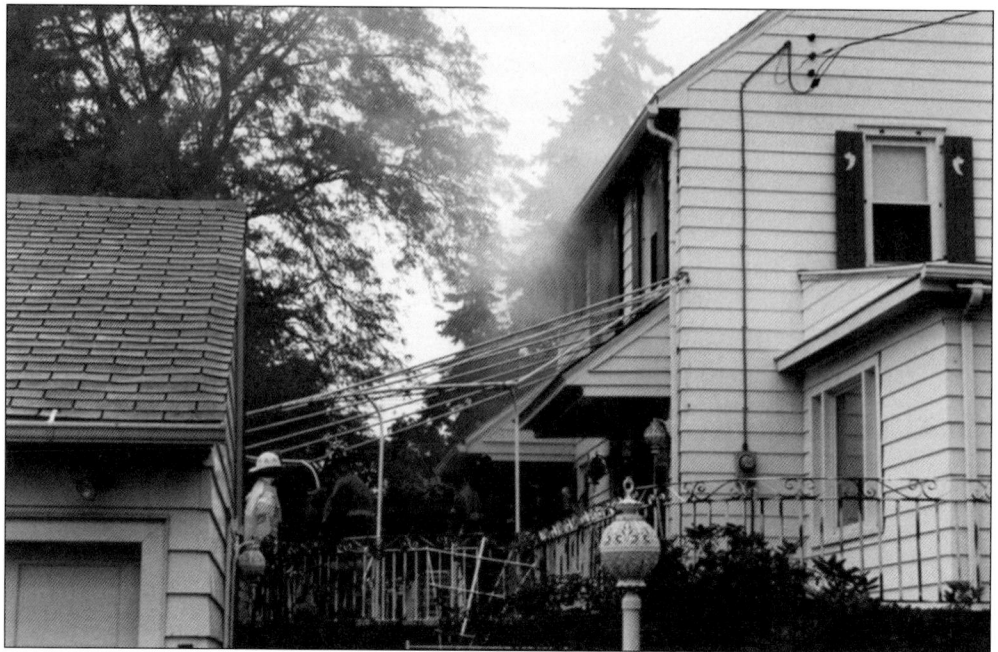

Firefighters and officers from Group D of Johnson City gather on the front porch of Nellie Corey's house on Theron Street. A faulty gas line caused a small kitchen fire. The fire was extinguished quickly, and there was minimal damage to her house. Officials from New York State Electric and Gas began showing up to assess the damage.

Lt. Robert Dempsey begins his investigation of this house fire. The fire caused heavy damage to the front window and bedroom. Firefighters have to attend classes at the fire academy in order to become a certified fire investigator. When an investigation is complete, it becomes part of the official records to be used by courts and insurance companies.

Johnson City firefighters Robert Matuszak (left) and John Fuller take a few minutes to cool off after fighting this unknown house fire. Once the fire is out and overhaul is complete, firefighters will take their airpacks off to lighten the load of equipment they need to carry around. When fully packed up, a firefighter might be carrying around upwards of 90 extra pounds of gear.

After a training session, members from Group C, north side station, gather for a photograph opportunity in front of engine No. 2. From left to right are firefighter Roger Boyer, Lt. John Thompson, firefighter Robert S. Blakeslee, and firefighter Robert "Julio" Matuszak. Most of the time, firefighters work with the same crew. However, vacations and illness sometimes require the men to fill in at another station.

This photograph is from the dedication ceremony in 1992 for the new engines for the Johnson City Fire Department. Fire Chief George Maney (left) and Fire Chaplain Fr. Dennis Ruda get together for a quick prayer. Father Ruda prays for the safety of the men while Chief Maney probably prays no one smashes up the brand-new trucks.

Lt. Rob Jacyna (long sleeves), then the master mechanic of the Johnson City Fire Department, rotates the tires on one of the chief's cars. Firefighters (left to right) David Zeitz, David Nugent, and David Smith stand by in case Lieutenant Jacyna needs any assistance. The fire vehicles were getting ready for the cooler weather that was soon approaching.

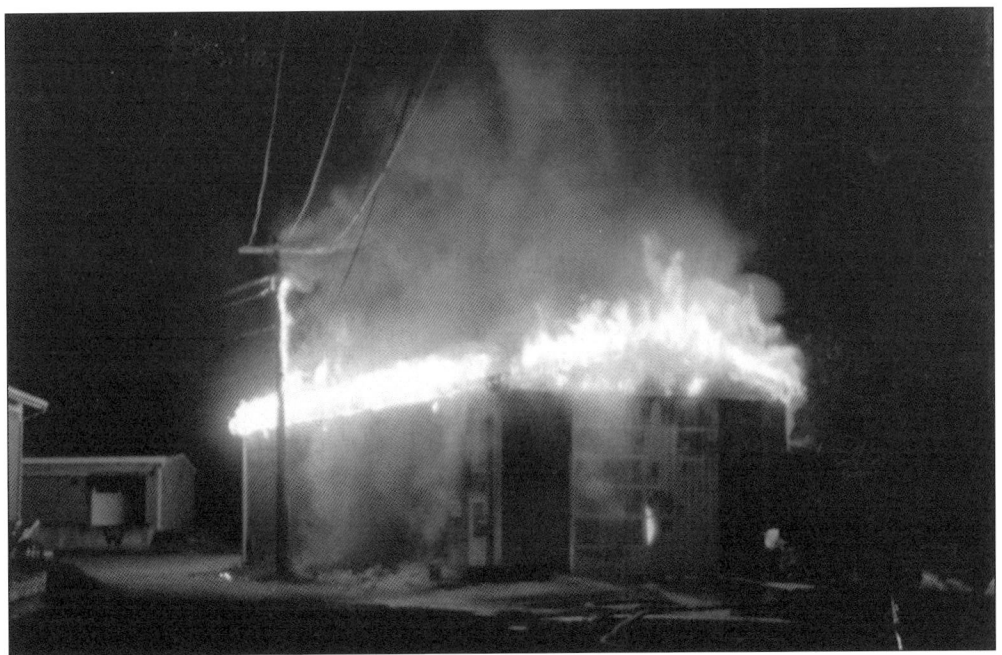

This shed caught fire in the summertime. It was a total loss because of the flammable liquids that were stored inside and because of the time it was burning by the time an alarm was sounded. This was right behind USA Baby on the corner of Valley Plaza Drive and Harry L Drive. It became a very difficult fire to fight because the entire building became energized when the electrical wires fell onto it.

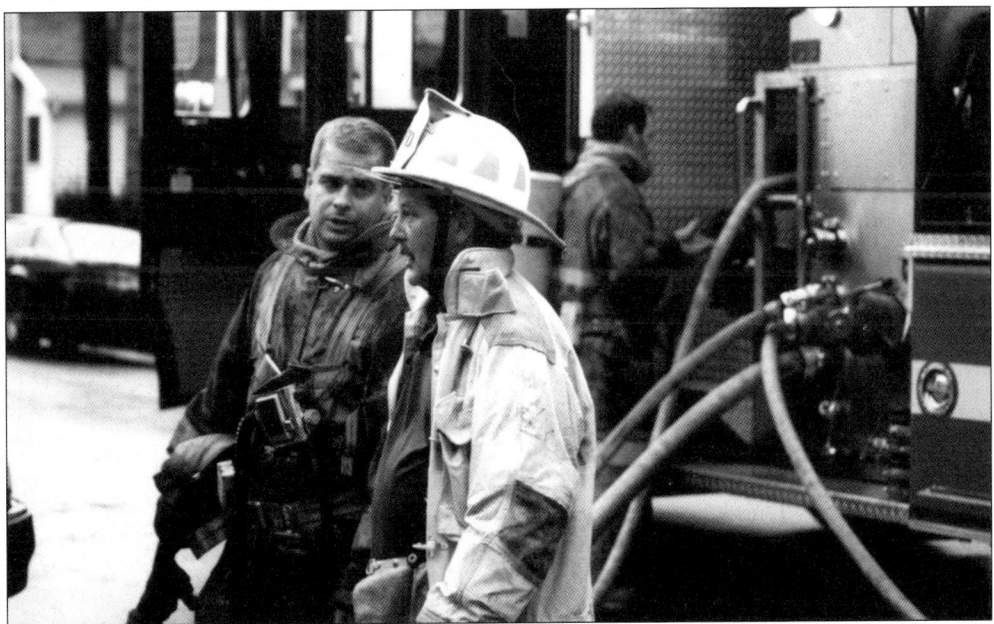

In this photograph, firefighter Scott Kocan confers with Fire Chief George Maney about the situation and looks for guidance as to what the chief wants done next. A chief officer was always on call during the nights and weekends and on holidays to respond to any emergency calls for which the duty captain would need him.

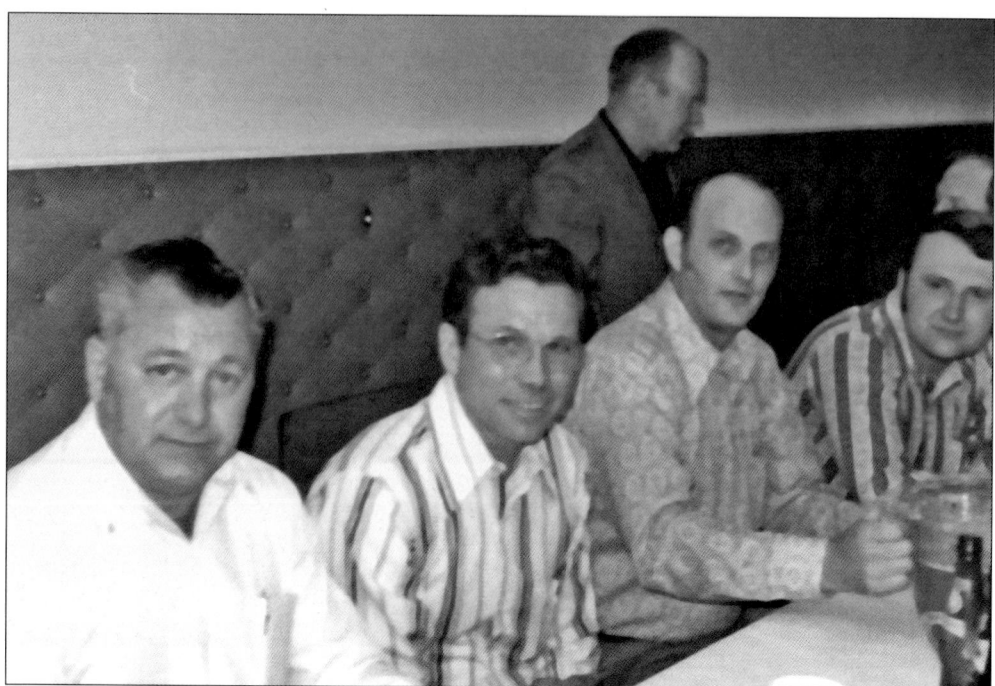

Above is another photograph of the men enjoying themselves at a retirement party for Capt. Les Genthner. From left to right are Steve Moschak, Emerson Chandler, Jerry Gardner (standing), Tom Litavish, and Paul Kocak. Below, Johnson City Fire Department personnel are getting ready to overhaul the smoldering fire at the Conklin Warehouse. Crews were put on fire watch throughout the night to make sure no more fires started. When paper is packed tightly for recycling, it is very difficult to extinguish the fire. A fire can smolder for a long time inside a bale until it finally breaks out into view.

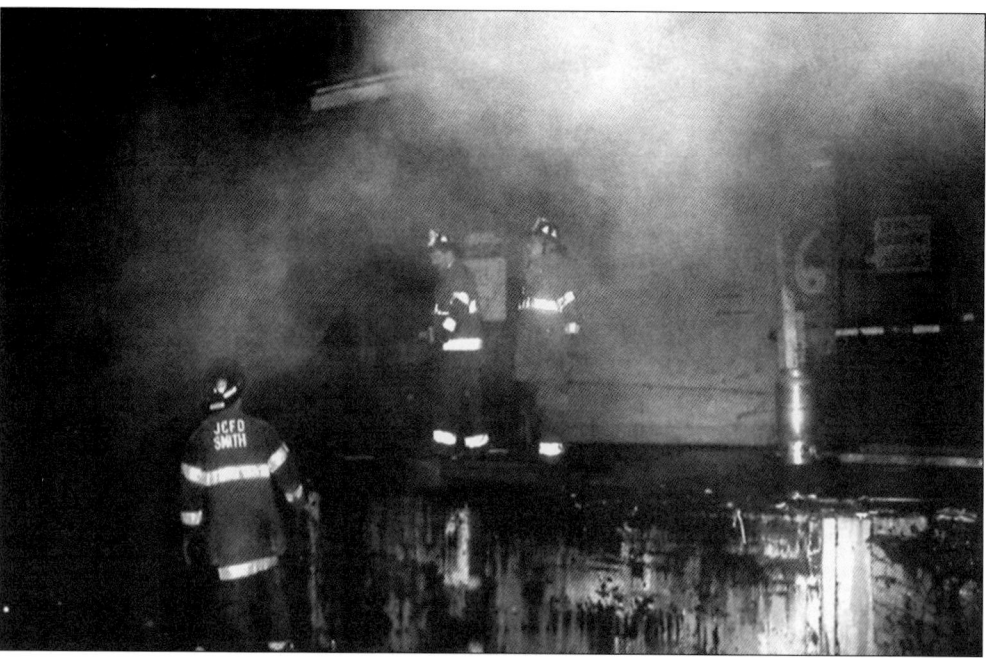

Above, firefighters Roger Boyer (left), Cliff Stewart (in boat), David Smith (far right), and Fire Chief Hank Michalovic (in baseball hat) are all looking over the just delivered new rescue airboat. Below, more firefighters listen to an airboat rescue training instructor. The instructor traveled from Washington, D.C., where he is a member of the swift water rescue team on the Washington, D.C., Fire Department, and also the Montgomery County Fire Department. Johnson City firefighters need to be trained in water rescue because of the Susquehanna River running along the village's border. In 1975, there was a horrible tragedy in the city of Binghamton, on the Susquehanna River, when three firefighters perished at the Rock Bottom Dam trying to perform a river rescue.

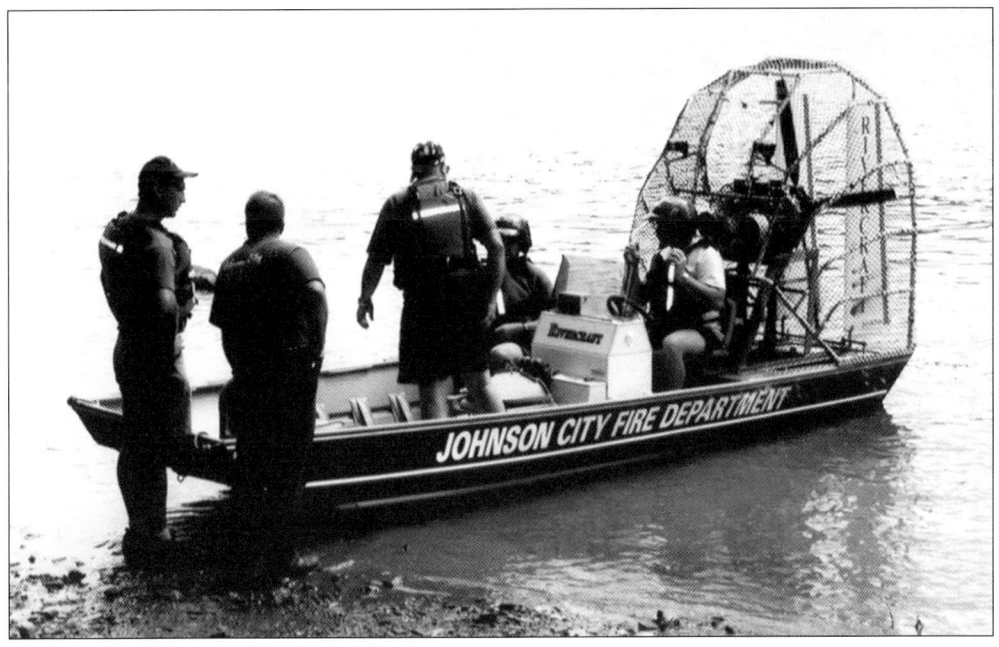

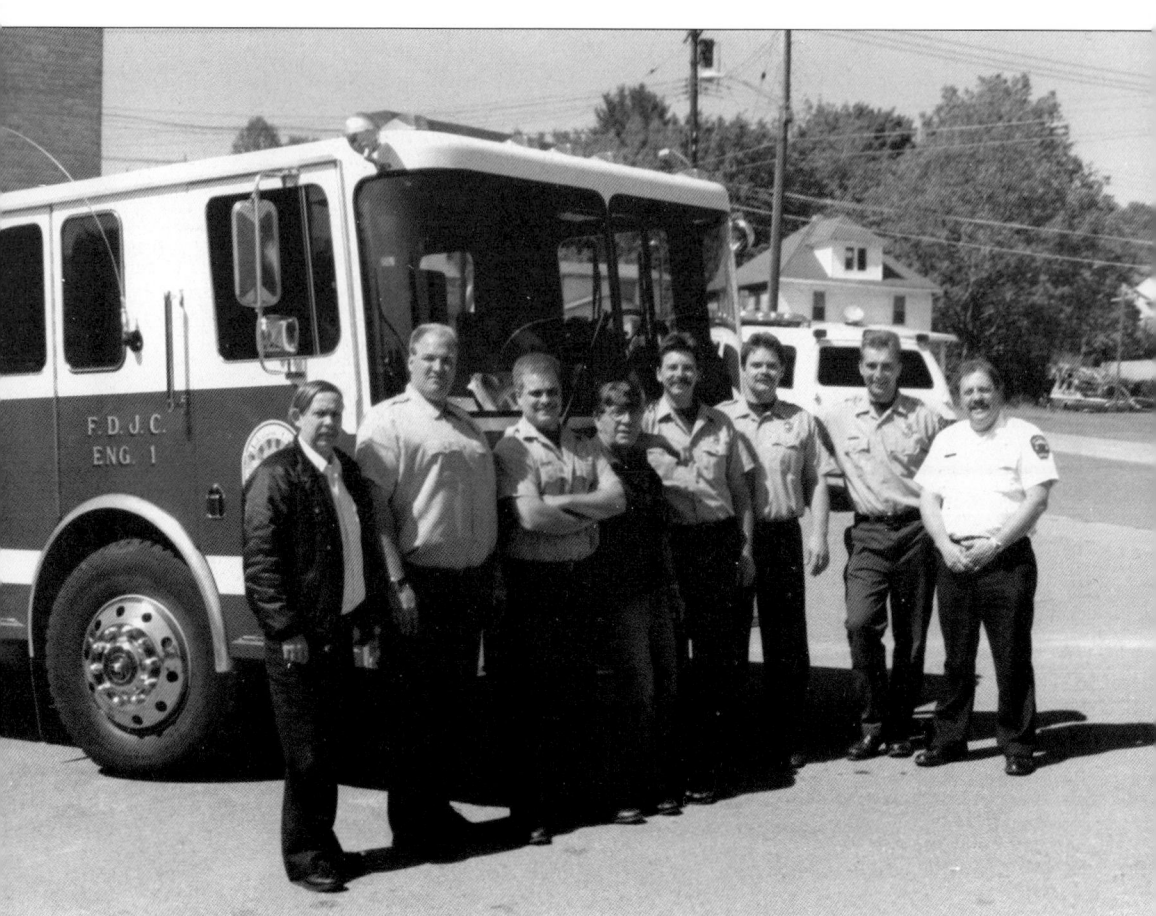

The Johnson City Fire Department provides 24-7, year-round emergency services protection, including emergency medical services, for the residents, workers, and transients coming through the village. The department has four working groups—A, B, C, and D—one of which is on duty at all times. Each group has a captain, a lieutenant, and eight firefighters assigned to it. Groups become like families in that they spend most of their time together. They eat meals together, sleep in the same dormitories together, train together, respond to all kinds of emergencies together, laugh together, and sometimes cry together. This is a photograph of Group D in 1993. From left to right are Capt. Robert G. Blakeslee, firefighter Timothy Moran, firefighter Scott Kocan, firefighter/mechanic John Greene, firefighter John Thompson, firefighter Rob Jacyna, firefighter Jeff Massis, and Lt. Donald Stashko. Two members of this group were off the day the photograph was taken.

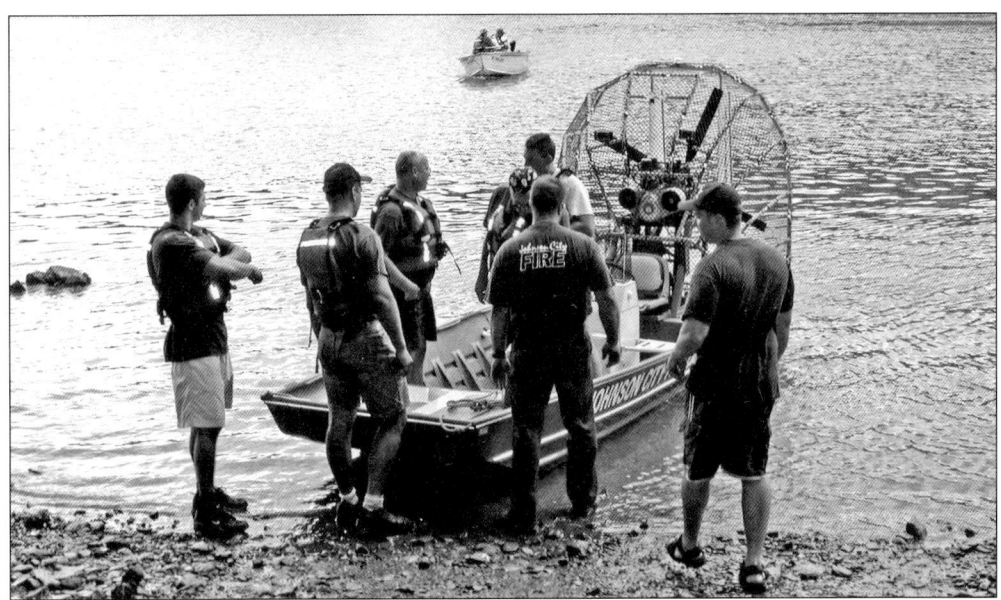

After a new airboat replaced the 40-plus-year-old boat, much training was required for personnel in the use and handling of it, and in water and swift water rescue. Through FEMA grants obtained by fire marshal Robert G. Blakeslee, funding was available for training and equipment. A certified airboat instructor from the Washington, D.C., Fire Department was brought to Johnson City throughout the spring and summer of 2003 to provide the required training. In the photograph above are, from left to right, firefighter Marco Michitti, firefighter Jeff Massis, instructor Steve Miller, firefighter Cliff Stewart, firefighter Dave Zeitz, Lt. John Thompson (white shirt), and firefighter Greg MacBlane. In the photograph below are, from left to right, Lt. Rob Jacyna, firefighter Dave Nugent, and instructor Steve Miller. Interestingly, on the first trip out on the river with the airboat by the instructor from Washington, the boat crew came upon, and retrieved, the body of a man who had been missing for months from the City of Binghamton, upstream.

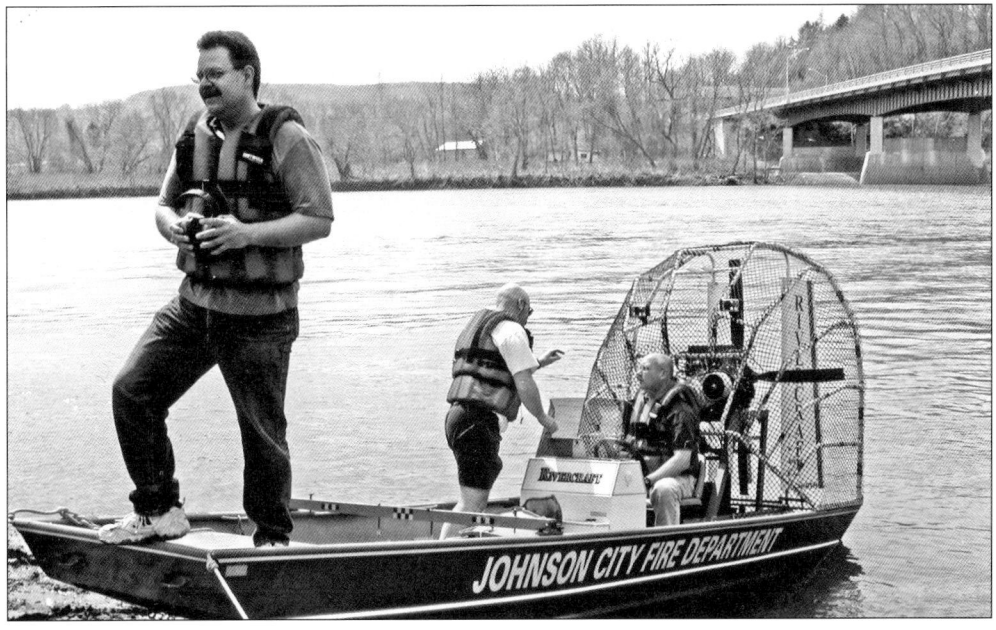

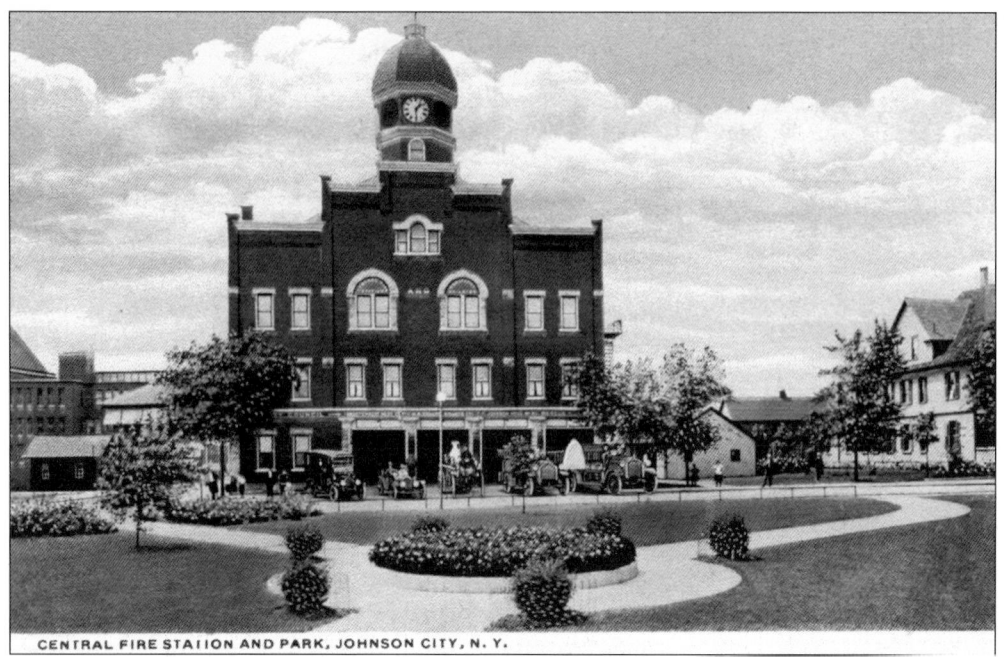

CENTRAL FIRE STATION AND PARK, JOHNSON CITY, N.Y.

Here are two vintage postcards showing the old Central Fire Station in Johnson City. These postcards were from around 1919, and both views show the old fire apparatus sitting on display on the ramps in front of the truck bays. The old horse-drawn steamer can be seen in both views. This steamer was in excellent condition when it was donated to the scrap metal drive of World War II. Many postcards of the Johnson City Fire Department were created, and many are still around and available even through eBay.

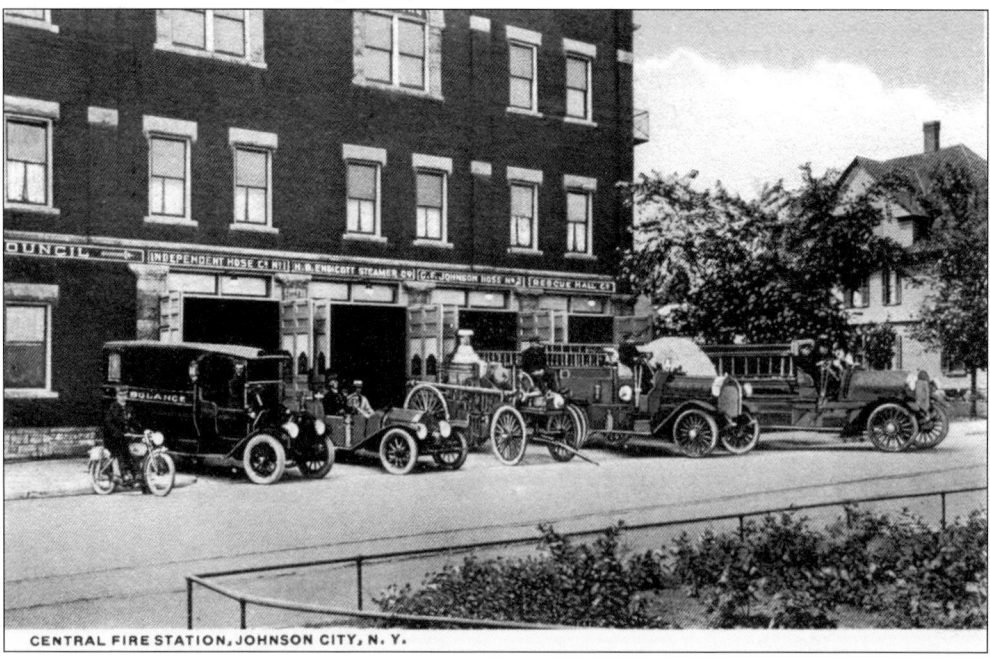

CENTRAL FIRE STATION, JOHNSON CITY, N.Y.

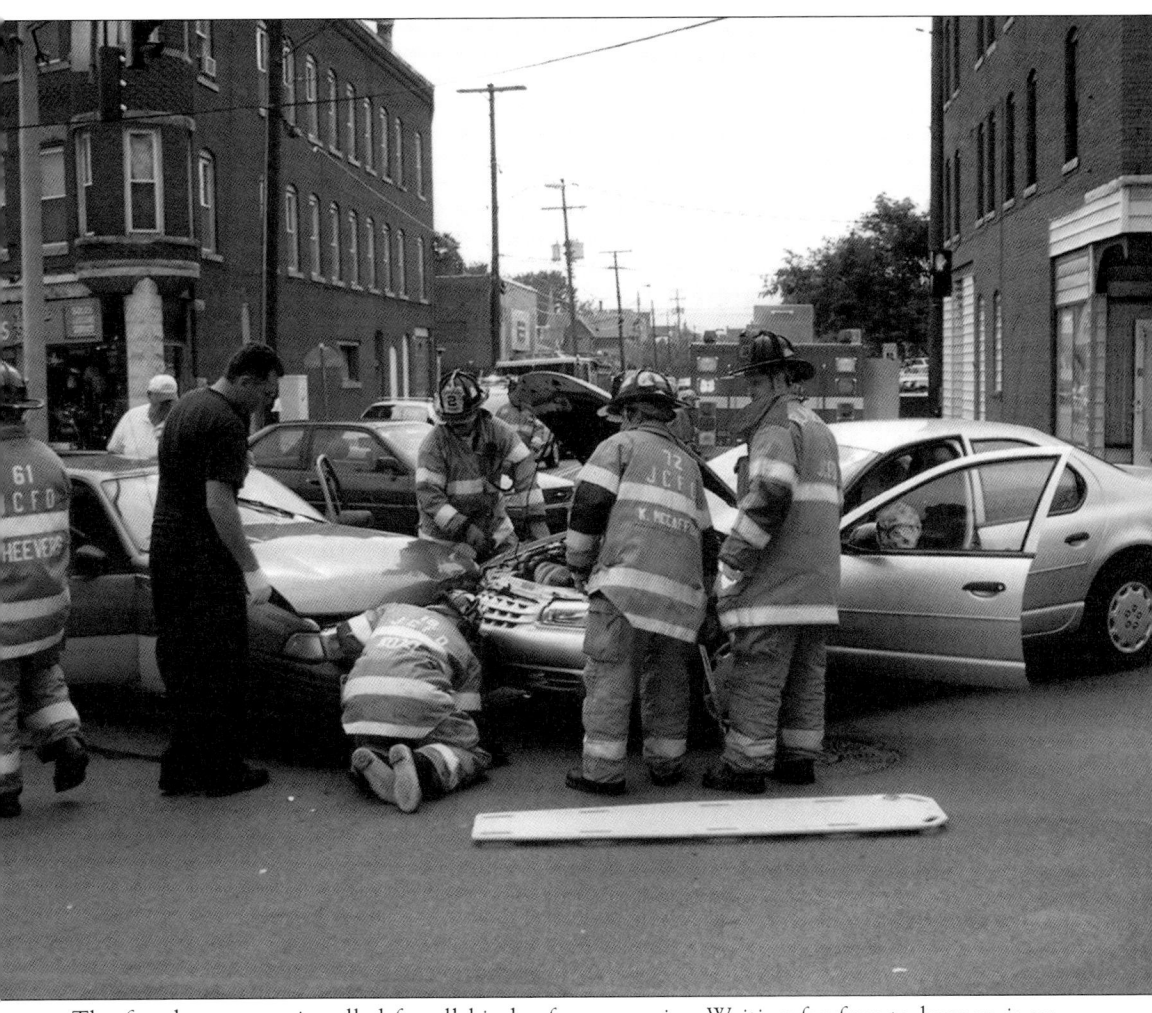

The fire department is called for all kinds of emergencies. Waiting for fires to happen is no longer part of a firefighters' job. The job today consists of a tremendous amount of training in a wide variety of subjects, such as extricating persons from automobile accidents, water and swift water rescue of persons in trouble or trapped by water, rescuing persons from confined space accidents, medical services, getting persons out of elevators stuck between floors, and more. This photograph shows Group A working at an automobile accident at the corner of Main Street and Arch Street. From left to right are firefighter Pat Cheevers, firefighter Martin Porcino, firefighter John Kozel, Capt. Kenneth Roe, firefighter Keith McCaffery, and firefighter Robert S. Blakeslee. The victims of the accident have received medical care, and the firefighters are in the process of disabling the electrical systems of the vehicles to prevent any electrical arcing.

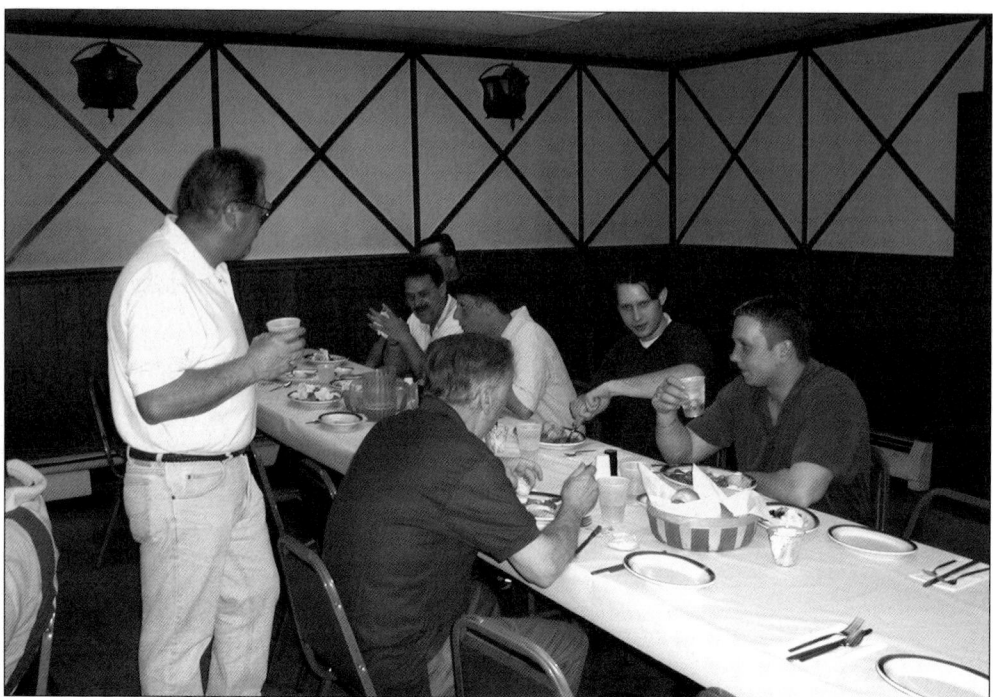

Pictured here is another annual get-together by the firefighters, this one at Red's Kettle Inn. Good times with stories and laughs are always had by all. In the photograph above, standing is Capt. Donald Stashko and retired firefighter Thomas MacBlane is sitting, back to camera. Sitting facing the camera are, from left to right, firefighter Peter Sobiech, Lt. Rob Jacyna, firefighter Nick Stashko, firefighter Robert S. Blakeslee, and firefighter Greg MacBlane. In the photograph below, Fire Marshal Robert G. Blakeslee sits with friend fire department chaplain Fr. Dennis Ruda.

Shown here is Lt. John Thompson with one of his crew, firefighter Robert Matuszak. The photograph was taken not too long before Matuszak's retirement from the department. Crews who work together get to know one another, good or bad, like their own family. They tend to try to take care of one another and are always looking out for one another, most notably on the emergency calls where they can get themselves into some sticky situations. Lieutenant Thompson was one who always looked out for his men under his supervision. Both of these firefighters have had good careers and have always welcomed the other men on their group.

Fire prevention is an important part of the Johnson City Fire Department. Many programs are provided by the department, and several of the men have always been very eager to help out in any way they can. These photographs show the men providing instruction and help with the Broome County Firefighters Association's Fire Safety Trailer at CFJ Park on National Night Out in 2004. The photograph above shows firefighter Roger Boyer, left, helping to make sure kids climbing down the ladder from the bedroom do not fall. Firefighter Thomas Novobilski, seen to the right at the table, sees to it that parents and children receive fire safety materials upon exiting the trailer. From left to right in the photograph below are firefighter Thomas Novobilski, firefighter Robert S. Blakeslee, Fire Marshal Robert G. Blakeslee, firefighter David Zeitz, and firefighter Roger Boyer.

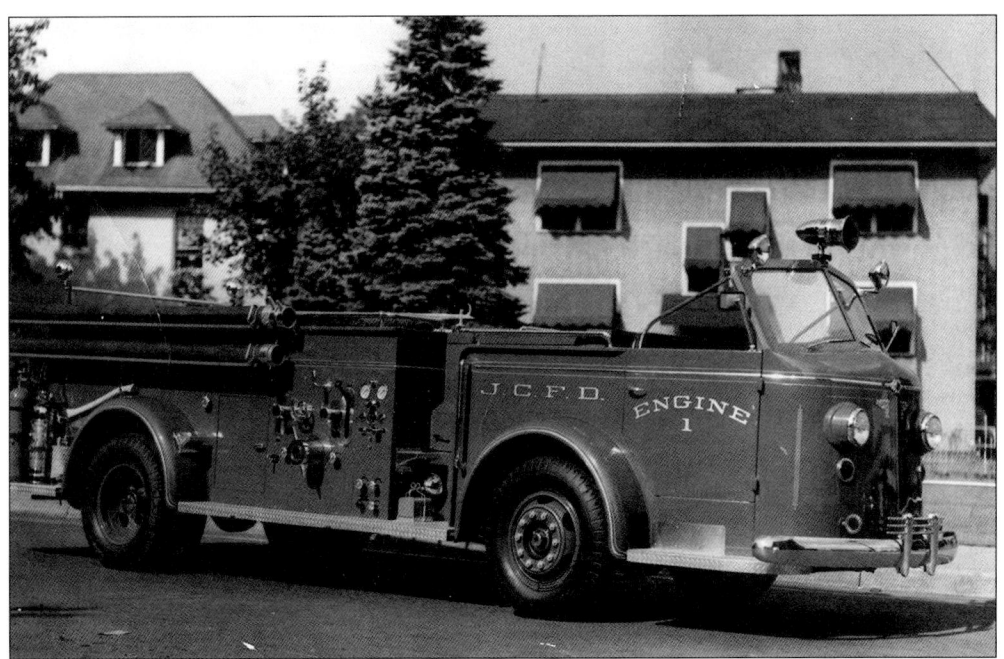

The old engine No. 1, later to be changed to engine No. 5 and used as a standby piece of apparatus, sits out in front of the old Central Fire Station in the early 1950s. This was an American LaFrance pumper and was in service for many years before being placed into standby status. It was sold in the 1970s.

The men of the department used to hold car washes out behind the old Central Fire Station to collect money to be donated to the Handicapped Children's Association (HCA). Quite a bit of money was raised through the years, and in this c. 1960 photograph, firefighter Vince Agati, right, is shown handing over a check to one of the officials of the HCA.

After the terrorist attack on the World Trade Center in New York City, firefighter Mike McCann wanted to do something for the families of those firefighters who had been killed. He came up with the idea of a sports auction, and with the aid of some firefighters in the department, was able to obtain hundreds of sports-related items, signed by professional players of virtually all sports. The auction was held on January 6, 2002, and a sudden snowstorm stopped many who had planned on coming, some from other states. The photographs above and below show just a sampling of the sports-related items and memorabilia that McCann received that went on auction.

To be hired by the fire department, one must go through a civil service written entrance exam and be successful in passing it—the higher the grade, the better. If one is being considered for employment, they must then go through an extensive physical exam by a medical doctor. Once passing the medical exam, one must go through rigorous physical agility testing, much of it new just within the past few years. Here new hopefuls for the Johnson City Fire Department go through that testing. Above, Billy Courtright is shown testing upper muscular conditioning with a long hose pull, which must be completed within a certain amount of time. In the photograph below, Michael Maney is shown being tested on a device that tests his strength in a manor in which he would be using a pike pole inside of a structure during a fire—not an easy test.

Capt. Kenneth Roe set up some lessons with a teacher at the Johnson City Middle School where classes would learn something about pulleys and weights. The classes participated, and Captain Roe had some volunteers from the department to help out. Apparently all had a good time and the teachers thought the program was a success. The students not only learned their lessons, but they also learned a little bit about what their firefighters are trained to do. In the photograph above, Capt. Robert Dempsey, with helmet on, is shown showing and helping the students lift a person up from a valley by using ropes with pulleys and other devices. In the photograph below, firefighter James Furman helps one of the students adjust some equipment around her waist.

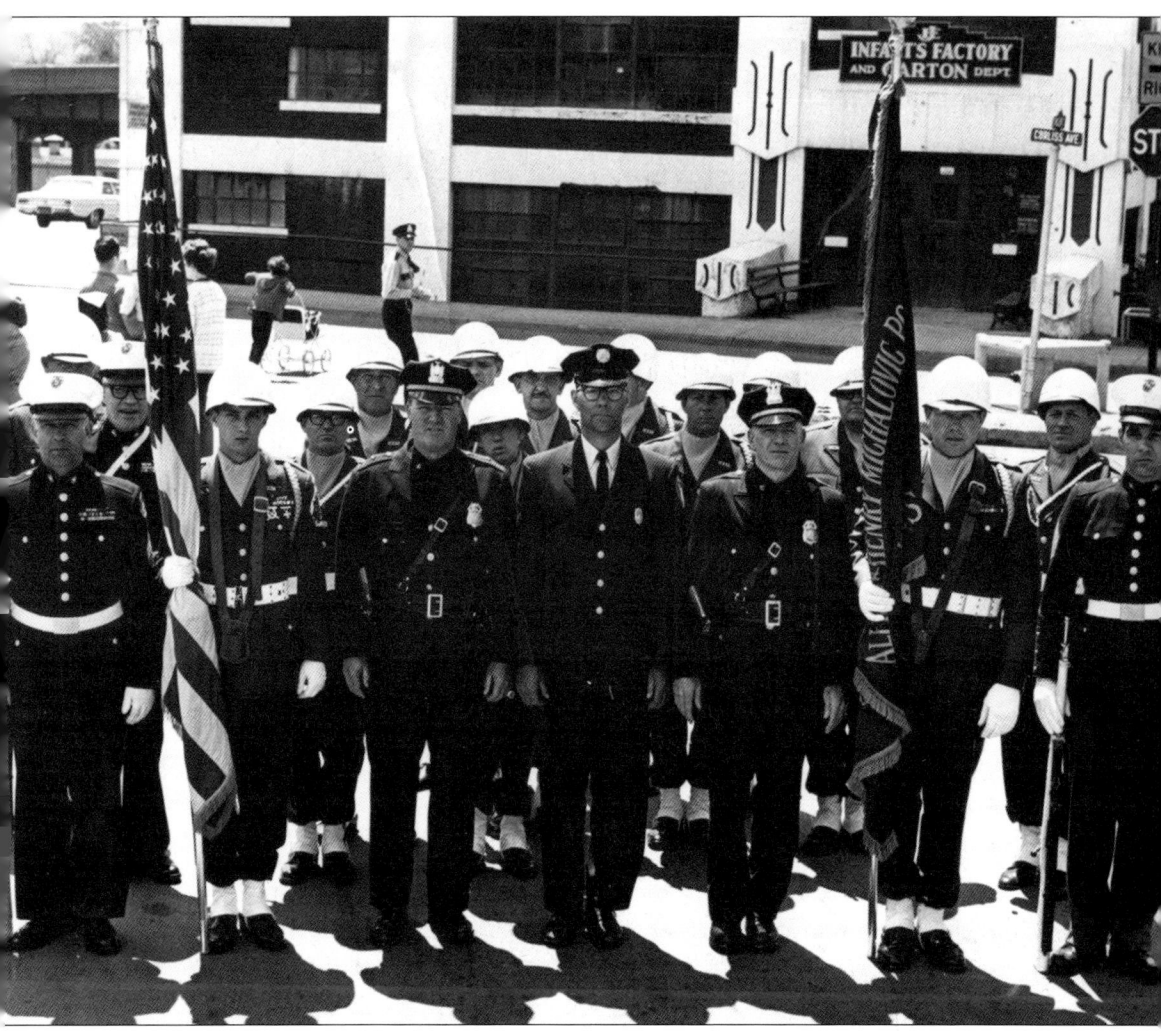

Years ago, many members of the department were veterans and many of those veterans kept close ties to their military experiences thought memberships in the American Legion or Veterans of Foreign Wars. This photograph shows a contingent of men at the small park across the street from the old Central Fire Station. The purpose of the gathering was the dedication of a new flagpole in the park, which still stands today. This dedication took place in the early 1960s. Pride in country and pride in their military service to the country is what bonds these men. Two members of the department are in this photograph of the dedication. In the center, between the two police officers, is firefighter Harry Shannahan, a U.S. Marine veteran, who himself was wounded seriously in Korea. Second from the right is firefighter Lawrence Campbell, a U.S. Navy veteran. As it is with other places of employment, the ranks of the U.S. Military veteran have declined substantially.

Firefighters have been involved with fund-raising for the Muscular Dystrophy Association (MDA) for years, raising millions of dollars across the United States for the Jerry Lewis Telethon every year. Johnson City firefighters have done their part locally as well. MDA sponsors a Spaghetti on Ice fund-raiser every year, and the firefighters have always helped out with that. For the dinner, members of the Binghamton Senators hockey team help wait tables at the spaghetti dinner in an effort to raise money for MDA. In this photograph, taken at the Veterans Memorial Arena where the Senators play, are the following, from left to right, Binghamton Senators player Denis Hamel (No. 17), Johnson City firefighter Mike McCann, Michael Osenni in his wheelchair, and an unidentified Bridgeport Sound Tiger player. Michael Osenni is currently a high school freshman, and he still continues to make appearances at many MDA fund-raisers.

In July 1940, the Johnson City Fire Department sponsored and hosted the 47th Annual Convention of the Central New York State Firemen's Association. Many things of interest, including banquets and tours, were planned for the visitors and attendees of the convention, including the wives. Nothing was left to chance, and by all accounts, everyone attending this three-day festivity left with more than pleasant memories. As with all other conferences and conventions, booklets were produced and advertising purchased within them. Here is the front cover of that booklet from 1940, along with an advertisement placed by the New York State Electric and Gas Corporation.

SALUTE to the FIREMEN!

Days and nights often go by without anybody paying any attention to you. You're just the Fire Department. Some people may see you beside the open door where the fire trucks wait and say "That must be a soft job!"

But let the house, place of business, factory or school catch fire—or let the pulmotor be needed to save a life—and you are the most important men in the world. Your jobs are not thankless when you cling to that careening truck on your way to risk your lives in a flaming building—or when you race on some errand of mercy.

A big salute to you from a humble champion of fire prevention!

REDDY KILOWATT
Your Electrical Servant

NEW YORK STATE ELECTRIC & GAS CORPORATION

Across America, People are Discovering Something Wonderful. Their Heritage.

Arcadia Publishing is the leading local history publisher in the United States. With more than 3,000 titles in print and hundreds of new titles released every year, Arcadia has extensive specialized experience chronicling the history of communities and celebrating America's hidden stories, bringing to life the people, places, and events from the past. To discover the history of other communities across the nation, please visit:

www.arcadiapublishing.com

Customized search tools allow you to find regional history books about the town where you grew up, the cities where your friends and family live, the town where your parents met, or even that retirement spot you've been dreaming about.